Underwater Photography
Art and Techniques

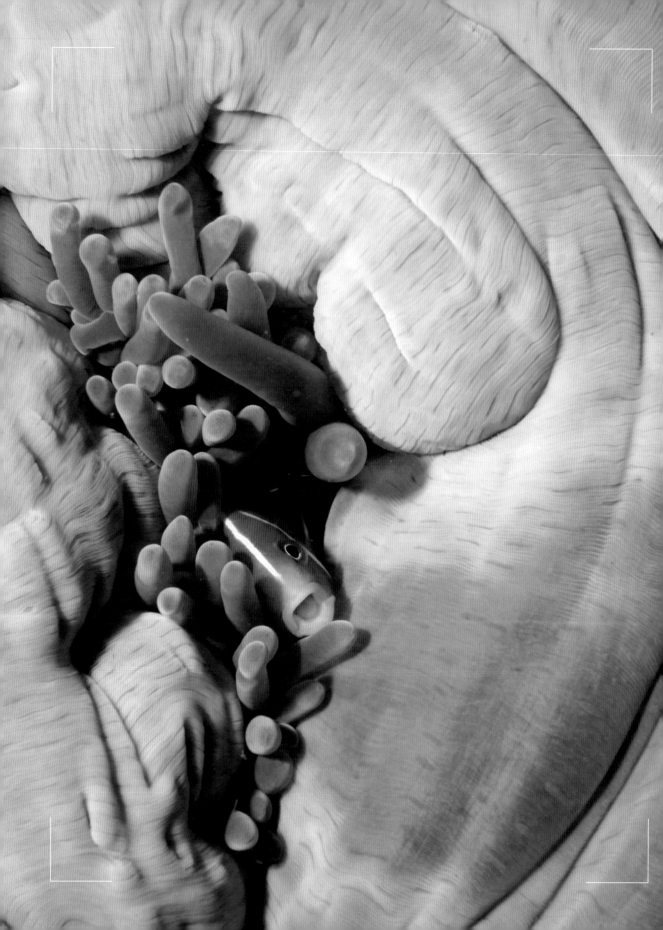

Underwater Photography
Art and Techniques

Nick Robertson-Brown

CROWOOD

First published in 2014 by
The Crowood Press Ltd
Ramsbury, Marlborough
Wiltshire SN8 2HR

www.crowood.com

British Library Cataloguing-in-Publication Data
A catalogue record for this book is available from the British Library.

ISBN 978 1 84797 657 4

Acknowledgements

I would like to thank all the people who have supported me throughout the writing of this book, in particular Nick Barrett for his tireless proof reading and painstaking attention to detail, and also Tom Tyler and Yo-Han Cha for their last-minute proof reading. I am grateful to Takuya Torri for some of the equipment images, and also to Steve Warren at INON UK for technical advice and for his kind words in the foreword. Finally and most importantly I owe a huge debt to my wife Caroline, for all the IT support she provided, as well as modelling for many of the photographs – several of the best images in the book belong to her too.

Frontispiece
Pink anemone fish tend to be shy and rarely approach the lens. This one was taken hiding in it's host in the Lembeh Straits, Indonesia.
1/100; ƒ22; ISO 250. Nikon D200, lens 60mm.

Graphic design and layout by www.peggyandco.ca
Printed and bound in India by Replika Press Pvt Ltd

CONTENTS

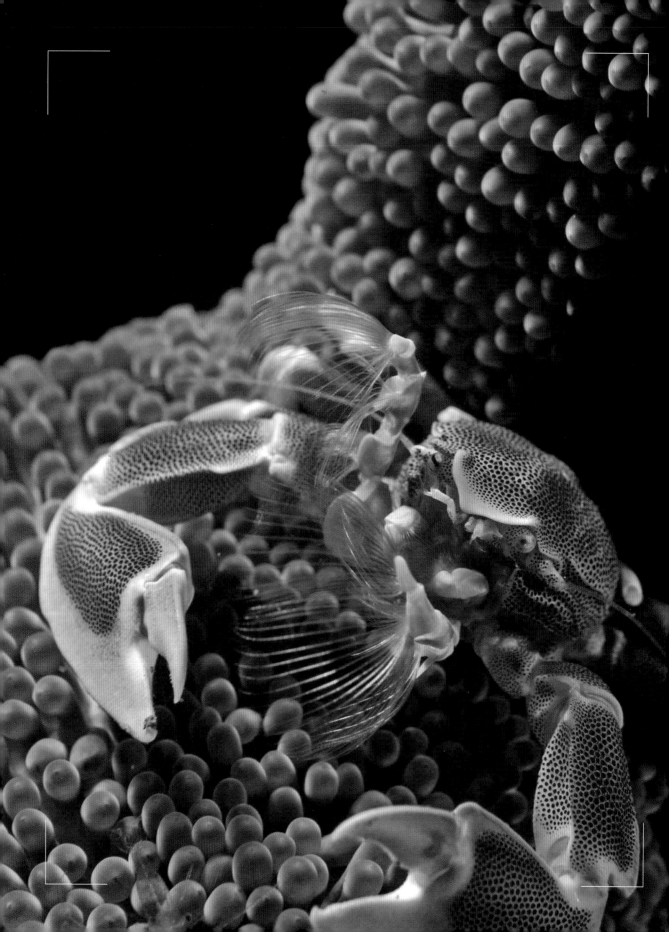

Foreword

Each dive we make promises to be a unique experience. For many divers underwater photographs have become the best way to recall and share those experiences. For how can a few words hastily scrawled in a damp logbook evoke the wonder of the lakes, rivers, seas and oceans each of us explores? And who else would read those words anyway? Most of us have been seduced to begin our incredible journey under the water through images. Through our own underwater photographs we remind ourselves and prove to others that we were actually there.

But taking good underwater photographs can be both difficult and frustrating. Although digital underwater camera equipment, especially the compact camera, seems to promise easy results through a smorgasbord of automatic functions that do all the work for the diver, the reality is very different. Unlike photography on land, where a casual shoot from the hip approach can work surprisingly well, it is rarely successful beneath the waves. The diver wanting to take good underwater images needs to understand how their camera functions and how to control it.

The underwater world puts a myriad of subjects before our lens. And, naturally, we want to photograph all of them! From the eel lurking in the twisted companionways of a sunken liner to the looming bows of the ship itself, we are spoilt for choice. But each subject requires different equipment and a different approach. In addition, underwater photography is almost always done against the clock. Few recreational dives exceed sixty minutes and even the most enthusiastic photographer is unlikely to spend even five out of every twenty-four hours actually taking pictures. The light is poor, visibility poorer still. Some subjects are incredibly hard to find and exceptionally wary, like orcas, and some underwater environments, such as caves, require specialized diving skills to access and survive. The odds of successfully taking that defining underwater image are stacked against us, the diver, in ways few land photographers will ever confront.

In this book Nick Robertson-Brown stacks the odds of success in your favour. He explains the must-know information that divers with little if any knowledge or experience of land photography will find essential for taking underwater photographs they can be proud of. Nick's approach is straightforward and is easily understood. The maxim 'a picture is worth a thousand words' is one that the best writers about photography skills embrace. So Nick gets to the point fast and breaks it down into information you can immediately apply. There is no self-serving waffle or obfuscation.

Nick's career as a working underwater photojournalist, his accreditations from the professional photographer trade associations and the stunning portfolios of the many students he has taught as an underwater photography instructor are solid proof of his abilities. Follow the methods and advice so hard won and yet so freely given by Nick Robertson-Brown and look forward to making great underwater photographs of your own.

Steve Warren
Owner of underwater photography specialists INON-UK; organizer of the annual underwater photography festival Visions in the Sea

◀ **Porcelain crab.**
These porcelain crab occupy an anemone, sharing their host with the "Nemo" fish and helping to keep it clean and parasite-free. 1/00; ƒ18; ISO 400. Nikon D700, lens 60mm.

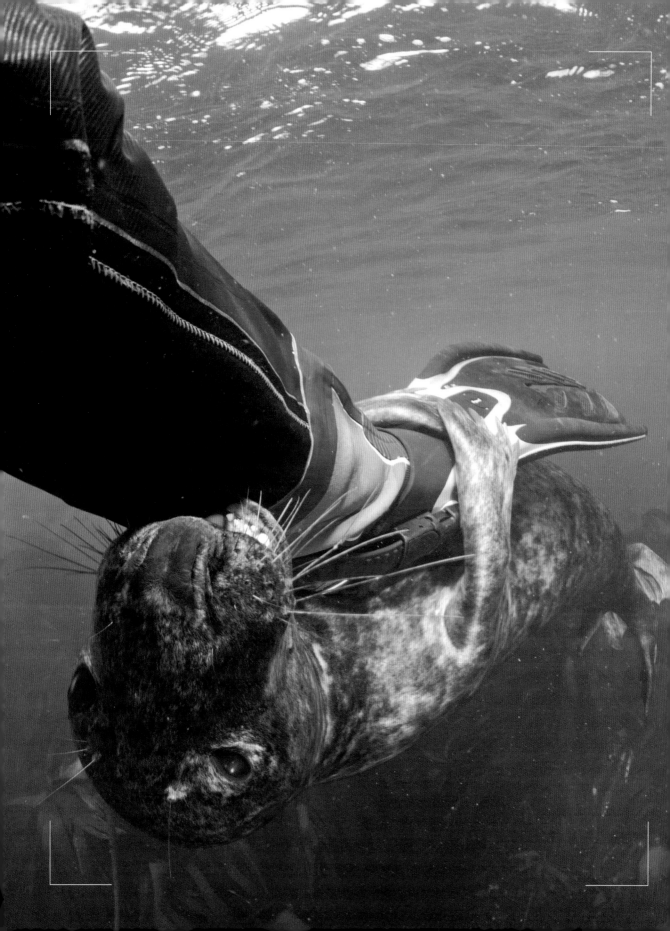

Introduction

When William Thomson, a solicitor, first put a camera under water off the English coast of Dorset in 1856 I am sure he had no idea what he was about to start. He put the camera on the end of a pole, and in about 6m of murky water he captured a rather indistinct picture of a bridge in the Wey estuary in southern England. Twenty years later, in San Francisco, Eadweard Muybridge attempted a similar experiment. The early image taken by Thomson has sadly been lost, and it was not until 1893 that Louis Boutan went under water in a hard hat with surface-supplied air that images were actually taken while diving. These photographs were taken in the Mediterranean and this exciting work was pioneering in its day. The work of Boutan is seen by many as the start of the story of underwater photography. His book *La Photographie Sous-Marine* was published in 1900.

Progress in underwater photography was relatively slow for several years after this, although in 1914 John Ernst Williamson shot the first ever underwater motion picture, and in 1923 W.H. Longley and Charles Martin took the first underwater colour photographs using a magnesium powered flash. There were small improvements throughout the First World War but it was not until the 1930s that really important developments started to take place which led to the improvement in underwater photography equipment and techniques. In the 1930s, exploration of the oceans led to the need for more and better photography equipment. In addition, the invention of scuba systems made it far easier for the divers to move around without being attached to a surface-supplied air hose. The invention and development of strobes as part of an underwater lighting system led to a rise in the number of people getting involved in underwater photography.

One of the principal characters in underwater photography is Jacques-Yves Cousteau. His books and films were seen by so many people on the new medium of television that the public began to believe that they could do it too. Working with the Belgian Jean de Wouters they developed an underwater 35mm camera called the Calypso-Phot. The design was innovative and made by Atoms of France. It was bought by a Japanese photography company and then released in 1963 as the Nikonos. It had a maximum shutter speed of 1/500 of a second and became the bestselling underwater camera series ever made. In the late twentieth century, ever-improving equipment and the increasing popularity of recreational scuba diving made underwater photography accessible to both amateurs and professionals alike. There are two other notable personalities from the pioneering era of the late 1940s to the 1960s who should not be forgotten; they were Hans and Lottie Hass. Their films and dedication to the protection of the underwater environment inspired many people to take up diving and underwater photography. In 1949, Hans helped to develop the famous Rolleimarin underwater housing for a double lens reflex Rollei square format camera. It became the most successful underwater camera of its time.

◀ **Farnes seal.**
Common seals are abundant around the coast of Great Britain and Ireland. This was taken in the Farne Islands off northeast England and is so used to divers that they love to interact.
1/160; ƒ16; ISO500. Nikon D700, lens 60mm

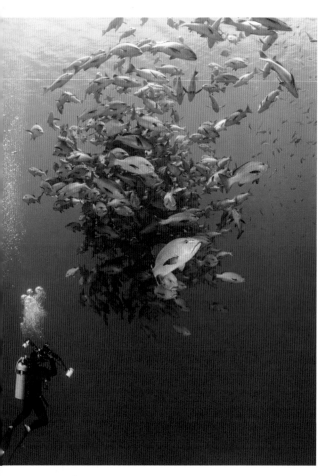

▲ Fig. 0.1
Boha snapper schooling in the Red Sea off Ras Mohammed.
1/160; ƒ16; ISO 640; Nikon D800

However, probably the most influential improvement in underwater photography occurred with the arrival of digital cameras. Even with the introduction of model-specific underwater housings for the 35mm SLRs, the diving photographer was still limited to the maximum number of shots he could get out of one roll of film. Once underwater, the photographer was committed to using whatever kind of film he or she had chosen: there was no changing of film speed, which can now be emulated in a digital camera while still underwater. The film speed or ISO is explained later on in the book, but essentially it increases or decreases the sensitivity of the film or the sensor, allowing images to be captured in darker light with a higher ISO. The screen on the back of the camera allows you instantly to review your images, and thus make any changes accordingly. In the days of film photography, many photographers would take three or four shots of the same image using different exposure settings in what was known as bracketing. Once the photographer returned to the surface, the film still needed to be developed and printed. Film has now, essentially, been replaced by a memory card. Even on the camera's highest resolution setting, most memory cards will hold several hundred images. The digital revolution has made a huge difference to photography and the pace at which improvements are being made is staggering.

If you are a scuba diver, free diver or snorkeler and you have decided to take your camera with you, then you have taken the first step to open up a new dimension to your passion. Capturing images under water can be seriously rewarding when you can review the amazing marine life that you saw on your last dive. It can also be both frustrating and confusing, very often on the same dive. I hope this book will be able to guide you through many of the pitfalls and teach you how to overcome them in lots of small, easy steps.

To be a good underwater photographer you need to be an excellent diver. Good buoyancy is essential, and awareness of your surroundings is equally important. If your camera system is not neutrally buoyant, then your own buoyancy is going to be affected. Ideally you should balance your camera system so that it is neutrally buoyant, but many underwater photographers prefer to have their systems slightly negative. There are many issues to consider and these will be covered in depth.

If you are new to underwater photography you may need to consider changing or adapting some of the equipment that you use. For example the exhaust vents of your second stage may direct bubbles in front of the camera lens, and you may need to consider getting the regulator that is more suited to underwater photography. Your eyesight may have been perfectly acceptable for normal

▲ Fig. 0.2
Orangutan crab hiding in a bubble anemone in Bunaken, Manado. These crabs really do appear to be covered in orange hair.
1/160; ƒ5; ISO 200. Nikon D200

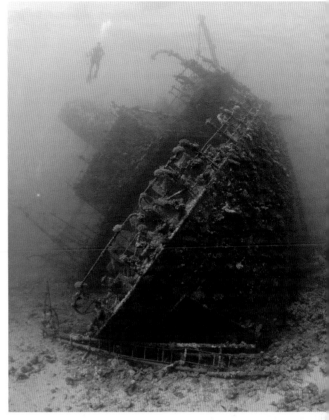

▲ Fig. 0.3
The *Giannis D* wreck off Ras Mohammed in the Red Sea, taken from the classic stern position and converted to sepia to add to the atmosphere of the image.
1/100; ƒ14; ISO 250. Nikon D800

diving, but you will need to review your images underwater on the screen, and as the screen is small it can be very difficult to pick out detail. If your close-up eyesight is not perfect then you may want to look at purchasing a twin lens mask with gauge readers in order for you to be able to review your images.

In photography there are numerous techniques and styles, and underwater photography is no different. You could spend a week diving in one location but the style of photography on the various dive sites of that location could be completely different. Some sites may be suitable for macro and super macro while others suit wide-angle or close-up wide-angle, and others could be reef and wreck photography. These sites are all different and require varying techniques, but there are no rules in the underwater photography world and many of the techniques are adaptable and interchangeable.

Many underwater photographers like to specialize in one category, such as macro or wide angle. While you might want to concentrate on developing your own style and focussing on what you enjoy, it is also great fun to try to expand your repertoire. You should be encouraged to try out new techniques and generate your own style. Underwater photography is about producing images that you, personally, find appealing (unless you are looking to sell your photographs). However, to get full satisfaction from your efforts you must learn to understand the limitations of your camera and equipment and be able to review your image under water, decide what is wrong and change it there and then. If this book helps you achieve this, then it will have succeeded and so will you.

Chapter 1

The Camera

Cameras have been around for a long time. The first cameras were believed to have produced images in 1816, and the principle of these first cameras can be seen in a simple pinhole camera with an opaque screen for the image. As the light passes through the pin hole (aperture) it is inverted and is displayed on the screen.

In the early cameras, the 'screen' was a photographic plate: a sheet of paper, or other material, impregnated with silver nitrate. The impregnated chemical reacts to the density of light, and this forms an impression of the image when 'exposed' to the light for any length of time. The image is thus 'burned' onto the plate as a negative and, when developed, the image can be seen as a print.

In the early part of the twentieth century Kodak took the lead in bringing photography to the people. The box Brownie camera was introduced by Kodak in the United States and Western Europe in the early 1920s and retailed for $1–3. It was capable of capturing some excellent pictures using 120 film with eight shots on a roll. It had up to three aperture settings and the expensive ones even had a limited choice of shutter speeds.

Digital cameras are not that far removed from these first cameras – in principle at least. The only real change is that the film has been replaced by an electronic device that is sensitive to light; we call this the sensor. The digital sensor is, however, only part of the work flow to convert light/subject into an image. The image is carried through several stages before it appears in a usable form at the memory card. The result can normally be viewed on the screen on the reverse of the camera.

The image passes through the lens, which is in fact a series of lenses, where it is then focussed onto the sensor. The sensor is a sheet of semiconductor

▲ Fig. 1.2
The image of the pinhole camera in this diagram shows the rear of the box. This one is actually a camera obscura and the image would appear inverted on the screen you can see.

▲ Fig. 1.3
This box Brownie camera dates from some time in the 1930s. This one was a limited run of red colour – most were black.

◀ Fig. 1.1
A Denise pygmy seahorse taken in Raja Ampat in Indonesia. This seahorse was taken with a high shutter speed and high ƒ-stop and just given a tiny bit of light from twin strobes to create the black background. This seahorse is very tiny indeed, around 2–3mm long. 1/250; ƒ16; ISO 250. Nikon D700, 60mm

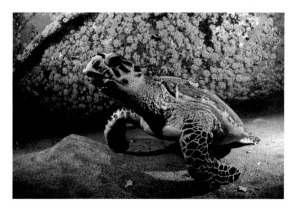

▲ Fig. 1.4
The image shown here is just to give an example of what can be seen on the screen on the back of the camera. I took this hawksbill turtle on a night diving whilst carrying out research on turtle populations on a tiny island in the Caribbean.
1/125; ƒ13; ISO 400; Nikon D700, 16mm.

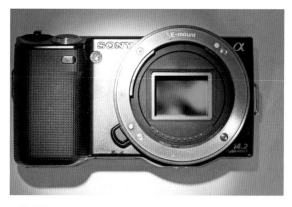

▲ Fig. 1.5
The lens has been removed from this mirrorless style camera and it shows an image of a sensor where the lens should be. You cannot see the actual pixels as the sensor is behind a protective screen that is covering it.

containing an array of millions of light-sensitive 'mini-sensors'. The number of these light-sensitive mini-sensors accounts, in a large part, for the resolution of the picture, and because there are so many of these pixels they are measured in their millions. Many cameras are, not always correctly, judged purely on their megapixel count.

These sensors are photo-sensitive diodes that convert the light into electricity and each one is sensitive to a particular colour: red, green or blue (RGB). The coloured light from the image you are trying to capture is usually a mixture of colours. Where you believe you can see blue light, it may be made up of components of blue, green and red. These individual components of colour are detected at the corresponding sensors. Each of these sensors has a small gap between them and it is the individual sensor plus the gap that actually creates what is termed a 'pixel'. Most modern digital cameras now have at least 12 million pixels squeezed into a space that is smaller than a postage-stamp on compact cameras. Even on a 36 mega pixel digital SLR, the sensor is approximately the size of a 35mm slide!

The signal sent from each individual sensor is proportional to the amount of light and colour. From here it then enters a buffer where it is stored for a

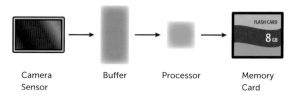

Camera Sensor Buffer Processor Memory Card

▲ Fig. 1.6
The simple diagram is to show how the image, once captured, passes to the buffer through to the processor, where it is then passed to the memory card.

fraction of a second before being converted from an analogue signal into a digital one. The really clever stuff takes place in the processor where the binary code from the digital signal is converted into an image. This again passes through a buffer before being written onto the memory card. Similar data is displayed on the camera screen, sometimes with all the metadata. Metadata is information, embedded in the image, about how and when (and sometimes where) it was taken. Many cameras now have a GPS system built into them – not just digital SLRs but most modern compact cameras will now also have it.

CONTROLLING THE LIGHT

What can you do to create the image as you see it or want to present it? Without using artificial light, there are three factors that you, the photographer, can change. As you can see from the exposure triangle (Fig. 1.7), the three factors that affect the light/exposure on the image are aperture, shutter speed and ISO. All three have their own distinct effect upon the outcome of your image, but there are penalties involved with each method of increasing the light. The amount of light that arrives at the sensor is called the exposure value (EV). Change any one of these factors and this value will also change. Change another and you can bring the required EV back to where you wanted it. It is a question of balancing the exposure to get the right value for your situation. It is also how you balance this value that gives you, the photographer, the control of how you want to present your image. (Exposure values are explained and discussed at greater length in Chapter 8.)

Aperture

The aperture is the hole behind the lens through which light enters the camera and can be directly compared to the pupil of the human eye. In bright light, the pupil will close down to a small round opening, restricting the amount of light that falls on the retina. As it gets darker, the pupil dilates to allow more light to enter. The aperture on the camera's lens can be opened and closed, like the pupil in the eye. The difference in the amount of light that it allows through to the sensor between being fully open and its minimum setting is extensive.

Aperture Setting

The aperture setting is referred to as the f-stop or f-number. The size of the hole is determined by a circle of blades that cause the central aperture to open and close by the overlapping of the blades on each other. This restricts or controls the amount of light hitting the sensor. The size of the aperture is given a number; these numbers are not just random figures but are, in fact, a ratio of the focal length of the lens to the physical size of the aperture. One of the issues that sometimes confuses many budding photographers is that a wider aperture giving more light has a small f-number, while a narrow aperture allowing a low level of light is a high number. Try and give yourself a simple mnemonic, for example – the higher the sun the higher the number aperture.

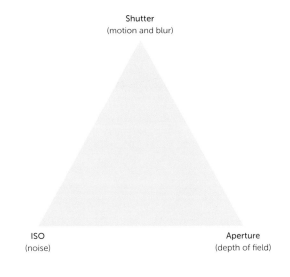

Shutter
(motion and blur)

ISO
(noise)

Aperture
(depth of field)

▲ Fig. 1.7
This diagram shows the exposure triangle, which itemizes the three principal components controlling how bright the image is.

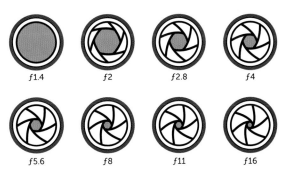

f1.4 f2 f2.8 f4

f5.6 f8 f11 f16

▲ Fig. 1.8
The aperture is completely open at its highest f-stop number, and the amount of light that can enter the aperture is halved at each f-stop number.

All camera lenses are calibrated on the same ƒ-stop scale. The range of the aperture numbers varies from one lens to another but the scale is constant. The ƒ-stop index is shown in the diagram, but a lens which had the whole range of the ƒ-stop options would probably be very expensive. Because the ratio of the aperture size to the focal length of the lens gives us the numbers in the ƒ-stop scale, each increase in ƒ-stop number equates to half the amount of light arriving at the sensor, for example, ƒ5.6–8, ƒ11–16.

Depth of Field

Opening and closing the aperture (decreasing and increasing the ƒ-stop) would appear to be a simple way of changing the light level on the sensor. However, as the aperture is opened (reduced ƒ-number), the depth of field reduces, and this has a very noticeable effect upon the image. So what does this mean? The depth of field (DOF) is defined as the amount of the image which appears to be acceptably in-focus.

You may think it strange that you would deliberately have large areas of your image out of focus, but some of the most impressive underwater images, especially macro, are taken with a very small DOF. The idea is to make sure that the centre-piece of your image is razor sharp and that everything in front and behind moves out of focus. We call this out of focus area 'bokeh'. This technique is used a lot in underwater photography as you can virtually eliminate a messy background by using a low ƒ-stop number to create a small depth of field – ideal for when your subject will not come out into the open. Nudibranchs are one example of a subject that will look great when taken head-on with a low ƒ-stop.

Lens Choice

Another consideration for varying the depth of field is the choice of lens. For those using a fixed lens compact, this is not possible, although zooming in and out or using housing-mounted wet-lenses

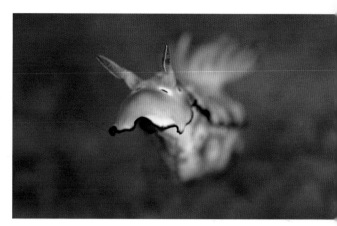

▲ Fig. 1.9
This beautifully coloured purple nudibranch is of the family Chromodorididae and is called *Risbecia tryoni*. It was taken in the Philippines with the lens only inches from the subject. A +4 dioptre allowed me to get really close to the subject. It was taken close to the surface using natural light.
1/320; ƒ4.5; ISO 200. Nikon D700, 105mm

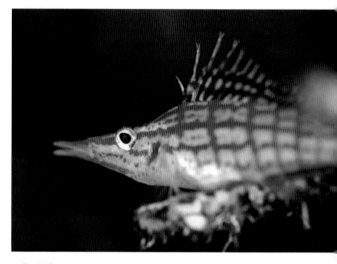

▲ Fig. 1.10
Longnose hawkfish taken on coral in the Gulf of Aqaba just off Dahab in Egypt. It was taken at around 18m or so; the dark blue background is a true representation the colour at that time.
1/125; ƒ5; ISO 400. Nikon D700, 105mm

and dioptres (discussed in Chapter 2) can achieve a similar result. However, for the SLR and mirrorless camera users, lens choice and depth of field are a dual consideration.

A lens with a small focal length, such as a wide-angle lens, has a much greater depth of field at any

▲ Fig. 1.11
Flamboyant cuttlefish taken in Dumaguete in the Philippines. This is taking the use of close-up bokeh to the limits by getting on the same level as the cuttlefish, using a +4 dioptre on the front of the port and setting a very low f-stop.
1/200; f5.6; ISO 500. Nikon D700, 105mm

given f-stop setting than a corresponding lens with a large focal length. For example, for the SLR users, a 28mm is a wide-angle lens and the depth of field is greater at a given f-stop than it is on a macro lens that magnifies the subject, such as a 105mm. As you move closer to the subject, the depth of field decreases. The effect is comparable with a compact camera between the widest angle (with no zooming) and the macro, or close-up, when you have zoomed in. The depth of field on the compact will be greater without being zoomed in. This is an important consideration when taking really close-up macro images, and for those super-macro shots.

Many SLR housings have an external thread on the port or other means of accepting external dioptres. All these dioptres work like reading glasses – they allow you to get closer to the subject and magnify the image. The penalty is that the depth of field is further decreased and the camera can only focus on subjects that are very, very close. Using an external dioptre means that you can remove them to take shots other than really close-up macro. If you were to put the +4 dioptre, for example, on the camera lens and then place it in the housing, the choice of subjects is limited to those you can get really close to. As long as you do not get too upset when you miss the shot of an eagle ray as it passes you a few metres away, the results can be very rewarding.

Shutter Speed

The shutter is a mechanical device that acts as a window blind, blocking the light from the sensor when not activated, but opening for a period of time to allow light onto the sensor when the release button is pressed. This means that we can control the amount of light that falls on the sensor. The faster you set the shutter speed, the less time the shutter will be open, and therefore the less light there is coming onto the sensor.

Of course the aperture restricts the amount of light entering the camera too, but as we have discussed, the more light we allow through the aperture, the smaller the depth of field. This means there is a balance or a trade-off in how we allow light onto the sensor. When you are photographing moving objects – like fish – the shutter speed becomes the dominant factor in deciding the level of light. If you do not use a fast-enough shutter speed when photographing a moving subject, it will look blurred and out of focus. This is called motion blur and it can be used to great effect if you get it right, as it will give the impression of speed and motion like a great racing car image. These effects will be achieved if you use a shutter speed in the region of 1/30th of a second to 1/60th of a second.

However, many compact and mirrorless cameras do not have a mechanical shutter – it is all done electronically. (Mirrorless cameras are discussed and explained in Chapter 2.) When the release button is pressed, the pixels in the sensor, which are already 'charged' with light, start reading it and then pass the digital image through to the sensor. It is now the case with many of the latest mirrorless cameras that the image is being captured before you operate the release button and the processor is storing this, and in some cases it can actually be accessed and used. This is not possible with a digital SLR as the mirror and shutter are shielding the sensor from any light, and it is the action of pressing the release button that stimulates the processor into receiving the signals from the sensors.

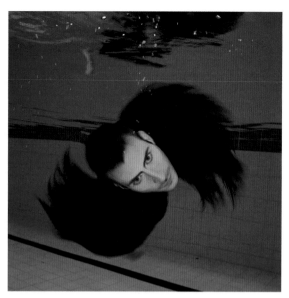

▲ Fig. 1.12
Using a slow shutter speed to create the blurry effect of rotation, this image was taken on a model shoot in a pool, with the model spinning horizontally as he moved towards me.
1/20; ƒ11; ISO 400. Nikon D800, 24mm

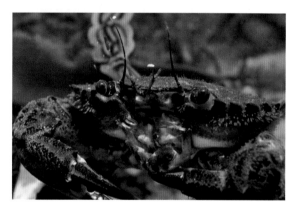

▲ Fig. 1.13
Using a shutter speed of 1/100th of a second; the crab's mouth during eating would look blurry if the motion had not been frozen by the use of strobes.
1/100; ƒ10; ISO 250. Nikon D200, 60mm

In underwater photography the shutter speed is also important for defining the background colour of the water, particularly if you are using flash. This is because if you are using a strobe, the shutter speed is not primarily defining the amount of light entering the camera, as it is the flash that freezes the action. The aperture should be set to expose for the

subject when the flash fires. The shutter speed can be adjusted, within a small range of about 1/60th to 1/250th second, so that the background will lighten as you increase the time you leave the shutter open. If you are using natural light, decreasing the shutter speed will increase the exposure on your subject too. The interplay of aperture and shutter speed will give you a light value that will vary in a similar way to how it does in air. It is when you introduce artificial lights – powerful strobes or video lights – that the options become greater.

Shutter Speed Settings

Like the f-number scale, the options for setting the shutter speed are defined. The increments used are those that will balance the light value, that is, if you open the aperture by one stop, then increasing the shutter speed by one increment will balance the light value to what it was before.

In the menu of many of the latest cameras there is a shutter setting called front curtain or rear curtain. Most SLR and mirrorless cameras will have this facility. This mode is for use when you are shooting with flash. In front curtain, the flash fires as soon as the shutter release is pressed; in rear curtain, the flash fires at the end of the shutter action. For most underwater work, rear curtain is usually advised. This means that the flash fires at the end of your exposure, so if you have slow shutter speed and the subject is coming towards you then you can allow plenty of exposure on the background and put flash on the subject as it gets closer to you.

ISO

The photographer needs a measure of how sensitive the film is to light, and so film speeds came about. The term ISO refers to the International Standards Organization, which originally prescribed measures for photographic film, and these are still used today. Film speed came in ISO 100, 200, 400, 800 and so on, getting considerably more expensive as the numbers became higher and the film more sensitive

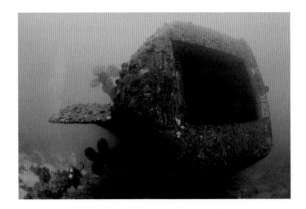

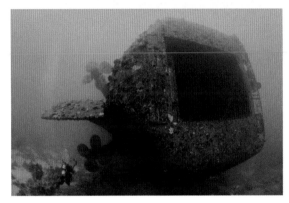

▲ **Fig. 1.14a and 1.14b**
The image of the wreck as it was taken using a low ISO, so the image is relatively noiseless. Fig. 1.14b has had noise artificially induced in Photoshop and reflects how the image would have looked had it been taken at a much higher ISO. The noise in the second image is clearly visible as lots of coloured dots that should not be there.
1/80; $f8$; ISO 200. Nikon D200, Tokina 10–17mm at 10mm

EXAMINING NOISE

You can actually test the limits of your camera for yourself by taking two photographs, one that is at your camera's lowest ISO setting and one that is at the highest. Focus on something black, in low-light conditions, and then zoom in on your results. The low ISO image should look clean and black, whereas the high ISO image will look really noisy with hundreds of tiny, unwanted spots.

to light. With no prior knowledge, you would as-sume that the higher numbers would always be the best to work with, but there is a penalty. As the film becomes more sensitive to light, the resultant image becomes increasingly grainy in appearance.

In digital imagery, the same standard has been adopted. If you were to compare a film camera using ISO 100 film to a digital camera using ISO 100, then both cameras should produce the same exposure value. High ISO is obviously a tool that can be exploited under water as high ISOs are designed to work in low-light conditions. However, as with film, the higher the ISO, then the lower the resolution and quality of the resultant image. The picture becomes noisy, giving an effect much like the grain of film – noise can be described simply as an unwanted by-product of image capture that adds extraneous information, often seen as tiny red dots.

If you have your settings in auto, the camera will select the appropriate ISO settings according to the light conditions. Under water it is normally dark and so most images taken under water in auto will be noisy due to the camera selecting a high ISO. Many novices complain that their images are not sharp and look fuzzy. This normally occurs because they have had their camera set to auto. This is one of the main reasons for the fuzzy noisy images and why you should not use the auto mode under water. High ISO can work in some compositions when noise may enhance the image. This is unusual but it does occasionally work, normally for a wreck or cavern imagery.

Metering for Light

Most digital cameras will offer a choice of methods for metering the light coming into the sensor.

Average

In this setting the camera will measure the overall exposure of what is on your screen or viewfinder. This is a good default setting which will tend to give the best results on an evenly lit scene.

Centre Weighted

While this system will work similarly to the *average* metering mode, it will place more emphasis on the central area of the frame, and is useful when it is either dark or light around the edges of the frame.

Spot Metering

This measures the light in the centre of your frame and is particularly useful when shooting at silhou-ettes, as it exposes for the dark subject and not the light behind. This will allow you to use the light and not lose it.

Exposure Compensation (+/-)

Most digital cameras, of any format, will have an exposure compensation (+/-) button. In the au-tomatic mode, the camera will look at the overall intensity of light in the frame and meter the ƒ-stop, shutter speed and ISO accordingly. You can affect the way the camera meters light by choosing a more suitable meter mode (see below), which works well in most situations, but the camera will still select the exposure for a midpoint between the lightest and darkest parts of the area that you have selected in the metering mode. If you are photographing a dark subject on a light background such as sand, or a light subject such as a silvery fish against a dark reef, then this can confuse the camera's light metering system. This will cause the subject to be predominantly exposed, either for the sand or the reef, and thus will be under or over exposed respectively.

By selecting a higher or lower setting on the +/- you can compensate for this. For bright scenes, you need to select a positive number (+1/3, +2 and so on) and for the dark scenes, move it to a negative num-ber. This confuses some people – increasing the exposure for a bright scene? Remember, the camera has metered for a bright scene so the camera will lower the amount of light hitting the sensor and your dark subject will be underexposed. Conversely, if the background is dark and your subject, say a shiny fish, is light then the average light your

▲ Fig. 1.15
These five images were all taken at the same time, but the exposure compensation button (+/-) was selected to: -2; -1; zero; +1; +2.

camera will see is low and it will allow more light through the sensor, overexposing the subject. This facility can also be used in manual mode; if you are using the camera's inbuilt light meter, which many cameras have, then it will be telling you the same thing. A dark background with a light subject will average the light in the scene and overexpose the subject. In this case, you will need to either reduce your exposure settings or choose a negative number on the +/- facility.

In the days before the digital revolution, photographers using film would 'bracket' their shots, setting the exposure one and two stops above and below the light meter reading, giving five shots of the same subject in all. You can do this yourself in several ways. You could shoot the same shot five times, at EV -2, EV -1, EV 0, EV +1, EV +2. An alternative way would be to adjust the ISO, shutter speed or ƒ-stop one and two stops up and one and two stops down, but this is quite long winded. The simplest way to do this would be to use the auto exposure bracketing if your camera has this particular mode, and it will do this for you, producing several images either side of your selected exposure.

FOCUSING OPTIONS

For underwater use, most photographers will switch their camera to autofocus. However, not all do, and there are certain circumstances when you may find it easier to switch to manual focus. Whichever way you choose to focus on your subject, remember that most focusing systems, including your eye, rely on contrast. In lower light levels this can be really hard, and while many cameras have an autofocus assist light to illuminate where you are pointing the lens, this is invariably lost inside the housing. If the majority of your underwater photography is done in darker conditions such as those found in temperate waters, then a focus light should really be an essential piece of your kit. When using autofocus there are, with most cameras, several options for how you choose to focus your camera upon the subject. There is often some confusion between autofocus modes and autofocus area mode. The first thing to do is to separate them.

Autofocus
Dealing with autofocus first, there are two basic operations – single and continuous. When using single autofocus, your camera will lock onto the subject when you apply a slight pressure to the shutter release button. It will remain fixed on that focus, at that distance, until you apply full pressure and operate the shutter release. This works really well with static subjects but is not always the best option on moving objects, like fish. In addition, as many will have experienced, a diver tends to be less stable in surge than the creatures they are trying to photograph. However, autofocus can be used to lock the focusing distance, which can be very useful when trying to shoot really fast creatures as they come towards you. Under water, continuous autofocus is generally the best option, as once the camera has gained a focus lock on the subject the autofocus system will track it.

Autofocus Area Modes

Looking at autofocus area mode, you will need to set the camera to interpret your focusing area in the manner you prefer or the situation you have in front of you. Most cameras will offer a single point or spot focus. This is the point upon which the camera will focus. Most cameras will allow you to move this point around as you probably do not want your subject in the centre of the screen. This is usually done by moving the cursor control, but various manufacturers use different methods and you will need to read the instructions for your particular camera as to how to do this. If your camera has good autofocus electronics, then this is going to give you the sharpest image.

Multi-area focus is where the camera is given several points to focus on. It then uses an average of your whole image and tries to find the best fit for all these points. This can work on wide-angle imagery like wrecks and reef landscapes, but single point will allow you to identify your prime subject and draw the viewer's eye towards it. Generally then, single point focusing is the best option, certainly as your default.

ZOOM FACILITY

A zoom lens offers you the opportunity to change the focal length, for example from 10mm to 17mm. On digital SLRs and mirrorless cameras, should you decide to use a zoom lens then you need to check that the housing you are looking to purchase not only has the facility to use zoom gear but also has a port available to accommodate the extension of the lens. Being able to use a zoom lens can be really helpful if you are diving on a site where you do not know what to expect. However, most serious photographers will choose their favourite lens for either close-up/macro work on the smaller creatures or a wide-angle lens for the big stuff. Using a lens

with a fixed focal-length lens will really help you to concentrate on what you are looking for.

If you are using a compact camera, nearly all these cameras will have a zoom facility. This allows you to change the camera's effective focal length, which is normally from reasonably wide-angle to close-up. Most compacts also have a macro facility which allows you to focus much closer to the subject. With the addition of an external macro wet lens the camera will focus much closer to the subject, making it appear considerably larger. Nearly all manufacturers require you to zoom in when using macro – but not all.

You should check the instruction manual for direction on your individual camera. On virtually all compact cameras there are two modes within the zoom facility. The first level of zooming in is the optical zoom – the lens moves to give a longer focal length, cropping in on the image. There is usually a stop at its maximum optical zoom but you can zoom past this in what is termed digital zoom. Avoid ever using the digital zoom, as the resultant image will look seriously pixelated when you view it on a full screen. If you really need a closer image it is always better to crop an image in editing software after your dive.

PUTTING IT
INTO PRACTICE

It may seem like there is lot of information to take in during this chapter, especially if you are a beginner. Some of it is technical, but once you have read it and feel you understand it, then it is up to you to get to know your camera.

Practise with it indoors. Pull the curtains and turn the light off, and get used to taking photos in low light. Photograph your children's or your pet's toys and see how close you can get to your subject in macro, especially in low light.

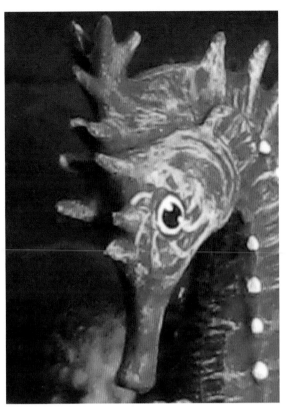

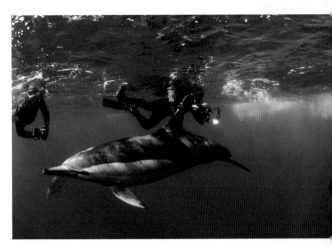

▲ Fig. 1.17
If you are close to the surface and there is plenty of light, switch off the strobes and use natural lighting. This photo was taken in South Africa when a pod of dolphins decided to come and play.
1/200; ƒ9; ISO 400. Nikon D700, 16mm.

▲ Fig. 1.16
I captured this image with a compact camera with the lens fully zoomed in and then the digital zoom applied. As you can see, resolution has been lost and you can start to see the pixels in the image, particularly around the eye.
1/200; ƒ8; ISO 200. Canon A570.

Once you feel you have command of your camera and you can operate the menu system sufficiently that it becomes second nature, put it in the housing and start again. Get used to taking photographs in the manual mode. You may decide you are not ready to experience full manual mode under water yet, but only by playing with the interaction of the exposure triangle, shutter, ISO and the aperture will you get confident enough to capture the image you want, in the way you want it.

Finally, make sure you have the camera in all the auxiliary settings that you want. As you scroll through the menu make sure you put it in the focus mode you want, the highest possible resolution, and have your ISO set to the lowest number you have as a default – you can always turn it up if you want

more sensitivity, but if you set it too high and you take that perfect image, you will find out when you view it on your big screen that it is too noisy.

Once you are comfortable with your camera and housing, try to get access to a swimming pool to practise under water. If it is your first venture with the camera, leave the camera behind, and check the housing to make sure that it does not leak. There are plastic models of fish and coral that can be easily bought to practise on, but make sure the paint is not water soluble; an aquarium store or website is a good place to start. Most of all, you should have some fun. By doing this, you will be much more comfortable when it comes to taking the shot you want in open water. And when you do get to take that shot, remember to squeeze the trigger slowly, rather than jerking it.

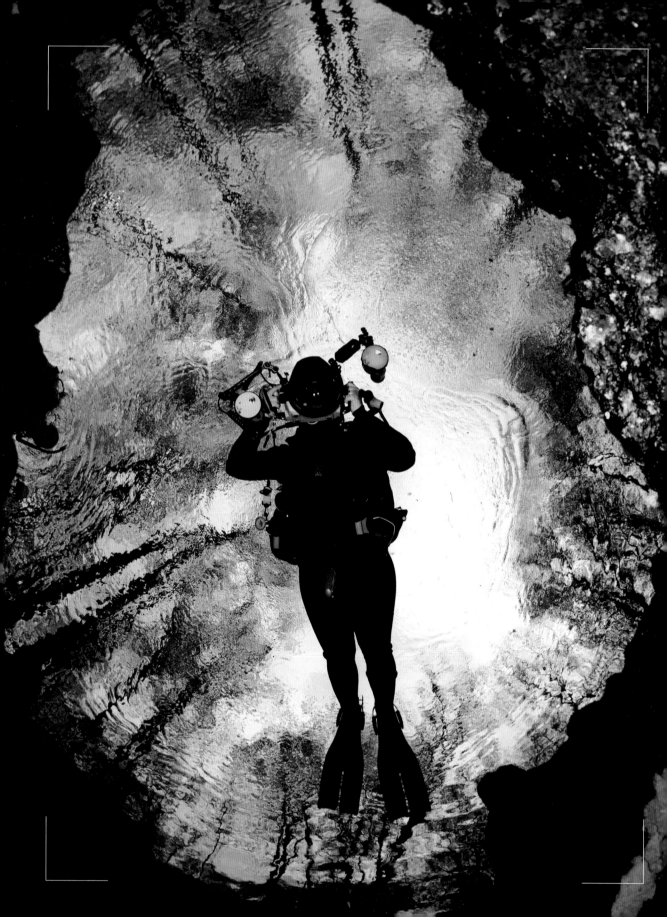

Chapter 2

The Equipment

You may already have an underwater camera system and be really happy with it. You may have a system and be looking to upgrade (or indeed, even want to down-size). Many of you may just be starting out on this venture and are looking for advice and guidance. The choice of cameras, housings, lighting and accessories is fairly expansive, but you need to make sure that whatever you go for, it is what you want and that all the components are compatible.

Many of the best cameras for land use do not always take the best photographs under water, and whatever camera you decide to go for, make sure there is a manufacturer who makes an underwater housing for it. There are numerous people who have bought a lovely camera only to find that the underwater housing for that particular model does not exist or is out of their price range. Always check it can be housed before you hand over your hard-earned cash.

FUNCTION CHECKLIST

Before you buy your new camera it is well worth compiling a check-list of functions. Ask yourself what do you consider essential, and what do you consider desirable. Remember that as a general guide, the more functions you place in the essential list, then the more expensive the camera and its

housing will be as well as increasing the number of functions for you to become familiar with. Most manufacturers produce the housing for their cameras as an afterthought. Bear in mind that the underwater camera market is less than 1 per cent of global sales for their cameras and equipment, so underwater photographers are fairly low in their priorities, in marketing terms at least. As a result, it is not unusual to find that while the camera you have chosen has all your 'essential' functions and all your 'desirables', when you place it in the housing you may find that several of the essential and desirable functions are inaccessible.

This list is just an example of most of the options that are currently available, and it is up to you to decide what you feel is important.

- Full Manual Mode
- High range of f-stops
- High ISO ability
- Manual white balance
- RAW
- Video
- Live view and payback
- Flash strength adjustment
- Zoom
- Histogram
- Grid 2/3
- +/- (exposure compensation)
- Digital zoom
- High pixel count
- Manual focus

◀ Fig. 2.1
Caroline descending into a cavern at Ginni Springs in north-west Florida with her SLR and two strobes. The image was taken with a fisheye lens and creates Snell's window through the gap in the cavern.
1/160; f8; ISO 500. Nikon D700, 16mm

What to Consider?

Throughout the book, most of these will be discussed in more detail, but here is a brief explanation of each function and what you should be looking out for.

Full Manual Mode

This feature allows you, as the photographer, the option to set the desired f-stop, shutter speed, manual white balance and ISO to achieve the style of image that you want. It offers the facility to independently control each one of these settings. Be careful with this, as there are several compact camera manufacturers who claim that their camera has full manual mode, when in fact much of it is limited. Look at the options for aperture selection: does the camera have a range of numbers, not just f-3 and f-8? If the camera does not have a high range of f-stops, you will find that this can seriously restrict your creativity, especially as you become more confident with your underwater photography.

High ISO ability

The ISO varies the sensitivity of the sensor – the higher the ISO number, the brighter the image. However, the penalty for using high ISO can be a noisy, grainy image. Research the camera's ability; most modern cameras, particularly the SLRs, are now offering low noise at high ISO, but the mirrorless and compact cameras are beginning to offer very good image quality at high ISO values too.

Custom White Balance

Adjusting the white balance (w/b) means shifting the camera's perception of colour so that it will attempt to present the colours as we would see them in air. Most cameras have an underwater mode and also an automatic mode. These can be satisfactory but will struggle to produce anything representative beyond 5m deep. Custom w/b gives the user the ability to adjust the colours by comparing the colour scale to a known white under water. On your camera or the one you wish to purchase, check if the white balance is an easy function to perform. It is usually possible to go into the menu and assign the white balance function to a single button or two simple push-button operations. Being able to adjust the white balance easily will make your life a lot simpler when you are trying to capture those moving creature images under water.

RAW

A RAW file is between two and eight times larger than a JPEG file, depending on the camera. It also holds the corresponding increase in information. When you capture an image in RAW you have the ability to increase or decrease the exposure, contrast and saturation and many other attributes in photo editing, post dive. The majority of cameras now being produced are offering a RAW facility. RAW files, and their use, are discussed in some depth in Chapter 8. RAW facility is a very useful tool, but you need to bear in mind that it can seriously slow down the camera's functionality.

Video

Most compacts now offer a video mode. If you believe that you may want to use the video, then check the quality level. Technology has brought HD video to compact cameras that was really only available in a dedicated video camera a few years ago. The video quality in a high-end SLR is so good that it is indiscernible from that taken with a high-end dedicated video camera, and a good compact camera is not far behind.

Live View and Playback

Being able to review your images under water is a really important facility, almost essential. Ensure that the camera has a screen that you can see, and if your close-up vision is poor use a prescription lens dive mask. A large review screen is a tremendous asset, but it can also be a drain on the battery.

Flash Power Adjustment

The term 'power' for the flash output is actually a misnomer, as adjusting this merely changes the burn time of the flash unit. It does, however, have the same effect and so the ability to vary it is really very important, especially if you intend to use flash-guns. In many cases these are fired by a fibre-optic link from the camera's own flash, so by reducing the burn time you will activate the external strobe by using considerably less battery power. This also reduces the risk of flash bounce around the inside of your camera housing, which will affect the image.

Histogram

An image histogram is simply a graph to show how the exposure of the image is distributed. It allows a quick check of under- or over-exposure. (Histograms are explained in more depth in Chapter 8.)

Zoom

The ability to zoom can be very useful, especially for macro work. However, ensure that it is optical zoom rather than digital zoom, which should be avoided due to the massive loss of pixels this will cause.

Grid overlay

The grid overlay is a function that you can select in the menu and comprises two horizontal and two vertical lines on the screen that can assist you when composing your image – it can be very useful and some underwater photographers like to keep it as a permanent display.

Exposure Compensation (+/-)

Exposure compensation can be really important if you are shooting in anything other than manual. Adjusting the +/- button positively or negatively will allow more or less light to the sensor. In simple terms, it overrides the camera's interpretation of exposure and allows you to set the exposure for your particular subject.

Pixels

The number of mega-pixels a camera has does not necessarily mean it will produce a better image. Equally important are the quality of the sensor and the resolution of the image once processed, especially in the low-light environment of underwater photography. While a larger pixel number will allow for closer cropping and larger printing, the resolution of the camera is also important and sometimes there is a trade-off in resolution by manufacturers to allow for a higher pixel count.

Lens Fittings

Does the camera and housing you have chosen allow for the addition of external wide-angle or macro lenses? Filters can normally be fitted internally in the housing but if the lens has a screw thread then you should be able to use a screw-on dioptre to change the focal length of your system. Many camera housings have an external screw thread on their port and this means the lenses can be changed under water. Research if there is a manufacturer that produces mountings that you can attach to the housing so you can fit different lenses this way. Make sure the diameter of the threaded portion is compatible with a sufficient range of add-on lenses or dioptres.

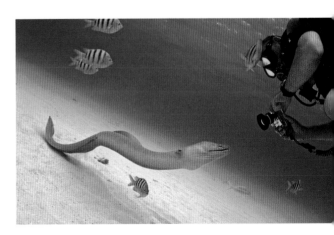

▲ Fig. 2.2
Compact cameras are light easy to manoeuvre, especially when you have animals moving around you.
1/80; ƒ4; ISO 100. Nikon D200, 10–17mm lens at 14mm.

Finally, does the camera feel right – not only do the ergonomics feel right in your hands, but do you think 'yes, I really like this and it ticks most of my boxes!' As with most things, go for the best you can afford; the one that satisfies most of your criteria – the least expensive option is the one you do not need to replace.

WHAT TYPE OF CAMERA?

There are several different routes you can go down when buying a camera. There are the small, easy to use and lightweight compacts, the slightly larger mirrorless cameras with interchangeable lenses, and there are the big boys: the digital SLRs. So what system should you go for?

Compact Cameras

There are many excellent photographers around the world who specialize in using a compact camera system. Modern compacts are sophisticated, easy to use and have excellent sensors. They are light, easily portable and great at being manoeuvred into tiny spaces and gaps that those with bigger systems just cannot even contemplate. They are a great point at which to start, and many of the accessories that you may buy to expand your system can be transferred to a new system whether you upgrade or not.

If you are just starting out, a compact camera system is the perfect tool to get you used to positioning yourself while maintaining buoyancy and avoiding damage to corals, sponges and any other wildlife.

Mirrorless, Micro 4/3s or EVIL Cameras

Despite the fact there are three different names, these are all more or less the same thing. They are an in-between, bridging camera, a compact form with a high quality sensor, powerful processor and

▲ Fig. 2.3
Modern digital compact cameras are capable of producing excellent resolution. This image was taken at Jackdaw Quarry in north-west England when overhead conditions were dark and the water temperature was 3°C. A single INON D2000 strobe was used. 1/200; ƒ8; ISO 200. Canon A570.

interchangeable lenses. EVIL stands for Electronic Viewfinder with Interchangeable Lenses, and the 4/3 is a historical name that refers to the size of the now-obsolete video tubes which were called a 4/3 type sensor. These systems are becoming ever more popular, and with good reason. They are capable of producing images in almost as high resolution and quality as a digital SLR. They are lighter than a DSLR, and with the high quality lenses that are designed for them, many people are questioning the future of DSLR systems, not only for underwater photography. The difference in bulk and weight is relatively large, and for those who want to travel by air to dive in exotic locations, this can be a considerable burden.

As with compact cameras, the ability to access all your desired functions is really important. You will want to be able to change the ƒ-stop, shutter-speed

▲ Fig. 2.4
A mirrorless camera setup can be just as impressive as a digital SLR,
and most manufacturers are now making an excellent variety of
ports, trays and accessories.
1/100; ƒ8; ISO 320. Nikon D700, 16mm

future of photography – they are now auto focusing
as fast as most digital SLRs; they are lighter, and the
resolution issues at the edges of early models have
been improved beyond all measure.

Before you buy the camera you need to ensure
not only that it can be housed, but that the housing
allows access to all the functions you need (and
want). Some cameras will have three or four different
manufacturers producing housings for a particular
model. You also need to bear in mind that hous-
ings are model-specific so if you decide to spend
£300–1,500 ($500–2,000) on a camera housing,
when it comes time to upgrade then you will need
a new housing as well as a new camera. This is
another good reason to make sure you choose the
right system in the first place. You may need to pay a
little bit more for the very latest technology, but that
should extend the time before you feel the need to
replace it.

Should you do decide to go for a mirrorless style
camera, then check out how fast it can auto focus
and capture the image. Many modern mirrorless
cameras are now using a contrast-based focus
system, and this has really reduced the shutter lag
to the point where the DSLR advantage has been
greatly reduced.

One disadvantage that can cause photographers
to struggle with the mirrorless and compact camera
is the live screen view for framing and composing
the shot. Many photographers, although not all by
any means, find it very difficult to compose the shot
using the rear screen, preferring to use the viewfind-
er. Many mirrorless cameras now have the digital
view through the eyepiece, but as yet, this does not
produce the clarity of looking directly through the
eyepiece to the lens, as in an SLR.

Finally, scroll through the menu system, use the
guide from the compact section and check just
what facilities it has. If you were thinking of choos-
ing a compact camera, look closely at the mirror-
less equivalent. You may be able to purchase a far
superior system for a much smaller sum than you
had imagined.

and ISO quickly and with minimum amount of
fuss. Some of the earlier models required scrolling
through the menu system to change some of these
basic functions, which afforded little advantage
other than weight saving. You will find that you will
want to have all three functions set up so that there
is one button or wheel for each principle operation.
At this point you may think you do not need this
convenience as you are going to shoot in Auto or
Programme. This may well be your intention at first,
but as you improve and become more confident,
you will want to get more creative and imprint your
own style on your images, which is very difficult
if you are going to let the camera 'decide' what
exposure settings you should be in.

The mirrorless cameras are, quite possibly, the

▶ Fig. 2.5
A snapshot taken in very poor
conditions demonstrates
just how easy it is to use a
digital SLR setup when even a
playful seal can use it.
1/125; ƒ10; ISO 400.
Nikon D700, 16mm

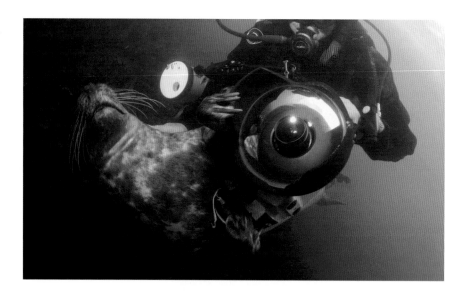

Digital SLRs

The digital SLR and its housing is the most expen-
sive option for taking photographs under water.
The SLR camera alone tends to be more expensive
than the mirrorless and compact options, although
a high-end mirrorless camera will cost more than
an entry-level SLR. In general the housings for SLRs,
too, will usually cost more than that for a mirrorless.
The advantages afforded by using a digital SLR are
slowly being eroded away. The mirrorless cameras
are still a little way short of the capabilities of a
high-end digital SLR, but some of the top mirrorless
cameras can exceed the capabilities of the entry
and lower-level digital SLR. However, response time
on an SLR is instantaneous – there is no shutter
lag – and if your intention is to try to photograph
fast-moving action then the SLR still holds the
advantage, just, over the new, smaller and more
manoeuvrable mirrorless cameras.

The sensors and the processors on a digital SLR
are larger than those of the mirrorless cameras
and considerably larger than compacts. This does
mean that resolution and pixel counts will gener-
ally be higher than the two smaller cameras. It is
also easier to reduce the depth of field and create a
highly blurred image, with the subject still in focus.

Mirrorless and compact cameras can do this but the
digital SLR still performs better in this function.

Most of the housings for the digital SLRs allow
access to all or nearly all of the camera's functions.
Currently, an SLR offers a wide range of lenses.
Canon, and Nikon in particular, have been using
similar, compatible lenses for many years, and many
lenses that were used on film cameras twenty or
thirty years ago can still be fitted and used under
water on modern digital SLR cameras. This may
however require the use of manual focusing gear.

If you have not yet bought into a system, then
venture out and take a look at some of the options
that are now available. If you are on a tight budget,
then modern compact cameras will produce stun-
ning results and will give any digital SLR camera
user a run for their money. The mirrorless cameras
with their interchangeable lenses are the next
bracket up in terms of cost and capability, and they
do offer near-SLR quality in terms of resolution –
sometimes better. They are light, and only slightly
more bulky than a compact system. The digital SLR
still holds the edge, just, in terms of high resolution
and high pixel count. Finally it is worth considering
that most SLR and mirrorless camera housings have
leak alarms fitted, which provide audible and visual
warnings on contact with water.

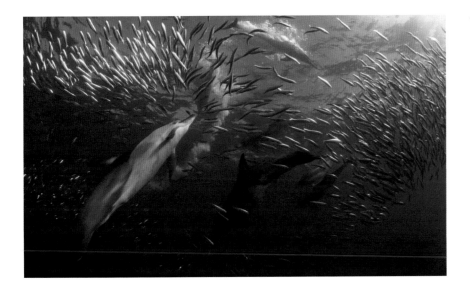

When the action all around you is fast and furious and you need to put some light on the subject, you will need strobes that can recycle really quickly. This award-winning image was taken on the sardine run in South Africa. 1/160; ƒ9; ISO 400. Nikon D700, 16mm

UNDERWATER LIGHTING

The best and easiest way to restore colour under water is to take your own lighting with you. As nearly all cameras can now produce high quality video, many underwater photographers are choosing to take a constant light source and an underwater flash or strobe. In underwater photography, a flash is generally called a strobe, but both names can be used and mean the same thing, whereas a constant light source is a collective term for video lights or powerful hand lights.

Light disappears by the square law under water and so it can be difficult to put sufficient light on your subject any distance away from you. A good mid-priced strobe will be able to throw the light, realistically, no more than 3 or 4 metres (10–12ft). A really powerful and expensive video light will struggle to illuminate anything more than 3 metres (10ft) away. There are several manufacturers of good quality underwater strobes. An indication of the power of the strobe is given by its guide number (GN). This is discussed in greater depth in Chapter 6.

There are two ways to fire a strobe: by light detection on the strobe's sensor or by a small electrical current from the camera's own hot shoe to a connection on the strobe. There are many underwater camera housings that do not have the facility to attach an electrical connection, known as a sync cord. Some strobes can only be connected using a fibre-optic link, as they do not have the electrical connection.

If your camera and housing has the ability to use either fibre-optic link or sync cord, it is worth deciding which system you would like to use. There are advantages and disadvantages to both. A fibre-optic link is simple and not susceptible to water ingress; however, as the strobe is fired from the camera's own flash, if you are in continuous mode, then some cameras will only fire once per trigger operation. This may not seem important but there may be situations where you will want to shoot with your camera in continuous firing mode. If you are in the middle of fast-moving action with subjects coming at you from all angles, then sometimes this is a huge advantage. If the strobe you choose to buy cannot keep up with the speed of your camera shutter, then you will have a collection of dark photographs. Ideally, you need to choose a strobe which can recycle in under a second on moderate power; anything longer than this may leave you disappointed and

frustrated.

Does the strobe you want to purchase have sufficient options to vary the power? Does it have the facility for you to shoot in TTL (through the lens)? Many underwater photographers like to use TTL as it will nearly always give approximately the right amount of light for the shot. A strobe with TTL allows the camera to measure the amount of light bouncing back to the sensor from the subject and uses this information to assess how much power to put out on the subject. This is a very useful facility, but for creative lighting it can be restrictive if you get so used to it that you lose the confidence to use the manual mode.

Another subject to consider concerns the angle of coverage by the light. If you are predominantly going to shoot in wide-angle then any strobe that will only give 60 degrees of coverage is not going to work for this kind of photography. Typically, a wide-angle lens would need a minimum of 100 degrees of light cover.

This section has focused principally on flash or strobe lighting. Most of the comments and guidance about a strobe can be translated into video light use, so that if you want to use video lights rather than strobes on your camera system then all the factors listed for a strobe should be taken into consideration. (More detailed discussion on artificial lighting for both strobe and video lights can be found in Chapter 6.)

Finally, it is worth considering how efficient the power usage of the strobe is. If the batteries or battery pack will only last one dive and you are on a boat to do three dives in a day, then again, you will be disappointed. Changing batteries between dives is a nuisance, but you also need to consider that every time you break the seal on underwater equipment you are increasing the risk of a flood.

LENS SELECTION

For Compact Cameras

While compact cameras do not have interchangeable lenses on the main body, many underwater camera housings can give you the opportunity to use external, wet-lenses to change the focal length. There are also adapters that can be purchased which will fit on the front of the camera housing, again so you can add different lenses. This is one huge advantage that a good compact system has over mirrorless and digital SLR users. You can switch from wide-angle to macro photography while still under water as many times as you want. There are, also, some mirrorless camera systems that have this

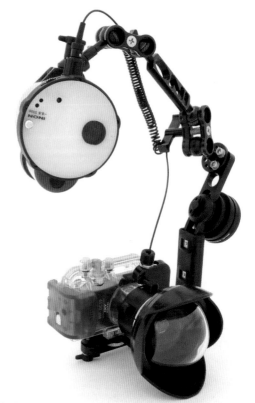

▲ Fig. 2.7
There are many accessories you can buy that allow you to build on your compact camera system. This a compact camera with fisheye lens and strobe; attached to one of the arms is a macro lens locked into a holder.

▲ Fig. 2.8
Vignetting is the process whereby you lose resolution at the edges of the image, either by using the port incorrectly (as in this photo) or using the wrong or low quality lens.
1/100; ƒ14; ISO 250. Nikon D200, 10–17mm at 17mm

option available to them.

If you are looking to purchase a new camera system, or a replacement system, then research carefully beforehand to ensure the system you are buying can take a lens directly or that there is an adapter available for the particular model you have purchased. Many underwater camera housings have a screw thread on the front, which is usually, but not always, 67mm. Using the 67mm thread will give you several options of manufacturers for both macro and wide-angle lenses.

A common issue with add-on lenses is vignetting at the peripheries of the image. The vignetting is the reduction of an image's brightness or saturation at the edges and can be seen as blurring or severe darkening. This normally means you would need to zoom forward slightly past the vignetting to give a clear picture. However, this will reduce the angle of coverage that you are trying to capture. Before you buy your system make sure you discuss this with an underwater photography specialist you can trust.

For Mirrorless Cameras

Mirrorless and SLR cameras both use interchangeable lenses. This allows the photographer to use a long-distance lens, a standard lens, a wide-angle

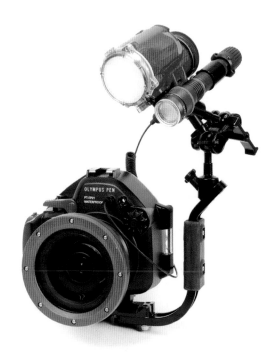

▲ Fig. 2.9
A mirrorless camera housing setup with strobe and modelling light attached.

lens or a macro lens. However, once the choice of lens has been made and fixed on the camera and placed in the housing, there is very little you can do once under water.

For macro work, there are wet dioptre lenses available that can be fitted to the front of the port, and some manufacturers are now making an external dome port, but other than these the lens choice has to be made before the dive and it can be a major decision. Taking a macro lens on a dive and being surrounded by feeding mantas can be somewhat frustrating. The choice of lenses for a mirrorless system will, to a certain extent, depend upon the manufacturer. Several manufacturers allow interchangeability with other brands. Essentially lens choice requires deciding on a macro lens, a wide-angle lens, a fisheye lens and possibly an intermediate, general lens. For macro work, a lens that will give you a one-to-one ratio is normally the photographer's choice.

For SLR cameras

As with the mirrorless cameras, the choice of lens needs to be made prior to the dive. On a dive site where the subject is predominantly smaller stuff, then a macro lens would be the obvious choice. As there are two types of sensor on a digital SLR, then this will affect the focal length of the lens you would choose for macro. A full-frame SLR mimics a 35mm SLR in image size. For a full-frame camera a 50mm or 60mm lens will offer a ratio of 1 to 1 – what is perceived as actual size. On what is termed a half-frame SLR, then the ratio is about 1.5 to 1. (Fig. 2.10 illustrates the cropping effect).

Whether you shoot with a full-frame or half-frame SLR, a 60mm, 90mm or 105mm is the choice of lens for most underwater photographers for macro and close-up photography. Make sure the lens you buy is a dedicated macro lens, as this allows you to get closer to your subject in order to be able to focus (some manufacturers refer to macro lenses as micro lenses). The greater the magnification, however, the harder it becomes to focus due to depths of field diminishing as the focal length gets longer. With many cameras and lenses the longer the focal length, the more likely they are to pick up on passing particulates in the water when using autofocus. As a beginner, with either a full-frame or half-frame SLR, the 60mm lens is the easiest to use.

If the site you are about to dive is predominantly inhabited by the larger animals or wrecks, then a wide-angle or fisheye lens is going to be needed. On a half-frame SLR, between 10mm and 20mm will give a really wide view. A very popular fisheye zoom lens is a 10–17mm, but unfortunately this is not made for the full-frame SLR. A 16mm fisheye lens is the most widely used focal length lens for full-frame SLR, but this can struggle to focus on very close objects. For those who do not like the fisheye effect, then there are rectilinear lenses. A rectilinear lens is one that offers a really wide field of view

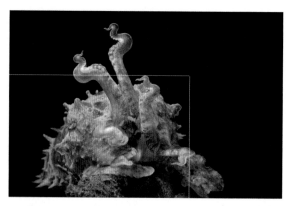

▲ Fig. 2.10
The difference in the size of the image between full-frame and half-frame SLR is quite significant as shown by this image, with overlay, of a cuttlefish in attack mode. The image was taken with a Nikon D700, which is a full-frame camera.
1/200; ƒ18; ISO 400. Nikon D700, 60mm

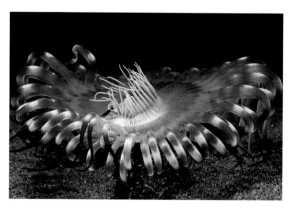

▲ Fig. 2.11
A banded tube anemone taken with a 60mm lens, which allows the photographer to get close enough to put light on the subject, but not so close that you cannot fit it in your frame.
1/200; ƒ18; ISO 400. Nikon D700, 60mm

but does not have the curving effect at the edges that is introduced on a fisheye lens. Another good wide-angle lens for full-frame or half-frame SLR is a 24mm. However, this lens struggles even more than the 10mm to focus when close to the subject.

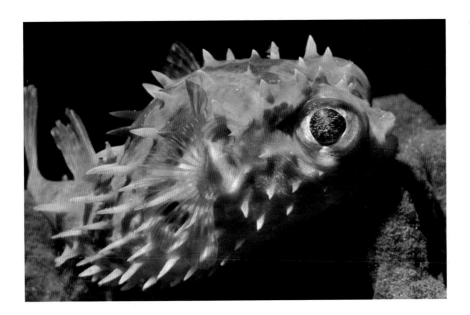

◄ Fig. 2.12
Porcupine fish taken in the Lembeh Straits; the bright blue eyes of these cute animals are really striking. 1/100; ƒ14; ISO 250. Nikon D200, 60mm

LENS GUIDE FOR MACRO/WIDE-ANGLE/ FISHEYE ON AN SLR OR MIRRORLESS CAMERA

The following is a guide to the focal length of the lens that you will require for the type of photography that you may want to do. So, for example, if you have an SLR camera and you want to shoot macro photography, then a 60mm macro lens or a 105mm macro lens would give you approximately the right magnification.

The exact focal length of the lens you require for your camera will very much depend upon the manufacturer and the lens that manufacturer produces. The focal lengths listed in the table will vary from manufacturer to manufacturer.

It is very important if you are purchasing a lens for macro that the specification lists macro as its capability.

Type of Photography	SLR	Mirrorless
Fisheye	16mm or 10–17mm zoom	8mm
Rectilinear	24mm or 14–24mm zoom	7–14mm zoom
Macro/micro	60mm or 105mm	40mm or 60mm
General	60mm	14–24mm zoom

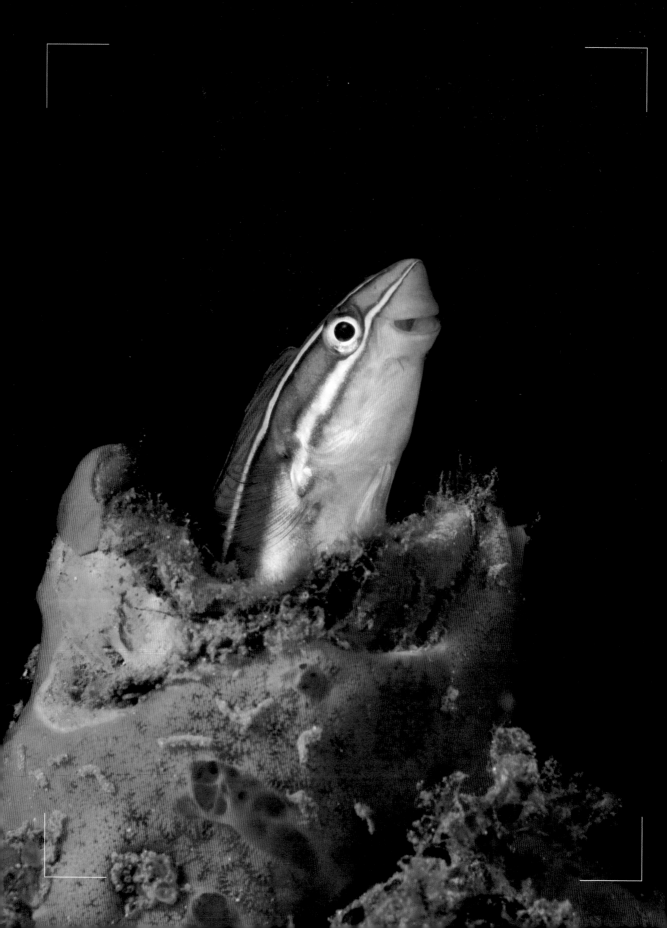

Chapter 3
Getting Started

Once you have decided upon the camera system, you have bought it and taken it home, it is then time to put it all together and take it in the water. However, before you take the camera under water it is important that you take the housing alone on a checkout dive to ensure that it is watertight.

On completion of the dive if there are any signs of water ingress then try to identify the point at which water is coming in. One simple way to identify this, if it is only a small amount, is to use coloured tissue paper – light blue is really good as an indicator as it turns dark blue on contact with water. Once you have identified the leak, if it is something simple and you can correct it, then do so and take it under water with you, once again without the camera.

Sadly, there is never a guarantee that you will not flood your camera if you are taking it beneath the water inside a housing. Below are some very straightforward and simple steps you can take which will vastly reduce the chances of this happening. The thing to bear in mind is that most camera floods are due to human error.

SETTING UP THE CAMERA

Putting your camera setup together should become a ritual, an habitual procedure that you follow every time that you put your system together. Ideally, you should assemble your camera in a moisture-free, dust-free and generally clean environment. The perfect location should also be well lit and have air conditioning.

If you are on holiday, it is always a good idea to have your camera set up and ready to go diving the day before. Make sure you have a full set of new or freshly charged batteries, a clean memory card – or one with sufficient space for your dive – and a thoroughly cleaned and lubricated O-ring.

Start by making sure your camera is set up the way that you want to use it. If you have been shooting with it on land, then the settings you have been using will almost certainly be totally different from those you would select for under water. Review the focusing and metering modes that you want: ask yourself if you want to shoot in single or continuous, and do you need to reset any function button for single operations.

Check the Housing

Now look at the housing. Open it up and carefully remove the O-ring using either finger pressure, a dedicated O-ring removal tool or possibly a credit card. Never use anything sharp or likely to damage the O-ring or worse, the housing. The finger pressure method involves pushing the O-ring together along the groove so that it is pushed up. You can then take hold of the loop you have created and

◀ Fig. 3.1
This blenny, sticking its head out of the sponge it had made its home in, was taken at Secret Bay in north-west Bali; a high *f*-stop and shutter speed were used to create the black background. 1/250; *f*20; ISO 200. Nikon D200, 60mm

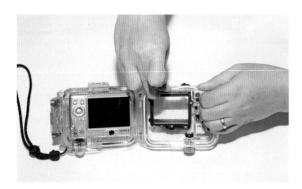

▲ Fig. 3.2
O-ring being removed using the finger push method.

▲ Fig. 3.4
O-ring groove being cleaned.

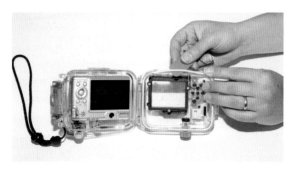

▲ Fig. 3.3
O-ring being removed using an O-ring remover.

remove the O-ring from the housing. This method will ensure that there is no way you can put any nicks in the O-ring; however, over time it will cause slight stretching to the O-ring.

Once you have removed the O-ring make sure you do not put it anywhere where it can collect dust or even worse, sand.

Clean the groove with a material that is unlikely to leave fluff or fibres; cotton buds are readily available and handy, but there is a possibility that they can leave fibres in the groove, and even the tiniest fibre can cause a leak. A dedicated chamois or microfibre towel is ideal and you can use them repeatedly. Once you have done this, inspect the groove very carefully for any signs of grit, dirt, sand or fibres.

You can now turn your attention to the O-ring. It is a really good idea to wash it in warm mild soapy water and then rinse it in fresh water. Gently towel it dry and inspect it for residue marks or tears. If you

are unsure, or have any doubts about the integrity of the O-ring then do not use it. You should always have a spare O-ring and they are really inexpensive compared to the cost of a new camera.

Once you are satisfied that the O-ring is still in good condition apply a small amount of silicon grease between your thumb and finger and work the grease around the whole O-ring. Remove any lumps or blobs of grease. The O-ring should be covered in a really thin layer, evenly distributed. A good policy is to lubricate the O-ring with your fingers and then try and take it all off. The thin residue that is left behind is exactly how the O-ring should be prepared. When the O-ring is covered in grease it is particularly vulnerable to attracting hairs and fluff, so quickly inspect it and replace it in the groove of your housing.

Putting it all Together

Pick up the camera and make sure the buttons and switches on your camera line up with any settings you may have on the housing and insert the camera into its seating. Some people like to put packets of silica gel in the housing to absorb any condensation

but if you do so, ensure you place the packs where there is no danger that they will interfere with the operation of the camera. There is also a recent product on the market (Leak Insure) which has incredible absorption properties and this could save your camera in the event of a minor leak. As you close the housing ensure the O-ring has not been caught or kinked, and then secure the lock or locks. This is vital, because this error is the biggest single cause of flooded housings, and hence destroyed cameras.

Lighting

If you are using any form of lighting with your system, you need to put this together too, taking the same care with this O-ring as you did with the one on the camera housing. Make sure any batteries are new or fully charged and connect the system for operation. Turn everything on and take a test shot. Look at the test shot and make sure it is what you expected. With an SLR or mirrorless camera it is not unheard of for photographers to take their cameras underwater with the lens cap on. This is never a good idea, even though it may provide amusement for the rest of the dive party.

TESTING FOR LEAKS

Submerge your camera system in a fresh water tank or bucket and look carefully for any signs of bubbles. Several small bubbles will form due to surface tension, so wipe these off and watch for a continuous stream. If you see more than just the odd bubble then remove it from the water and examine the case for signs of leaks.

If you are doing this in the rinse tank immediately prior to a dive, and you have concerns that it may be leaking, you need to either abort the dive or leave the camera behind. If you take your camera under water and you develop a leak, you will either lose your camera to water ingress or else you may

end up ascending too quickly in an effort to save your camera. Needless to say, ascending too quickly is dangerous and your life is more important than your camera.

It is a good habit to get into checking for bubbles from the housing as you descend. If you get to 5m (15ft) and you have seen no bubbles, then you would be very unlucky if your housing then developed a leak, unless there were other traumas on the dive.

Rinsing

Once you are out of the water it is important that you rinse the housing with fresh water as soon as you can. If there is no rinse tank on your boat (it may be a small operation) take an extra bottle of water with you so you can at least rinse the buttons on your housing. If you are on a dive boat and there is a rinse tank, unless you are the only person using it, do not leave your camera system in the water, as other people will put their cameras in the tank, and very often this is where damage can occur.

Hold your camera system in the water and push each of the buttons two or three times to expel the salt water and gently rotate any knobs. Unless you need to open the housing for any reason between dives then you should avoid doing so as you have already established the integrity of the seal. However, if you are going to open the housing for any reason, make sure you have dried it thoroughly before you do so.

Dealing with a Leak

If there is a minor leak and you spot it underwater turn your camera off and rotate the housing so that it is face down, and any water will accumulate in the port of the housing where the lens is. Keep it in this position and make a normal safe ascent with your buddy – it is all too easy to ascend too quickly to save your camera and put yourself at risk.

When you get to the boat, make sure you explain to the person that you are passing your camera to that it needs to be kept lens down. If there is a

language barrier, be patient, as once you have lifted the camera it is out of the water and there will be no further water ingress – any damage that may occur will already have happened.

If your camera has suffered a leak, rinse everything in fresh water. Remove the memory card and batteries. If the camera has had salt water ingress it is almost certain that the camera will have been destroyed. However rinse and dry off the memory card and you will almost certainly find your images are intact. Memory cards, generally, are pretty resilient.

Now is the time to try and find the cause of the leak. Look for a stray hair or a crimped or damaged O-ring. If there is nothing visible then it is worthwhile getting it pressure tested at the next opportunity. If that is not an option, perhaps due to the fact you are in a remote location, then put your housing back together properly, leaving the camera out, and take the housing under water again on your next dive. Put coloured tissue paper inside, so if the housing does leak you will be able to see where it is coming from and possibly be able to fix it.

If you follow these guidelines every time you take your housing underwater, you will be very unlucky if you get a leak. However the only way you can guarantee that you do not flood your camera is to not take it under water, and that would clearly defeat the purpose of you buying housing in the first place. It is really important that you allow time to assemble your equipment correctly, as if you rush the process there will come a time when you will make a mistake – you will forget or overlook something. Your camera system is expensive – look after it.

MAINTENANCE

Every serious underwater photographer will have his or her own ideas about what should go into their essential maintenance kit.

Essentials Kit

Listed below is an idea of a comprehensive kit. You can choose to follow it all or you can just select the items that you feel are important to you. There may be other spares and maintenance equipment that you feel are also essential.

Silicon Grease

Whatever else you may decide needs to be put in your essentials kit, silicon grease is a must. Silicon grease will keep the O-rings pliable and prevent them from drying out. It is important that you always make sure you follow the manufacturer's recommendations for your specific kind of O-ring.

Lint Free Cloth

This could be a chamois or microfibre towel, and is needed for cleaning the grooves in the housing and the housing port. You may need more than one so that you have separate cloths for each function. Polishing the housing port with the silicon grease-impregnated cloth will leave it smeared, so it is a good idea to keep these in a small Ziploc bag.

Small Towel

It is a really good idea to lay a small, clean towel on your working surface so you have a clean area to lay out all your equipment for an assembly. A golfer's hand towel is perfect.

Electrical or Duct Tape

Hopefully you will never need to use the tape but it is excellent for quick, temporary repairs. It is remarkably robust in the short term.

Precision Screwdriver Set

Watchmaker's screwdrivers can be used to tighten up those tiny screws and also for removing the small circlips that secure the buttons inside and on the housing. Do not attempt to service these yourself unless you are competent with small repairs.

Static Dust Brush and Blower

These are great for cleaning out small pieces of grit that are difficult to get at. Blowing any grit out of the O-ring groove, should it be there, is the best way to remove it as this will avoid scratching the housing.

Cotton Buds or Make-up Sponge Applicator

Cotton buds are cheap and easy to use when cleaning out grooves; however there is a possibility they can leave fibres behind. A small make-up sponge pencil is a better option, as it is fibre free and can be reused. If you do have to use cotton buds, once you have finished cleaning it examine the groove really closely for any signs of residue.

Allen Key Set

You could select just the Allen key sizes that your camera system uses. However, a good Allen key tool can be priceless, not just for your camera but your dive equipment too.

Adjustable Spanner/Wrench

This is a useful tool for many eventualities and together with the Allen key set can be used for much of your diving equipment too.

Spare O-rings

A spare main-housing O-ring is an essential part of any underwater photography maintenance kit. Other O-rings for the buttons, ports and so on are also very useful to have. Even if you do not have the technical ability to change them, there may be someone around who has, and if you have the spare parts then it may be possible that person will be able to get you back beneath the water with your camera.

Spare Sync Cord/Fibre-optic Link

If you are using underwater flashguns, then a spare sync cord or fibre-optic link, depending on your method of firing, can be very useful. If you are using a single strobe and you lose the ability to initiate a flash, you will be left with the sole option of natural lighting.

Battery Charger and Spare Batteries

If you are using rechargeable batteries, then do not forget the battery charger. Likewise, if you are using non-rechargeable batteries, then make sure you have plenty of spare batteries, especially if you are off to a remote destination. (In very hot climates it is a good idea to keep these in a refrigerator.) If you are taking rechargeable batteries to a remote destination it might be worth considering taking at least one set of non-rechargeable batteries in the event that you may lose power at your resort.

Memory Card

It is important that you always have a spare memory card even if it is not as fast or as large as your primary one. While unusual, memory card corruption can occur, and it would be a shame to lose the facility to take photographs for the sake of a spare memory card.

Multifunction Penknife

Try to choose one that has the functions you can use on your camera system, and the fewer redundant functions the better.

Cable Ties

It is always worth having three or four cable ties of various sizes, if only to keep things tidy, like the sync cord or fibre-optic cable.

▶ Fig. 3.5
This is a typical
representation of what
many people would keep
in their essential camera
maintenance kit.

Silicon Spray

A small spray bottle of silicon liquid can help with
a great quick-fix should buttons on the housing
become sticky. Carefully spray the offending button
from the inside of the housing, and press the button
a few times, and then wipe the inside of the housing
clean with a lint-free cloth.

Waterproof Box

Ideally you should choose the smallest size you
can and yet it must be big enough to hold all your
desired items.

Packing

All photographers will have different ideas on how
they pack and transport all of their valuable, and
sometimes, fragile equipment. Most choose a hard,
waterproof plastic case. Using Styrofoam or sponge
you can pick or cut out shapes of your various
pieces of equipment and even under fairly serious
impact, your equipment should survive.

If you are flying to your destination it is a really
good idea to have your camera and lenses go with
you as hand luggage. Many photographers use a
purpose-made photography rucksack with pouches
or compartments specifically for the camera's lenses.

It is a good idea to make a list of all the items that
should be in your boxes. Keep your list in one of the
boxes and then each time you pack your equip-
ment for a photo dive trip, you can run through the
check-list to ensure that you have packed all your
components.

Once it has been packed, then you should weigh
it. If you are heading to your destination by air,
airlines are becoming really strict on weight limits,
and even a small amount above your permitted
baggage allowance can cost you dearly. It may
well be worthwhile investing in a set of baggage
scales or a spring balance so that you can check the
weight of your luggage before you get to the airport.
Remember to take it with you so you can do the
same for the return journey, as most people tend to
have accumulated weight in their baggage while on
a vacation.

Once you have established your own routine for
setting up and putting together your camera system,
you will get more confident and the time taken to
complete it will reduce. However, it is not a ritual
that you can rush. You should take your time and
be vigilant. If you are buying your equipment from
a dedicated underwater photography specialist, and
this is always advisable, get them to talk you through
the procedure and make sure you are comfortable
and you can do it yourself.

You will, no doubt, have your own ideas about
what you want to put in your maintenance kit. And
you can be sure that whatever you decide not to take
in your kit will be the first thing you need on your
next trip abroad.

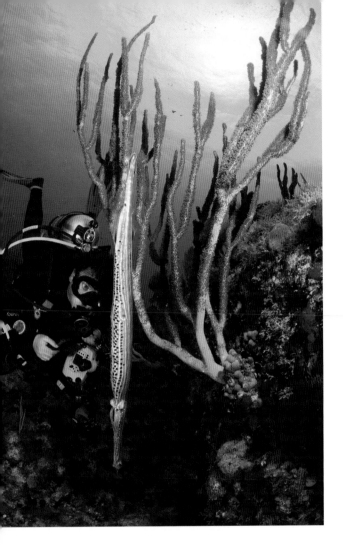

▲ Fig. 3.7
When you are looking for suitable subjects to photograph, or lining up your composition, make sure you avoid getting too close to the delicate corals on the reef.
1/320; ƒ9; ISO 200. Nikon D200, Tokina 10–17mm at 10mm.

◀ Fig. 3.6
If you are trying to get close in to a subject and there are corals and sponges all around you, it is a good idea to make sure that your fins are higher than your head.
1/125; ƒ18; ISO 400. Nikon D700, 16mm.

ETIQUETTE AND ENVIRONMENT

Showing great skills and good behaviour under water will leave you feeling confident and satisfied – your fellow divers will appreciate it, and you will be doing your tiny bit towards saving the environment. In addition, you may be influencing any fellow divers who may follow your good example.

Some animals are disturbed by close attention, especially if you are using video or strobe lighting. Try to take your photo with minimal disturbance to the subject. Try not to stay too long, and ensure that the other divers have the chance to see what you have found. If you cannot get the shot of your subject without touching, and hence damaging, coral or

sponges around it, then do not take it – there will be another opportunity.

Above all, be aware of your fins. Avoid knocking over coral or sponges or other animal habitat just so you can line up your shot. If you have a camera in your hand move slowly, kicking gently with your fins so you are not disturbing the substrate. This will help reduce backscatter not only in your own shot but also for those behind you. If you are using paddle fins learn the frog kick method, if you do not already know it, as this is less likely to stir up the bottom. (Advice on how to protect the underwater environment is covered in more depth in the Chapter 14.)

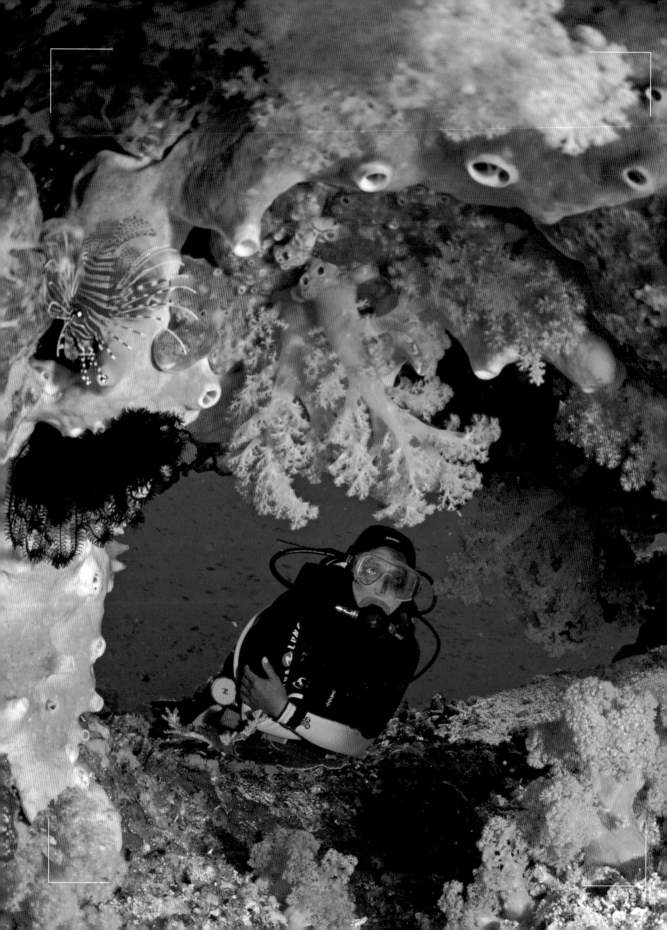

Chapter 4

The Underwater Environment

As you start to make your descent under water, you begin a voyage to a world that is totally alien to the one that you have just left. Water is about 600 times denser than air and at as little as 10m (30ft), which is relatively shallow, in diving terms, the water pressure that is acting upon your body is about the same as the air pressure that inflates an average car tyre.

LIGHT LOSS

Light disappears at an alarming rate the deeper you go, and the absorption by water causes notable colour loss at only a few metres. It is vitally important as an underwater photographer that you appreciate these effects if you are going to understand how you are to be able to compensate for these light and colour losses. Many divers, new to photography, find it really frustrating that their photographs look blue or green and this creates really dull and soft images that lack contrast and definition. There are several ways that the underwater photographer can compensate for these effects, but strobes or powerful video lights that can restore the colour are the most effective way of doing it.

Light loss is not just about the vertical distance from the surface – the Total Light Path (TLP) comprises both the vertical and the horizontal component. This, for example, means that even at 2.5m (7–8ft) in depth, if you are the same distance away from your subject, then all the red light has gone, as the TLP is 5m (15ft). This is one of the main reasons

◄ Fig. 4.1
A gap in the coral, with all its beautiful colours, creates a natural frame for a subject, whether it is a dive guide or a fish.
1/200; f11; ISO 400. Nikon D700, 16mm

The bars show the approximate depth at which each colour of light is lost.

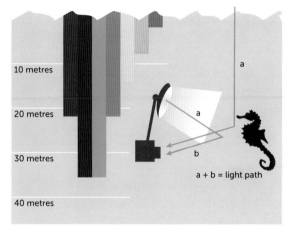

▲ Fig. 4.2
This diagram indicates how colour changes with depth and distance in clear water.

As the sea gets rougher, the light penetration decreases due to increased feflection of the sun's rays.

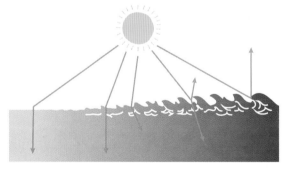

▲ Fig. 4.3
The amount of light under water depends on where the sun is in the sky, whether the sea is calm or rough, and also if it is cloudy the light is diffused.

to get as close as you possibly can to your subject, as if you can close this gap to half a metre or less, then you will still have a significant amount of red in your picture, for this particular example.

If the visibility is poor, then these distances are reduced due to absorption by the water and the particles that are in it. Water is never clear; it absorbs light and colour. It is much denser than air, and even the cleanest, clearest water will prevent light from being transmitted anything like as efficiently as it is at the surface.

It is important to remember that the amount of light that penetrates underwater is due to several factors other than depth and visibility. The weather and the time of day will play a huge role in light penetration and hence the amount of light you have available to your images. (The visibility under water is affected by numerous factors and is covered in more depth in Chapter 11.)

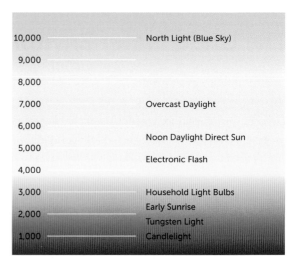

▲ Fig. 4.4
Table showing Kelvin temperatures and colour equivalents.

The table shows the following Kelvin temperatures and colour equivalents:

Kelvin	Colour equivalent
10,000	North Light (Blue Sky)
9,000	
8,000	
7,000	Overcast Daylight
6,000	
5,000	Noon Daylight Direct Sun
	Electronic Flash
4,000	
3,000	Household Light Bulbs
	Early Sunrise
2,000	Tungsten Light
1,000	Candlelight

Timing

The ideal scenario for maximum light penetration is two hours either side of midday on a calm flat sea. This allows for minimum reflection of the waves, and the angle of sun (solar angle) is at its smallest. This, however, does not necessarily mean that it is the best time to take your camera under water. Early morning and late afternoon sunlight affords a wonderful soft warm light on the subject, in just the same way as it does on the surface. However, by about four o'clock in the afternoon the light is starting to diminish very quickly underwater. By this time the difference in light will be at least one stop, and if you want to keep the same depth of field, adjusting the ISO may be the best way to compensate for this.

Interestingly, when we talk about warm light, converting it to a temperature equivalent it is in fact cooler. The temperature scale is based on hypothetical black-body radiation. The colour it radiates becomes bluer as the temperature increases. Understanding of this is important if you are going to adjust your camera's white balance by using the temperature scale in Photoshop.

Depth

As discussed, light disappears as you make the descent underwater. The rate at which the light level reduces is particularly dependent upon the visibility of the water. Experiments have been done to try to quantify this light loss, but as there are so many factors it becomes somewhat complicated. Essentially, however, in good visibility in tropical waters then the difference between light levels at 5m (15ft) and 30m (100ft) can be as little as one f-stop. In temperate waters with the visibility of 10m, the f-stop difference can be four or five. Where the visibility drops below 10m (30ft), taking photographs with no artificial light becomes almost impossible without using a tripod and slow shutter speeds.

REFRACTION

Water is much denser than air. At 30°C air is 858 times less dense. In the early part of the seventeenth century, the Dutch astronomer Willebrord Snellius was credited with the law of light diffraction passing between two media of different optical densities. When light moves through different densities, it affects how fast light travels. The light is refracted, or bent, towards the optical axis perpendicular to the plane between the media when going from a less dense to a more dense medium. When going in the opposite direction, light is directed away from the perpendicular axis.

It is this effect that produces Snell's window. Fig. 4.5 shows how light is diffracted at the surface as the incident angle reduces. When the light from the horizon passes at an angle of about 48 degrees, known as Snell's Angle, the window at the surface is created. To capture the whole of the circle a 12mm fisheye lens is required; however the majority of underwater photographers will accept most of the circle by using a 15mm fisheye lens.

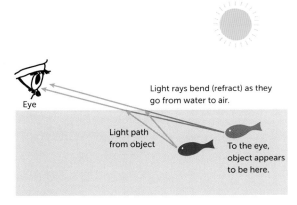

▲ Fig. 4.5
As light passes from air to water it bends or refracts; this diagram shows why things appear closer than they are in the water.

TEMPERATURE

One of the key factors to consider when you are embarking on underwater photography is the water temperature. There is a massive range of water temperatures, depending upon whether you dive in the tropics, temperate waters or even those of the Arctic or Antarctic (polar). These temperatures range from around 1°C/33°F to a balmy 39°C/85°F. The water temperature will obviously have a great effect upon the make-up of what you will see of the water. In the polar environment, where only a few people dive, the corals and sponges will be sparse. In the tropical

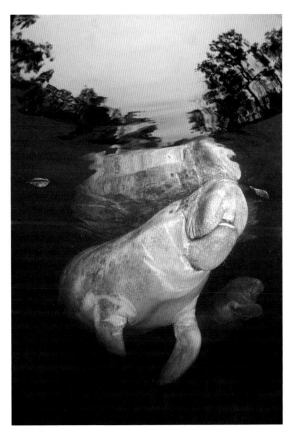

▲ Fig. 4.6
Photographing towards the surface with a fisheye lens will create a window that allows you to see the surroundings above water. This image of a manatee was taken in Florida with twin strobes to illuminate the subject and help create the reflection on the surface. 1/100; ƒ6.3; ISO 250. Nikon D700, 16mm

▶ Fig. 4.7
This grey seal was taken near
the surface in poor visibility
in the Farne Islands off the
north-east coast of England.
By using a high ƒ-stop and
the strobes set to low, any
backscatter was kept to a
minimum.
1/160; ƒ16; ISO 500.
Nikon D700, 16mm

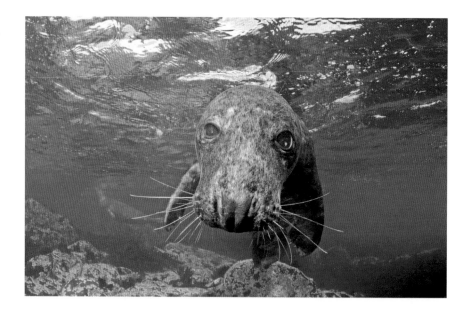

▶ Fig. 4.8
A 2.5m Basking Shark off the
coast of Cornwall in south-
west England; using natural
light helped eliminate the
effects of the plankton in the
water which had reduced the
visibility.
1/200; ƒ6.3; ISO 260.
Nikon D700, 16mm

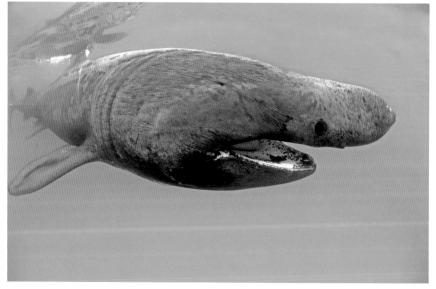

zones, in a nutrient rich environment which has not
been subjected to human pressures, then the corals
and sponges can be numerous. It is the nutrients in
the water that play the greatest role in the flora and
fauna density.

The temperature and the salinity of the water
can impact upon the underwater photographer in
several different ways. There are many underwater
photographers who refuse to dive in cold water.

There are also those who refuse to dive in anything
other than temperate water because of all the poten-
tial stinging creatures in this region. This is a matter
of personal choice; however, taking photographs in
cold water can be really rewarding – there are some
exceptionally wonderful creatures to photograph,
like seals for example, and generally, though not
always, the visibility can be exceptional.

Cold Water Equipment

The secret to diving in cold water is to use the
appropriate equipment. If the water is cold then it
makes sense to be wearing at least a 5 or 7mm hood,
5 or 7mm gloves and, of course, a dry suit. If you
have a membrane dry suit and you intend to dive
in sub 10°C water, then a good quality under-suit
is also essential. There can be lengthy periods of
relative inactivity when you are lining up your shot,
and you are more likely to find yourself getting
cold when you are not moving than when you are
finning around. While at the beginning of the dive
it may be difficult to operate some of your controls
through thick gloves, you will almost certainly find
it gets harder as your fingers get colder, number and
stiffer.

Another disadvantage of having to wear all this
extra equipment is that it makes you far less mobile.
Manoeuvring yourself into position to line up your
shot is cumbersome and so you are far more likely
to kick up silt. You need to be more aware of your
surroundings so that you do not damage them.

Many photographers who dive regularly in cold
water have taken to using a re-breather system. This
helps to keep you warm, as your own air is recirculat-
ed and scrubbed by the lime so that you are breath-
ing in much warmer air than you are from a scuba
tank, where the temperature will be the same as the
surrounding water in a very short space of time.

The difference in the equipment you need to
use between warm and cold water will make a huge
difference to your buoyancy. You will probably find
you will need to use at least three times the amount
of lead in a dry suit with 7mm accessories than you
would in a 3mm wetsuit.

Every time you dive in a different environment
you will need to adjust your weights accordingly. It
is a really good idea to itemize in your log book the
weight you are using for each of these different dive
environments. This will make it far easier for you to
set yourself up for good buoyancy the next time you
dive in a similar environment.

▲ Fig. 4.9
When the water temperature is less than 5°C, appropriate gear is
essential. Admittedly thick gloves can make it difficult to operate the
controls, but not impossible if you are determined.
1/125; f10; ISO 800. Nikon D700, 24mm

Chapter 5
Natural Lighting

As soon as you begin your descent under water, the light surrounding you starts to change. It gets darker and all the colours that make up the light spectrum at the surface, in air, start to diminish. If you refer back to Fig. 4.2, which illustrates how colours are lost underwater, you will see that within the first metre red light is disappearing and after three or four metres deeper it has gone altogether and orange is rapidly disappearing too. Once you descend to 8–10m (25–30ft), depending on the surface light, conditions and water quality, realistically it is only blue light that remains. The light levels depend not only on the quality of the water you are in, but also on the conditions and the quality of light at the surface.

The simplest way to restore colour and light beneath the surface is to take your own light source with you. However, this adds bulk and weight to the camera system, and many divers consciously elect to use natural lighting for their images – after all, that is what you see when you dive, apart from the hints of colour that your brain tells you is there. Even if you take your own hand-held light, you can only illuminate a small area.

This chapter is designed to try to help those who choose natural light over artificial light. Even if you are a great fan of taking your own light with you, it can be refreshing at times to take the camera without any light and take yourself back to first principles. White balancing properly every few metres, especially using a white balance filter can in good conditions reveal colours at depths of over 8m (25ft).

◄ Fig. 5.1
This image was taken in Raja Ampat shooting into the light to create a silhouette as well as Snell's window. The sun coming from behind the jetty is creating sunbeams and the window allows you to see the people on the boat as well as those on the jetty.
1/250; ƒ8; ISO 100. Nikon D200, Tokina 10–17mm at 10mm

THE SUN AND THE TOTAL LIGHT PATH

When using natural, or ambient, light the position of the sun becomes increasingly important. If you are shooting silhouettes, then you will need to point your camera into the light, sometimes directly into the sun. If you are photographing a reef or wall, and you are trying to capture some of the detail, than it is really important that you shoot with the light behind you. This may mean you would need to dive a particular site at a particular time of day. For example, the wall in Dahab on the Gulf of Aqaba runs virtually north–south. Dahab is on the western shore and as the sun rises over Saudi Arabia in the east, the best time for natural light photography on this reef is the morning or at least before noon.

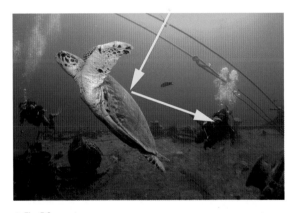

▲ Fig. 5.2
The light path to the camera involves both the horizontal and vertical component. The light must come from the surface to the subject and then from the subject to the camera. This image shows a turtle and divers on the wreck of the *Thistlegorm* in the Red Sea. 1/80; ƒ7.1; ISO 160. Nikon D200, Tokina 10–17mm at 10mm

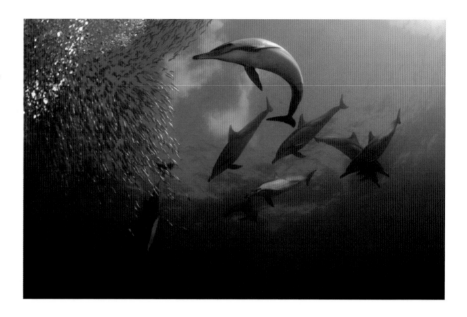

▶ Fig. 5.3
The effect using auto white balance makes this a blue image; the photograph is of dolphins on the sardine run in South Africa.
1/200; ƒ9; ISO 400.
Nikon D700, 16mm

A major consideration for using natural light is the total light path (TLP), which is the distance the light has to travel from the surface to the subject and then to the lens. This generally means there is a vertical and a horizontal component to the total light path; both distances need to be added together.

WHITE BALANCE

With the camera's white balance set to surface conditions, colours disappear as quickly as they do in the human eye. However, the electronics of the camera can be adjusted by shifting the colour curves. Within limits, the camera can be told that blue is white, and it will compensate accordingly. Most compact cameras will have three white balance modes: underwater mode, automatic and custom. Mirrorless and SLR cameras tend to rely on the operator using manual white balance or on postproduction editing of RAW files, but not everyone does this. (This technique is described in Chapter 13.)

Auto White Balance

This is a simple option but is designed purely for surface conditions and colours; it was never meant for the blue or green hue that you will encounter in the water. Generally speaking, auto white balance is the least effective of all the white balance options. Put simply, in auto the camera looks at colours and makes an electronic 'best guess'. It can be effective in shallow water, before too many colours are lost.

Underwater Mode

A slightly better option is to use the underwater mode. This is normally annotated by a fish symbol and is designed for people who want to use the camera for snorkelling in blue water. It generally gives fairly decent results as long as you are diving in shallow water. Once you descend beyond 5–6m (15–18ft), the results become less realistic. If you are diving in temperate waters the results are not quite so good, because the colour balance is designed for blue water.

Custom White Balance

The best option, by far, is to use the custom white balance setting. Very basically, this involves telling the camera that blue, or green if you are diving in temperate waters, is white. To carry out a custom white balance, you will need to use a clean white

▲ Fig. 5.4
As long as you are only a few metres under the water, the underwater mode can give acceptable results, as this image of schooling fish under the pier at the eco-resort in Raja Ampat shows. 1/250; ƒ11; ISO 200. Nikon D700, 16mm

▲ Fig. 5.5
Custom white balance will always give the best results, as this photograph of a dolphin in a bait ball demonstrates. 1/200; ƒ9; ISO 400. Nikon D700, 16mm

slate and select custom white balance in the camera's menu system. Point the camera at the slate and press the white balance button while trying to fill your screen with the whole of the white slate. Try to get as much light on the slate as you can, and avoid getting the shadow of the camera and your hand in the frame. The camera will measure the average of what it can see. Therefore if you have any surrounding dark blue or green it will factor that into what it sees as white.

Ideally, while it may seem unnecessary, try to carry out a white balance measurement at the surface before you start your descent. Every 2–3m (6–10ft) repeat this process, and this will allow the camera to use your previous results as a reference and it will give better white balance results.

Using a white balance filter can give even better results. These are ideal for compact and mirrorless cameras and come in various sizes. The idea is to fit the whole of the filter over the lens and press the white balance button. They look like a lens cap made from translucent white polythene and they are really quite inexpensive.

If you are white balancing and you are using artificial light, then you need to complete the process of the white balance with the lighting turned on. You should always white balance for the light conditions

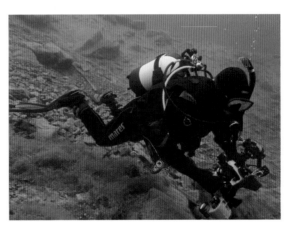

▲ Fig. 5.6
This image was specifically taken to demonstrate how effective white balance filters can be. It was shot at 16m on a dark day in a fresh water inland site in the north-west of England using natural light only. Whilst the image is not of award-winning quality, red and yellow are still clearly visible. Because it was dark, a wide aperture was selected.
1/125; ƒ2.2; ISO 250. Canon S100

that the sensor is going to be exposed to. If you perform a white balance without light and then turn on the light, the results will be far too red or yellow.

In the Editing Suite

Most of the compact cameras that are on the market now have the ability to shoot RAW files. As the name implies, these files are in an unprocessed condition but contain about ten to twelve times

▲ **Fig. 5.7a and 5.7b**
White balance in Photoshop before (Fig. 5.7a) and after (Fig. 5.7 b).
This goliath grouper in the Florida Keys is yawning.
1/125; ƒ14; ISO 640. Nikon D800, 60mm

the information that is on the corresponding JPEG. (RAW is looked at in some depth in Chapter 8.) If you have the facility, then as a general guideline, you should use it.

While it is always better to shoot the image at ideal settings, including a manual white balance, these adjustments can be done successfully in the post-dive production editing. The white balance can be adjusted by changing the colour temperature slide in your digital photo-editing software. (This process, along with how to carry out all basic adjustments in imaging software is dealt with in Chapter 13.) Many photographers shoot in both RAW and JPEG, if the camera has that selection as an option. However, this may slow the camera down and you may find that the recycling times are unrealistic and unacceptable. As long as selecting RAW and

JPEG does not affect the speed of your camera too much, then the advantage of shooting in RAW and JPEG is that the JPEG files are easier to read when you have downloaded your images. The idea is that you look through the JPEG files and decide which of the images you would wish to run through Photoshop. The images you actually manipulate should be the RAW ones.

Underwater Filters

Another simple technique to introduce some colour to the image is to use filters. There are several manufacturers who produce underwater filters. Essentially there are two kinds: green temperate and blue tropical. Should you be shooting in blue tropical waters then a red filter can provide pleasing results. The effect will be a more even distribution of colour across the whole image. If you are in green, temperate waters, then you will need to use a magenta filter.

With both filters, a white balance still needs to be carried out while at the depth you are shooting. As you change depth the density of the water's colour will vary and so, even a small change in depth will affect the white balance. It is also important to remember to shoot with the sun behind you and point the camera slightly downwards.

TECHNIQUES

--

Natural light photography is great for shallow water – 8m (24ft) or less – especially where the light and water quality is good. Using manual white balance, particularly with a white balance filter, will give excellent results. There are also several different techniques that you can use that work particularly well with no artificial lighting. Some of these techniques require additional lenses and ports, but if you want to become creative and produce something a little bit different, then it is worthwhile considering the extra cost.

▲ Fig. 5.8
Taken in Grand Turk in the northern Caribbean, this image shows
Snell's window with a calm sea. The boat and the clouds in the sky
can be clearly seen through the window the refraction has caused.
1/125; ƒ13; ISO 200. Nikon D700, 16mm.

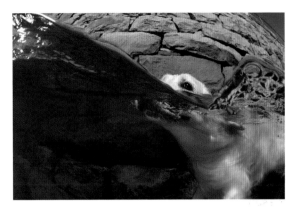

▲ Fig. 5.9
This was a bit of a fun shot taken of my golden retriever swimming
round a pier at Trefor in North Wales. Because the dog is shallow
and there was plenty of sunlight available, his fur beneath the
surface is still nicely exposed, despite using a fast shutter speed.
1/400; ƒ13 ISO 320. Nikon D200, 10–17mm at 10mm

Snell's Window

This technique requires a wide-angle lens, pref-
erably a fisheye. You can achieve this effect by
pointing the camera upwards towards the underside
of the water's surface. The refraction of the light
causes the surface to become an almost completely
circular window that you can see through. If the
water surface is totally flat, then looking through that
window is like looking through a pane of glass. The
shorter the focal length the greater the circle you will
see. It is, however, almost impossible to capture the
whole circle on your screen, as this would require a
super fisheye which is not only expensive but also
not much use for any photography other than Snell's
window.

Split Shots

This particular technique requires good water
quality and sometimes needs artificial lighting to
balance the exposure between the part of the image
at the surface and the area in the underwater shot.
However, if conditions are good, the results can
be amazing. As with Snell's window a wide-angle,
preferably a fisheye, is needed. It can be done with a
flat port but results will almost certainly be improved
with a fisheye or dome port. The bigger the dome
port you use, the better.

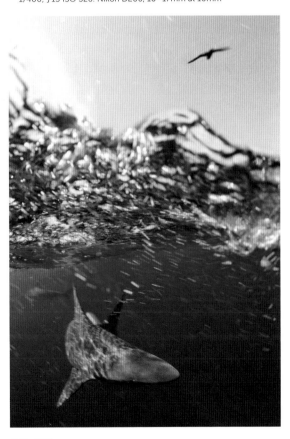

▲ Fig. 5.10
This split-shot of the shark was taken in fairly choppy water in South
Africa without the use of strobes. Because the shark was near the
surface and there was plenty of light I was able to meter for the
shark without overexposing the sky.
1/160; ƒ10; ISO 200. Nikon D700, 16mm

Silhouettes

Some magical effects can be produced by shooting directly into the light with the subject blocking or partly blocking the primary light source. The best light for these shots is bright sunlight with no clouds to diffuse the light. With the right subject, you can capture sun bursts or halos around the shape – these images make really good pictures for framing. You will need to align yourself with the subject and the sun directly behind the subject. Where you can, focus on the dark subject and set your exposure for the light. Any features on your subject should be indistinguishable as you have exposed for shooting directly into sunlight.

Sunbeams and Cathedral Light

Most divers will have seen sunbeams coming through the water, creating mystical effects as they appear to make their surroundings move or dance. This effect is often referred to as dappled lighting, very much like you could see in woodland on a sunny day. Using any form of artificial lighting can flatten out these effects, so under these conditions, natural light is the perfect choice.

If you are lucky enough to have a good-sized subject to photograph in these conditions, try shooting down on the subject and meter your exposure to get the dappled light on the surface of the subject. The best places for sunbeams are usually in caverns or under man-made structures such as piers or jetties, and they tend to be better when taken at shallower depths. However, the effect in open water can be equally effective, when conditions are right.

It is also important to get the background colour right if you are shooting subjects in mid-water against this kind of light. Changing your shutter speed or your f-stop will do this; however, when using natural light, closing the aperture is generally more effective, but remember that this will reduce the depth of field.

Be cautious when you are shooting into the sun. Digital sensors really struggle with the dynamic

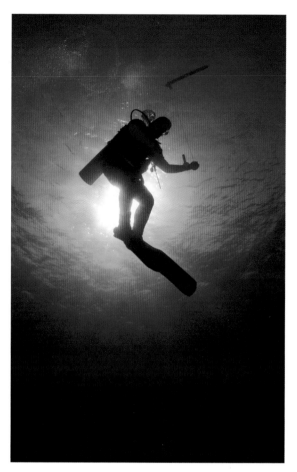

▲ Fig. 5.11
By trying to line up the diver with the sun directly behind him you can create a halo around the silhouette.
1/200; f22; ISO 160. Nikon D700, 16mm

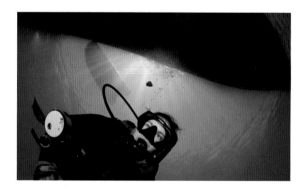

▲ Fig. 5.12
While this is not a natural light image, as the flatworm and Caroline have been illuminated by strobes, the effect of the natural light coming from behind the silhouette of the boat creates a nice sunbeam effect. The high f-stop is as a result of metering for the sunlight.
1/125; f20; ISO 400. Nikon D700, 16mm

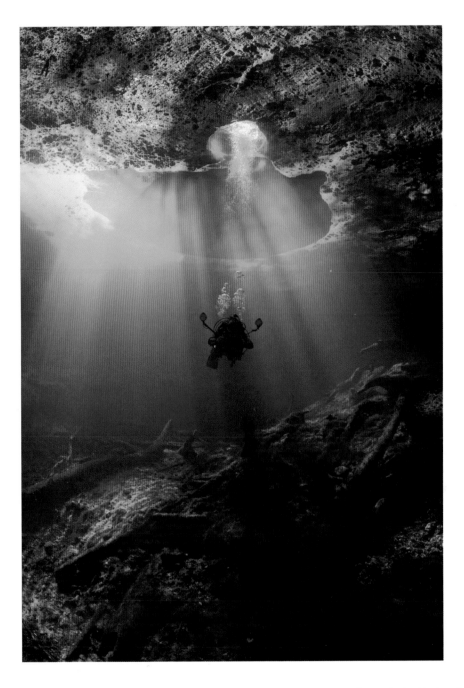

Fig. 5.13
The surface of the water is covered in duckweed, and the diver's bubbles have created a circle for the sunlight to burst through. The diver is too far away for the strobes to illuminate and so a nice silhouette is created against the green background. The location is Manatee Springs in north-west Florida.
1/60; ƒ8; ISO 200.
Nikon D200, Tokina 10–17mm at 10mm

range required to capture what you are seeing, or trying to portray, and it is very easy for you to over-expose the image. It is a good idea for you to spend some time practising shooting into the light with your camera so that you understand its limitations. Try various settings and see which ones work best for your particular camera. Shooting into the light can really push the limits of a digital camera and it is worth understanding what your particular model is capable of. Different manufacturers and cameras vary how they process their images and it helps for you to understand how your own camera manages the situation.

▲ Fig.5.14
A basking shark taken off Cornwall in England shows how the sunbeams can create dappled light on the back of a subject. This picture also shows the benefit of converting some pictures to black and white, particularly when the poor visibility, caused by a plankton bloom, can make the image too green in colour.
1/125; ƒ11; ISO 500. Nikon D700, 16mm

Long Exposures

Putting the camera on a tripod while under water will let you use longer exposures than you can by holding it in your hands. This will allow you to adjust your aperture to give you a large depth of field which is ideal for wrecks and wide-angle photography. Using a longer exposure also reduces the effects of particles in the water because you are not freezing the action. This kind of photography does not work particularly well if there are moving divers or marine life in the frame, unless you want to be really creative.

Reflections

Using reflections can really create a 'wow' image. Conditions need to be good, and you will need to be shallow in order to get the reflection of your subject off the underside of the surface. Getting reflections is far easier with a wide-angle lens than it is with a macro or close-up lens, but it is possible to use your macro lens, particularly with smaller subjects.

Reflections can be obtained using either natural or artificial lighting; however if you are using artificial lighting, be very careful not to overdo the intensity or illuminate the surface where the reflection should be. For the natural light shot, you will need to ensure that the ƒ-stop is set reasonably high, at least ƒ11 or ƒ8 is required in order to be able to make sure that both your subject and reflection are in focus. If you are using a full frame digital SLR, then an aperture setting of ƒ18 or ƒ22 would be more realistic. The effect can be very difficult to get right, and patience is so important when taking this type of photograph, but it can be really worthwhile when you do manage to get it.

Monochrome

Black and white, or sepia, images look really effective when they are done properly. If you shoot the original image in black and white, you cannot convert to colour later, if you have second thoughts. So you should avoid ever putting your camera into black and white mode, as converting it to monochrome can be done afterwards in the editing suite.

However, the technique for getting the black and white shot is generally different than it is when you are shooting colour or when using artificial light. If you are planning on turning your image to monochrome then the image you are making needs to have plenty of contrast. Shooting into the light at the subject will give contrast, as will shooting into shadows. If the shadows are in a line, shoot along them, as this will show off and maybe exaggerate the contrast. If you shoot across the shaded lines, the image will lose its impact.

Shooting for black and white can be really rewarding, and if you do it regularly, you will soon find what works best. However, like all these techniques, the key is to practise. Sometimes, just de-saturating the image in the photo editing suite will give a softer, more pleasing effect than simply turning it to monochrome black and white.

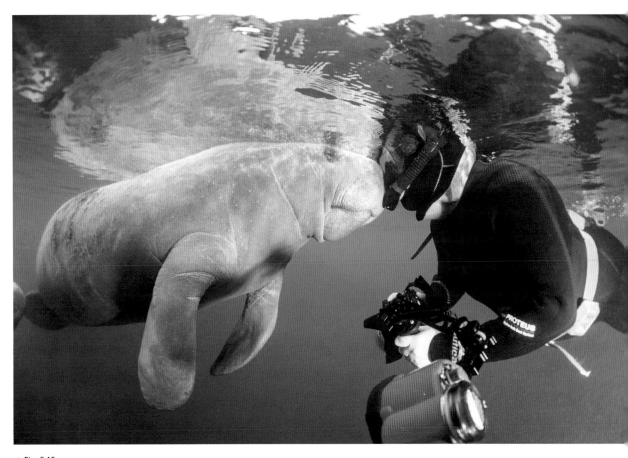

▲ Fig. 5.15
In poor visibility, if you stay close to the surface and use low power, reflections can really enhance the image. Here, a manatee approaches right up to the snorkeler until they are touching faces. 1/125; ƒ6.3; ISO 400. Nikon D700, 16mm

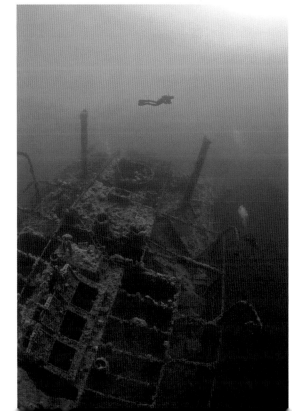

▶ Fig. 5.16
Rather than selecting black and white, try moving the saturation levels in Photoshop almost completely to the 0 level. This will give a de-saturated, silvery blue tone. 1/100; ƒ10; ISO 500. Nikon D700, 16mm

ENVIRONMENTAL CONDITIONS

Finally, when using natural light for your underwater photography, the environmental conditions can play a major role. Sometimes there can be insufficient light or visibility to make it viable. In really poor visibility it can be almost impossible to take any images worth keeping.

The weather conditions are the prime factors in many cases, with water turbidity being a key component. If the seas are being stirred up and surge is evident, then usually macro photography is the only option. Whether the sun is shining will, of course, affect the light, but very often, cloud cover can make for excellent underwater conditions as the clouds act as total light diffusers and create a nice evenly distributed light for you to work with. As discussed in Chapter 4, the height of the sun and the way in which the waves are moving around will affect light quality as a result of radial light factors.

Very often, near the shoreline, you may experience thermoclines and haloclines. Where the cooler water mixes with the warm layer above and with the halocline, the salt water interacts with the lighter, fresh water. In some environments, plankton can reduce the horizontal visibility immensely. (This is dealt with in more depth in Chapter 4.) The positive effect of plankton, however, can be amazing, as it is usually this that brings the giant filter feeders with it.

Using natural light can be rewarding and many people appreciate the look of the natural light underwater photograph, probably because it looks like how you see it when diving. The secret of natural light photography has to be careful and effective manual white balancing. This can involve the use of the white slate, although white balance filters generally achieve superior results. With natural light, white balancing at the time you are taking the shots is a far better option than trying to correct the colour in the photo editing suite.

This chapter has also looked at various techniques for getting the best out of natural light photography. Using a tripod and the camera set to a long exposure will help to reduce the appearance of particulates in the water. Shooting into the sun to create silhouettes or capturing the sunbeams and cathedral light can produce really vibrant images.

Images taken using natural light also tend to transfer to monochrome-sepia and black and white images better than those taken in artificial light. It is worth bearing in mind that even if you are carrying your own lighting with you, be prepared to turn them off and shoot with natural, ambient light.

▲ Fig. 5.17
The shot of a manta coming towards me was taken in Bali. The wide-angle lens flatters the visibility, as it could only be seen when it got within 5m (15ft).
1/250; ƒ9; ISO 200

▲ Fig. 5.18
Another fun shot of my golden retriever sitting in the rain water run-off from the Snowdonia mountains. The fresh water is mixing with the salt water at the surface to give this blurry effect. The high shutter speed was possible due to the bright sunlight.
1/400; ƒ9; ISO 200. Nikon D200, 10–17mm at 10mm

▲ Fig. 5.19
Capturing images at the surface, or in the shallows, affords a great opportunity to shoot with natural light. This manatee approached very close to the camera, so the total light path was minimized.
1/125; ƒ6.3; ISO 400. Nikon D700, 16mm

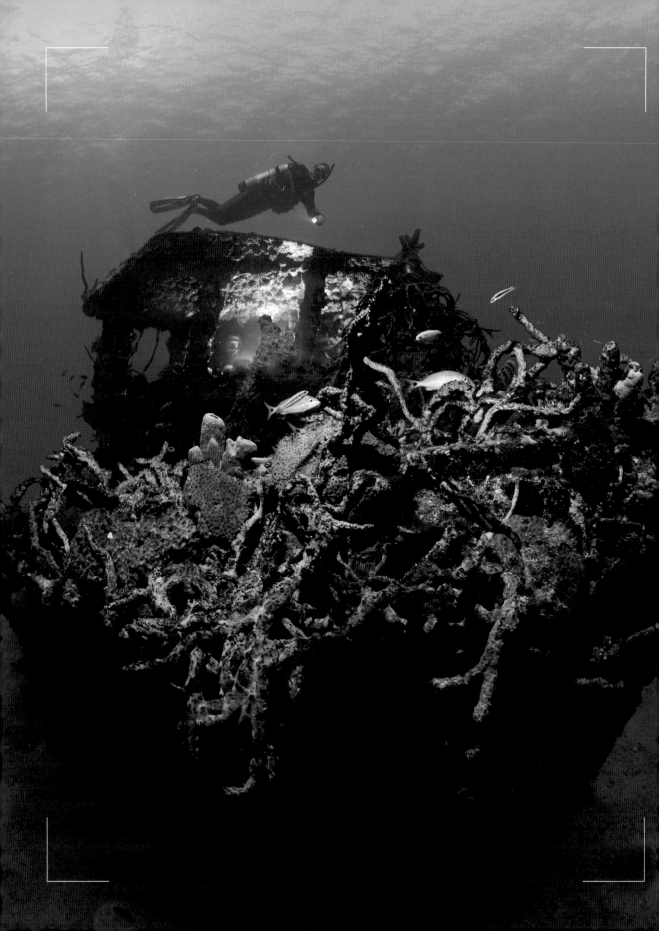

Chapter 6
Artificial Lighting

Even a beginner to underwater photography may very quickly want to add some artificial light to their setup. When you venture under water, taking your own lighting with you will bring out the colours, capture greater definition and your images will be truer to what you actually see under water. This is because the human mind sees the blue images under water and translates this to the colours it expects them to be.

Lighting is seen by most serious underwater photographers as the most important factor in underwater photography. As you have already read, once you descend beneath the surface of the water the light and the colours very quickly disappear. If you are diving in temperate, green water where the sun rarely rises beyond 70 degrees in the sky, then you will know how quickly the light and colour can disappear. There are many boat captains who operate in these waters who will refuse to let you in the water without a light. So if you are intending to dive in these waters the choice as to whether to use artificial lighting is a lot easier.

With the advent of powerful LED lighting, predominantly for video use, the choice of constant or flash lighting is a far more realistic consideration than it was only a few years ago.

FLASH GUNS OR VIDEO LIGHTING?

Deciding whether you choose to use flashguns (strobes) or constant source video lights is a personal decision by you. There is some confusion about underwater flashguns and what they can achieve, and in addition, they can be difficult to master and the results can only be seen once the shot has been taken. However, strobes are far more powerful and are good for live subjects because they do not scare your subject away before you even get there, although they certainly may when they fire.

Many cameras have built-in flash units, and with the camera placed in a transparent housing, the flash can be used to illuminate the subject. However, the built-in flash is not very powerful and the

COMPARISON OF FLASH GUNS AND VIDEO LIGHTING

Advantages of strobes
- Provide powerful light.
- Directional control.
- Can lose the silhouette when shooting against the sun, and fill flash.

Disadvantages of strobes
- Bulky and can be heavy.
- Distance-dependent, and therefore provide limited amount of light you can put onto the subject under water.
- Can take time to master.

◄ Fig. 6.1
This image is taken of the wreck of a tugboat in St Eustatius, Caribbean. Inside the wheelhouse are four remotely triggered strobes, and the light on the front of the boat has been produced by two on-camera mounted strobes. This pulls out the colour of the corals and sponges at the front while the remote strobes in the cabin show the 'captain' driving the boat. To balance the composition there is a diver hovering just above the cabin. 1/60; ƒ14; ISO 200. Nikon D700, 16mm

shape of the underwater housings can often leave a shadow on the image. It is possible to use a diffuser, normally supplied by the housing manufacturer, which will reduce the shadow on your image. It will, however, also reduce the amount of light you can put on your subject. In addition, because the flash source is close to the lens aperture, it is quite likely to put backscatter in your resulting image.

If the built-in flash unit of the camera is used, especially with the diffuser, the light is really insufficient for anything other than general close-up shots. Should you use the camera's inbuilt flash you will need to use it on its highest power setting, and this will considerably slow down the recycle time of your camera. Even on a high-end SLR camera, the recycle time is slower if the built-in flash is used.

▲ Fig. 6.2
This setup of a camera with two strobes shows the most common way to rig your lighting for wide-angle photography. It is particularly useful where there is backscatter as the lights are mounted a good distance away from the dome or lens. They are also set up so they have fallen behind the line of the lens and they are also angled 10 to 20 degrees pointing out.

LIGHTING ISSUES

Backscatter

Backscatter is one of the major factors that underwater photographers face, even in beautiful clear water. If you get your lighting positioning wrong, then backscatter will ruin your photograph. This is especially the case if you are photographing wide-angle, using a dome port. Whether you use the camera's inbuilt flash, numerous strobes or video lights, backscatter can still be a serious issue. Backscatter has the potential to destroy the best image you have ever taken.

So what is backscatter? Any water that you will be diving in contains small particulates, and when light hits these particles, it will be reflected. When this light bounces back at the lens, the effect is magnified by refraction, making the reflected and refracted particles appear larger than they are. This effect is often referred to as dirty water.

The closer the light source is to the aperture of the lens, the greater the chance of backscatter. Backscatter is far more obvious on your image

against a dark background, but if you are using a flash close to the lens there will be backscatter in your image. The only way to eliminate or reduce backscatter when using artificial lighting is to move the light away from the lens, even behind the camera, and point the light source at least 45 degrees from the lens, especially where there are lots of particles in the water.

Reducing backscatter is a major reason for using external lighting. By adding an external strobe, you will be able to achieve far more control over your light placement, and it allows you to angle the light onto your subject from any direction you choose. A strobe is more powerful than a video light, and offers a greater variation of power. This can be really important if there are large numbers of reflective particles in the water. If the visibility in the water is low due to these particulates, then using lower power from your strobe and turning your ISO number up will help reduce the backscatter.

When using your strobes for wide-angle photography it is a very good idea to use diffusers. While diffusers will reduce the amount of light emitted by one to two stops, it will increase the angle of coverage and soften the edges of the beam. Many underwater photographers will use diffusers for close-up and macro work too, as it softens the light and reduces the harsh shadows that can be created

▲ Fig. 6.3
A camera and strobe setup with diffusers on each strobe. The translucent plastic helps spread the beam, but it does reduce the intensity.

by the non-diffused light. Using diffusers on the strobe is particularly useful on reflective surfaces, although it will not prevent the reflection, merely reduce it.

Power Output or Guide Number

The power output of the strobe is expressed as a guide number (GN). While the light output is referred to as power, this does not refer to the intensity of the light but simply the burn time of the strobe per firing. This means that as you turn up the power setting on the strobe, you are just increasing the time the light will burn for. However this does have the same effect as increasing the power; if you take a shot at one setting and then increase this, there will be proportionally more light in your image. The guide number for most strobes is in the region of 14 to 32 GN (this number is measured in air at ISO 100) and is used as a guide when comparing models.

As mentioned earlier, if you are using a wide-angle lens, then the spread of light from the strobe, needs to be the same as or greater than the angle that the lens can cover. Diffusers help to spread the light and also soften the edges with about 10 degrees of greater coverage, but they do absorb power. Light falls away by the square of the distance under water so that the distance with which you can throw light,

CALCULATING GUIDE NUMBERS

The guide number can, in theory, be used to calculate the aperture required for the light to reach the subject; however this formula is used for calculations in air. In water it becomes almost irrelevant as light loss varies greatly depending upon the water you are in.

In relatively clear water, as the power intensity is influenced by absorption and diffusion you could divide the guide number by two.

Aperture (f) = GN/d where d is the distance

In this example, if the subject is 2m away and the strobe you are using has a guide number of 20 the equation would be:

$f = 20/2 = 10$

The f-stop required is therefore 10, and you would have to use $f11$ on your manual setting as there is no $f10$ in the standard range.

This is the formula for air, so halving your result for water will give you $f5$. In manual settings this would be $f5.6$.

If you had been photographing in particularly turbid water then you could divide that figure by as much as four, giving you an f-stop of $f2.8$.

This is a very rough science for underwater photography and so you will probably find, very quickly, your own settings that work with your camera and strobes under different diving conditions.

even with a powerful strobe, is considerably less than it is in air. Up to a metre is realistic and beyond 2m very little light will fall on your subject.

One other option to bear in mind when choosing a strobe is that different strobes have different colours; some light is much warmer than others, and the light from one strobe may not suit your style of photography. Some manufacturers are now producing diffusers that act as colour filters, which adjust the temperature of the light emitted by the strobe, thus changing the colours you see in your resulting image.

Exposure Control

Like the built-in flash on most cameras, the majority of underwater flashguns have variable exposure control. Most will give you an option to decide on the mode you prefer to use.

Auto Exposure

If the strobe is set to auto, then the strobe must be angled directly at the subject in order for its internal metering system to monitor the amount of light that will be reflected back towards it. Not only is this likely to be entirely the wrong angle that you want your light to come from, it may also lead to backscatter.

Some cameras may also require the ISO to be set to 100 in order to synchronize the strobe. This could be entirely inappropriate, especially if working in water with a high number of particles.

Unusually, on modern cameras the f-stop may need to be dialled into the strobe, and several compact cameras will change the f-stop randomly. You are only likely to find this however, if you are using an older-generation camera. Auto results are usually somewhat inconsistent but may be a useful starting point for someone new to strobe use.

S-TTL (Synchronization Through the Lens)

S-TTL is often referred to simply as TTL, and is commonly used. Some underwater photographers demand it when buying a strobe. Should a sudden

opportunity arise to grab a particular photograph, by setting the underwater flashguns to TTL then the lighting should not be too far from the optimum. It may be worth considering setting the strobe in the TTL mode as a default condition, but then switch to manual when you have time to create your own picture.

In S-TTL the flash strength is measured by the camera through the lens. The light reflected back from the subject is measured by the camera and a signal is sent to the strobe to determine the duration of the flash. This means that in TTL the camera is telling the strobe how much light is needed.

Manual Control

In manual control you, the photographer, take responsibility for the amount of light required to illuminate the subject. For anyone serious about lighting and creative lighting in their underwater photography, manual control is realistically the only option. If you are photographing in turbid water, you require far less light to be emitted from your strobe than auto or TTL would give you. You may just want a bit of light to fill any shadows on your subject, or you may be using two strobes with one set to reduce, but not eliminate, shadow on one side in order to give depth and perspective to your image. Most strobe manufacturers provide a variety of power settings, and any reasonable strobe should have a minimum of ten options.

One important point to bear in mind is the recycle time of the particular strobe you are using. If you are shooting in continuous mode, the strobe will not recharge completely between shutter operations. Most decent strobes however will give sufficient light without being fully recharged to put some light on your subject, although it will be underexposed if you had your settings correct for full power. The effect can be minimized by reducing the power setting on the strobe and this will allow it to recycle faster. It does, of course, involve adjusting the exposure settings on the camera to allow more light, and

Fig. 6.4
This image shows a camera housing and how it is connected to the strobe unit using an electrical sync cord.

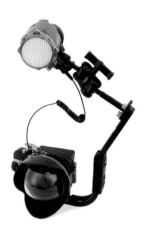

Fig. 6.6
A compact camera and strobe with a fibre optic cable. The fibre optic connects to the light sensor at the strobe and picks up the light from the camera's own flash at a transparent opening in the housing.

Fig. 6.5
This shows the synch cord connected on the strobe unit.

circumstances may not allow this. However, if the ISO on your camera will allow an increase without too much noise, then this can certainly help.

One of the major considerations, if you decide to use underwater flashguns as your lighting system, is whether to use a fibre-optic link between the camera's flash and the strobe or an electrical sync cord from the camera's hot shoe to the strobe connection. For most compact and mirrorless cameras, the facility to use electrical synch cords is just not there. With the electrically fired system, the strobes are initiated from the camera's own hot shoe via an electrical connection. There is an electrical socket on the strobe and another on the camera's own housing. An electrical sync cord with a plug at either end connects the strobe to the housing. Inside the

housing there is another connection from the back of the housing's socket and this goes to a connector which fits onto the camera's own hot shoe. While this system does have built-in potential for electrical fail points, many photographers would argue that this is the better of the two systems for firing a strobe.

Conversely, many digital SLR users have gone over to using a fibre-optic link to fire their strobes. With this system, a fibre-optic link is used to transmit light from the camera's own flash to the light sensor on the outside of the flash. The glass fibre thread inside a protective black sheath carries the light from the camera's flash to the strobe. This way, the fibre-optic link acts as the light carrier to trigger the strobe but this is not without its own issues. On transparent housings the internal flash can cause backscatter, cross lighting and internal reflections. Also, many cameras will not fire on continuous mode when the inbuilt flash is operational.

Another criticism of this method is that using the camera's own flash causes an excessive drain on the battery. This can be minimized by reducing the strength of the camera's flash to its minimum setting. The operation is done through the camera's own menu system and is usually straightforward. The strobe sensor will pick up the smallest flash from the camera. While we refer to the strength of the camera's flash as power, remember that it is in

fact the length of time the flash burns for. The light intensity does not vary and so the lowest setting on the camera's own flash is sufficient to fire the main strobe.

CONSTANT LIGHT SOURCE – VIDEO LIGHTS

Many of the advantages and disadvantages of using video lights are in fact similar to those of using flashguns when comparing artificial lighting to natural lighting. The advantage of using video lights over strobes is that when you look through your viewfinder or on the screen, what you see is what you get. You have already illuminated your subject and you can use this light value to assess the settings that you require. This is a great advantage, especially to the beginner but there are more disadvantages to using video lights for still photography than there are with strobes.

VIDEO LIGHTS COMPARED TO STROBES

Advantages of video lights
- What you see is what you get.
- Easy to assess the settings that you require using current light value.

Disadvantages of video lights
- Not nearly as powerful as strobes.
- Lack the range of a strobe.
- Bright lights frighten fish.
- Lights attract small animals (such as sea lice) in gloomy conditions.
- More delicate than strobes.
- Batteries drain more quickly.

POSITIONING THE LIGHTS OR STROBES

Every underwater photographer has his or her own idea about how to position their lighting. The most important thing to bear in mind is backscatter and, therefore, however you position your lighting you must ensure it is at an angle to the lens aperture. It is better if you position the light pointing slightly away from the subject. If you must point directly at the subject then move the light as far away from the lens as you can and point it towards your subject.

Whether you put your light above or alongside the camera housing will depend on what direction you want your light to hit the subject from. If you are using a single light, for most shots, the light is better suited above the camera so the light is coming down on the subject, but point the light slightly upwards. Shooting with a single light from one side or the other will create dark shadows on the blind side of the subject.

If you are shooting in wide-angle, and particularly if you are using a fisheye lens, it is vital that you keep the light behind the line of the dome or lens. If you are shooting macro or close-up, where you choose to place the light is dependent upon how you want to light your subject.

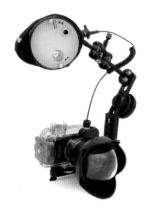

▶ Fig. 6.7
This image shows a camera and single strobe and demonstrates the standard positioning with a fisheye lens. It should be placed approximately one fist above the camera pointing 20 degrees upwards.

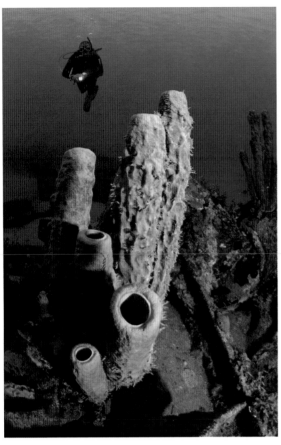

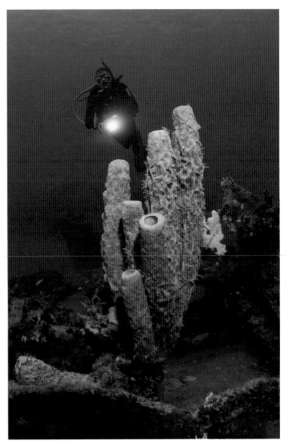

▲ Fig. 6.8a
This image demonstrates the wrong way to use lighting. The composition is nicely put together, but there is a dark shadow on the left which lets it down. In this shot the strobe on the left needs to be at around half the power of the strobe on the right, to balance the horizontal lighting.

▲ Fig. 6.8b
This demonstrates a better way to illuminate the subject by using far less power on the left-hand strobe.

▶ **Fig. 6.9**
An SLR in housing, with wide-angle dome port and two strobes. The strobes are behind the line of the dome port and angled away by a few degrees.

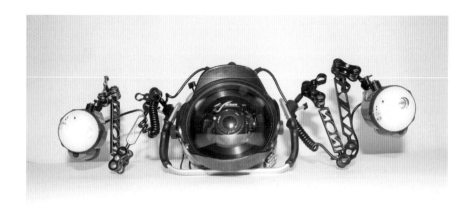

▶ **Fig. 6.10**
An SLR and housing with twin strobes set in their standard format for macro photography. The strobes are angled slightly away from the lens – a good way to have your equipment set up as a default. You will probably wish to move the strobes around to put the lighting where you want it for specific shots.

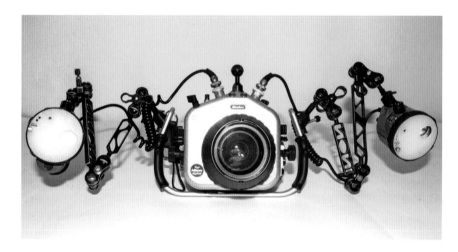

If you are using two lights, then it is possible to point both lights close to the subject, illuminating the foreground as well as the subject. If possible, put one light on half, or at least reduced power compared to the other strobe, so it is softening the shadows on the subject but still creating depth and perspective to your image. If you intend to use this technique, you need to ensure that the brighter light is illuminating the part of the subject you want to see, and the one on lower power is then going to be softening any shadow that may be created.

If you choose to use two lights, then you need to ask yourself if you would use two strobes or a strobe and video light or even two video lights. As most cameras are now producing high quality video, many photographers are choosing to use the video light option. But two lights are not always going to give you any better images. If you are a beginner, it is probably better to start with one light, especially if you have chosen a strobe light over video lighting. A third option is to use two strobes, set left and right, and a video light mounted above the camera. Many underwater photographers are now adopting this setup so they can use the video light for video work.

◀ Fig. 6.11
This image nicely
demonstrates how using
two strobes can balance the
lighting on the subject. The
dominant strobe is on the
right correctly illuminating
the subject, and the fins
on the left would be a dark
shadow if no light was
coming from that side. This
lionfish was taken in Dahab,
Egypt.
1/250; ƒ7.1; ISO 400.
Nikon D700, 16mm

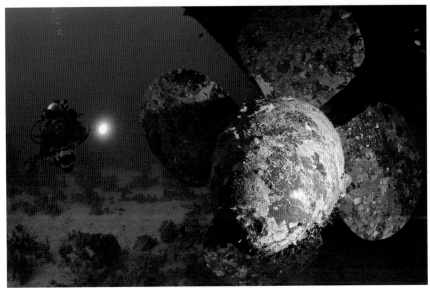

◀ Fig. 6.12
In this image the left-hand
strobe has either failed to fire
or is set at too low a value. It
creates an uneven balance to
the lighting across the whole
image.
1/80; ƒ9; ISO 400.
Nikon D700, 16mm

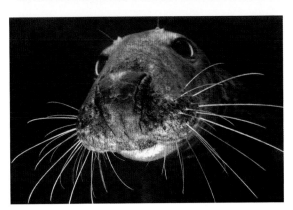

◀ Fig. 6.13
With a video light mounted
centrally above the lens, as
well as two strobes mounted
normally, the little bit of light
on the subject's head gives
an overall balance to the
lighting.
1/100; ƒ5.6; ISO 250.
Nikon D200, 10–17mm
at 12mm

▶ Fig. 6.14
Using articulated arms allows
you to put your light further
away from the lens, even
behind the subject to create
this backlighting effect.
1/160; ƒ16; ISO 500.
Nikon D700, 60mm

MOUNTING SYSTEMS

Flexi-arms

There are two kinds of arm system for mounting the
lighting. Flexi-arms are an easy and less expensive
way to mount your light compared to the articulated
arm and ball system, which are constructed from
several small cones pushed together to create a flex-
ible, normally plastic arm. This system tends to be
favoured by the compact user as it is light and easy
to use. However, flexi-arms can struggle to stay in
position with heavy more powerful strobes or lights.

Articulated Arm and Ball

The other option is articulated arms and balls joined
together with clamps. These use lightweight arms
with balls on either end that can be secured together
using a clamp. While slightly heavier than the flexi-
arm system, articulated arms can give greater reach
and flexibility. They are slightly more cumbersome
to use, but the greater length makes them more
compatible for use with creative lighting. When
using several arms, as you would for some creative

▶ Fig. 6.15
A camera housing with a
flexi-arm for mounting the
lighting.

effects, for normal use the arms can easily be folded
in toward the camera housing.

SOME TECHNIQUES

Different styles of photography from the various
ways of capturing and presenting images is dealt
with in the relevant chapters later in the book.
However, listed below are a few ideas for using
artificial light to create the effect that you may want

to portray. These ideas are far from comprehensive, but as you work your way through the book, you will find lots of ideas in the chapters on composition, animal behaviour and wreck photography.

Remote Lighting

Once you have mastered the art of using artificial light, and for those who have already done so, remote lighting can provide some stunning images; the light will bring out the vibrant colours that exist in the water. This involves setting up your lights or strobes around your subject before you take the shot and then backing away to compose the shot with the lights illuminating the subject. This method can really help to reduce any backscatter as the lighting is from a different angle to the subject than the camera lens is. Using a constant light source allows you to see where the light is going to fall before you take the shot, and while this is an advantage the power given out by a video light is insufficient for any shot over one or two metres away.

Triggering the strobe can be difficult, as most inbuilt light sensors and proprietary light triggers work on light differential. In a dark environment the photographer can be five or six metres away and the strobe will still fire, but in clear water in a sunny environment that distance is greatly reduced. There are several manufacturers producing light triggers, but currently these are all fired using a sync cord connection to the strobe. This allows the light sensitive trigger to be placed a metre or so (depending on the length of the sync cord) closer to the photographer and hence the flash. Attaching a light trigger to your strobe is not always necessary as many of the light sensors on modern strobes are very sensitive. The results can be amazing and can create some spooky effects, particularly on wrecks.

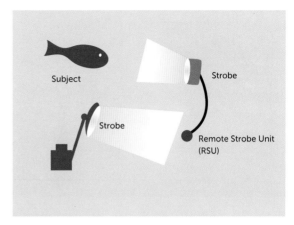

▲ Fig. 6.16
Diagram to show how to use a Remote Strobe Unit (RSU) to initiate the firing of a strobe that is not connected to the camera.

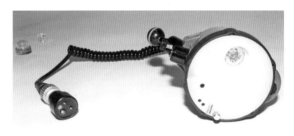

▲ Fig. 6.17
A remote light triggering units connected to a sync cord. The sync cord is then connected to a strobe which can be placed remotely to enhance the lighting in your image.

▲ Fig. 6.18
This image shows how remotely fired set of lights can be used to create different lighting effects under water. Several strobes have been placed inside the wheelhouse of a fishing vessel and the sensor has been placed just outside the windows of the wheelhouse so it can pick up the flash from the strobe the photographer is using. 1/160; f10; ISO 200. Nikon D700, 16mm

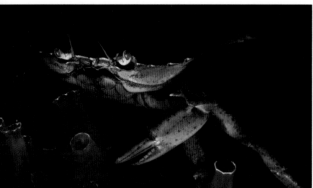

▲ Fig. 6.19
This image was taken on Halloween 2012 using only the light from a narrow beamed torch/flashlight. By metering solely for the light on the subject it is very easy to create a spooky effect with everything else blacked out.
1/125; ƒ16; ISO 320. Nikon D700, 60mm

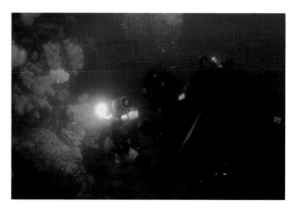

▲ Fig. 6.20
This image was taken in the Eyemouth, Scotland when the visibility was less than 3m. Backscatter has been reduced to a minimum by firing the strobes away from the camera on a very low power, and the light sensor cover on the photographer in the image has been removed to detect the light from my strobes. When his strobes fire, they illuminate the orange anemones on the reef.

Snoots

A snoot is a tube that is attached to a strobe or a light so that it directs the light into a small beam rather than diffusing it. The tube will normally have a reflective surface on the inside so the light is not absorbed by the device. Snoots are a great way to focus a small beam of light onto your subject and leave everything around it dark or black. They are predominantly used in macro photography, as a strobe snoot is quite difficult to line up on the subject.

If you are going to try to use a snoot on your strobes, it is advisable to mount the strobes onto tripods, which will allow you to line up the light before you take the shot although this is not necessarily suitable if you are working with mobile subjects. It is far easier to use a narrow beam constant light source although your exposure settings will have to be a lot higher.

▲ Fig. 6.21
The manatee has been illuminated by another photographer's strobes being fired remotely, due to their light sensors picking up the low powered light from the camera taking the shot. The glow from the dome port creates a 'street light' effect.
1/160; ƒ7.1; ISO 400. Nikon D700, 16mm

Model Lights

While model lights have been covered in Chapter 7, one aspect not mentioned is to use the light from your model to illuminate your subject. Using a model requires communication which tends to be a little more complicated under water than on the surface. If you know the shot you want to take

and how you want to take it, discuss this with your model and ensure that your model understands your image. The shot may work even better if you turn off your own lighting and just use the light from the model. This does, however, require the model to carry a light of sufficient power to achieve your desired image. Another way to use the model's lights is to use their strobes to illuminate a subject. By using your model's own strobe light sensors, set your

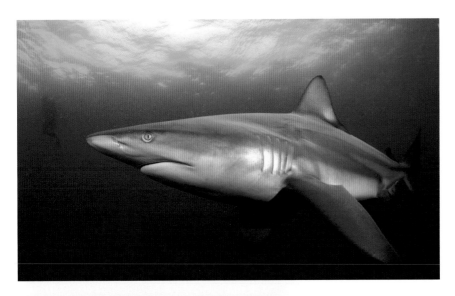

◀ Fig. 6.22
This is a balanced light image and shows how natural light has illuminated the surface giving perspective to the image, whilst the two strobes have lit the shark as it sweeps past in front of the photographer. A high ISO has been used on the shot to allow the strobes to be turned down to avoid any reflection from the light colour of the black tipped shark.
1/250; ƒ11; ISO 1600. Nikon D700, 16mm

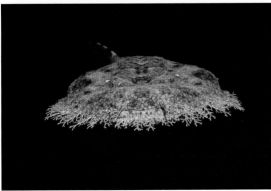

▲ Fig. 6.23
The tasselled wobbegong was illuminated with twin strobes on low power. The high shutter speed and high aperture created a black background and a large DOF.
1/250; ƒ18; ISO 400. Nikon D700, 60mm

close-up, wide-angle, except it involves using a much lower flash setting for the foreground. Set the exposure for the background and with minimal light on your subject in the foreground the shot should appear beautifully balanced.

Using artificial light to create your underwater images will help restore colour and can give a feeling of depth and perspective to your image by careful use of soft or harsh shadows, depending upon the effect you wish to portray. While using natural light and careful white balancing in relatively shallow water will allow you to portray stunning and realistic images, adding a bit of light will usually enhance the final result. This is, of course, not always the case and it is you, the photographer who must decide how you want to present the scene that you can see before you.

This chapter has covered several different techniques and offered a few ideas to vary the way in which you put the light onto the subject. It is only by practising, experimenting and playing with your lighting that you will understand how to get the image you want, from the equipment you have.

own strobes to a suitable power setting, and when they fire that should trigger your model's strobes and that will illuminate the main subject.

Balanced Lighting

The technique of balanced lighting, as its name implies, uses artificial lighting to illuminate the foreground while using natural light to illuminate the background. It is a very similar technique to

Chapter 7

Composition

Anyone can take a photograph – a two-year-old toddler with a camera can snap a picture – but of course, there is a lot more to creating great images than pressing the shutter release. Earlier chapters discussed the technical aspects of capturing images, and how to use light. The exposure triangle looked at how aperture (f-stop), shutter speed and ISO all interact to allow the required amount of light, your desired exposure value, to the sensor. The technical part of capturing the image certainly has more than a small element of artistry in how your subject is presented. Changing the f-stop will create greater or lesser depth of field, and the slowing down of the shutter speed may allow for selective blurring or darkening of the background.

However composition is pure art; there is very little technical ability in the framing the subject. When you raise the viewfinder to your eye, or you look at the screen on the back of your camera, you should be thinking about how you want to frame the situation that you can see in front of you. If you have got all of the technical aspects set correctly, like shutter speed, ISO and f-stop, then what you really need to consider now is how you are going to compose the subject in front of you; how are you going to make your picture?

Remember, when you squeeze the trigger, you have chosen your own settings, you have composed the image as you want to present it so you are not

> If a photograph is to communicate its subject in all its intensity, the relationship of form must be rigorously established. Photography implies the recognition of a rhythm in the world of real things. What the eye does is to find and focus on the particular subject within the mass of reality; what the camera does is simply to register upon film the decision made by the eye.
>
> – Henri Cartier-Bresson

just taking the picture, you are making it. For example, many underwater photographers in particular seem to forget that you can take a photograph in portrait, not just landscape. Be prepared to rotate the camera into the vertical position and look at your framing on the screen or through the viewfinder. What is in the background? Is it messy, does it need blurring, or do you need to use any curves or angles to provide a natural frame for your shot? Remember also, if you are using artificial lighting that you will need to adjust this too. This chapter will be looking at many different ways of capturing images under water. The basic guidelines will apply to all photographs, but the way you will need to frame a close-up wide-angle shot will of course be quite different compared to a macro or close-up shot.

As you will see, the first move to composing or framing your shot is to decide what the subject is. You need to decide on a single focal point – something or someone you want to draw the viewer's eye towards. There really is no point in having several interesting subjects in the composition as this will only confuse the viewer. This, of course, does not

◄ Fig. 7.1
A classic picture of wide-angle balanced lighting. The subject of the picture, the sponge, is reaching out from the whole of the ship like a hand to envelop the diver in the background as he approaches; the diver is carrying a torch and provides depth and balance to the overall composition.
1/60; f11; ISO 200. Nikon D700, 16mm

▲ Fig. 7.3
This nudibranch, from Bali, Indonesia, was caught in open water falling from one level of the reef to another. The camera was already in the correct settings for this shot, having been taking images using black background techniques when the nudibranch appeared. Had it been in its natural environment it would have been grazing on a photographically messy reef, but because it had fallen and was in mid-water, it creates a really bright and stunning image.
1/250; ƒ14; ISO 250. Nikon D700, 60mm

▲ Fig. 7.2
A good example of how and when to take a picture of an animal in its environment. The pygmy seahorse is hiding in the sea fan; under normal circumstances if it had been disturbed the red open polyps you can see in the picture would be closed. This photograph was taken using a lot of patience to slowly approach the subject, and as a result of this careful approach, the sea fan did not react to my presence. Without the pygmy seahorse in the sea fan – its environment – the image would not show the story.
1/250; ƒ25; ISO 500. Nikon D700, 60mm

distracts the eye away from the subject needs to be eliminated. The negative space you use in an image can be as important, sometimes it can be more so, as your subject. How you see and use this space when composing your picture will define the result. Of course, your subject does not have to be in negative space. There will be many occasions when you want to put your subject in its environment. A common, but often successful, use of this technique is the anemone fish protecting or guarding its host anemone, or a pigmy seahorse in its sea fan.

mean you can only photograph one subject, but that you should make one individual or one group of individuals the centre of attention – your subject.

In addition to this, it does not have to be at the centre of your framing, but the idea is to lead the viewer's eye-line towards it. This is where the use of negative space becomes important. You can imagine negative space as anything that is in the image that is not the subject. You may capture a fantastic image of, say, a cuttlefish in aggressive mode attacking it's reflection in your lens, but if the background is messy or interfering with the shot, then the photograph will not work. Anything that

CLASSIC GUIDELINES

There are many rules when it comes to composing an image. These rules, however, should be seen as guidelines; some of the best pictures can break all the rules.

Rule of Thirds
When framing your composition one key component to consider is the rule of thirds. As in all photography you should not be driven by rules, but

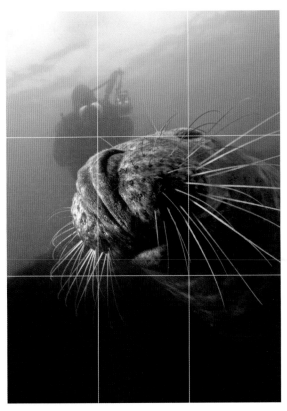

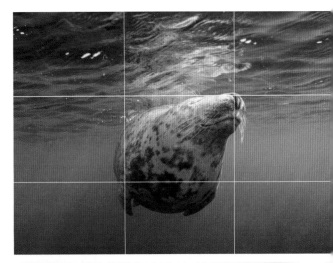

▲ Fig. 7.5
This image also demonstrates the use of the rule of thirds; the subject has been lined up to sit the nose at the point of intersection. 1/125; ƒ14; ISO 800. Sony NEX-5, 16mm

▲ Fig. 7.4
This image demonstrates how using the rule of thirds can create a really good composition; note that the eye lies directly on the cross. It was taken on Puffin Island, Anglesey, North Wales. 1/125; ƒ11; ISO 800. Nikon D200, Tokina 10–17mm at 10mm

steered by guidelines. Divide your frame into nine equal sections and decide how you would want to frame your subject. Most cameras have a grid over-lay on the screen, which you can switch on or off, and there are many people who leave this grid on permanently. It can be very helpful as it may assist you in composing your image in a variety of ways.

Firstly, you should look at the four centre crosses where the lines intersect. Rather than putting the centre of interest of your subject right in the middle of the frame, theoretically the overall effect works much better if it is offset slightly. Putting your subject in the centre of the frame is known as bulls-eying and is one of the first reasons that it can be rejected in photography competitions. As you can see Figs 7.4 and 7.5, if you put the eye or

the nose of the subject on one of these points, then most probably the image will work much better. All photography is subjective, but be aware of the rule of thirds and perhaps try both positions. Of course, it need not necessarily be the eye or the nose; the concept of using the crossed grids is to give you, the photographer a reference in which to frame your subject.

The rule of thirds is not a new technique, by any means either. Famous painters have been using the rule of thirds for centuries, and if you were to look at some of the paintings by the past masters, and mentally overlay the rule of thirds grid, then you will see that the artist has put his focal point on one of the intersections.

Another way to view rule of thirds is to look at the horizontal divisions; for example, the top third could be used as negative space, the subject is placed across the middle and the supporting baseline runs along the bottom. This technique is particularly useful when photographing subjects such as un-derwater landscapes, as you can use the foreground as a supporting baseline, the reef or wall along the centre, and the top third would be negative space with possibly the subject hanging in mid-water.

▶ Fig. 7.6
This colourful image of a
lionfish, taken in Zanzibar,
shows how to use the
horizontal sectoring of the
rule of thirds. Whilst it also
incorporates a diagonal,
essentially the lower third
of the photo is the reef, the
upper third is negative space
and the subject, the lionfish,
is hanging in the middle.
1/125; ƒ9; ISO 200.
Nikon D200, Tokina
10–17mm at 12mm

Baseline

A major component to consider when composing
your picture is the baseline. This is the part of the
picture that supports the subject. Even if you bokeh
or black out your background, you need to put the
base of your subject into some sort of perspective.
Using a baseline in underwater photography is
particularly important as many of the subjects you
will photograph may not be everyday subjects to the
person viewing the image. You may choose to show
your images to friends and family who may not
even be divers.

 You need to present your subject in its environ-
ment to a greater or lesser degree. It is not dissimilar
to photographing above land; if you take a photo-
graph of a group, then chopping off everyone's feet
normally tends to ruin the image. This is very much
the case under water – try to get the whole image
in frame. This cannot always be done as you may
be using a lens with the wrong focal length for the
subject, and changing lenses under water is not
possible. However, if you try and change the angle
you are shooting from, you may be able to bring the
whole subject into frame.

As you can see from Fig. 7.7, getting the baseline
set correctly is important. In the first frame there is
too much negative space both in the foreground
and the background. The subject is obvious, but the
image as a whole is not pleasing because the subject
is lost in its environment.

 The second frame is about right (there is no ab-
solute) and it pulls the subject into its environment
without too much wasted space. It can also create a
sense of perspective and scale which can be lost if
you zoom in too far.

 In the third frame the subject's environment is
lost altogether, and while the individual's detail is
clearer because you have magnified it, the overall
effect is more of an identification shot that you may
find in an underwater fish guide than a pleasing
underwater image.

▲ Fig. 7.7a
Whilst the subject of this image is pleasing, there is too much
foreground at the bottom of the image frame so the subject is lost.

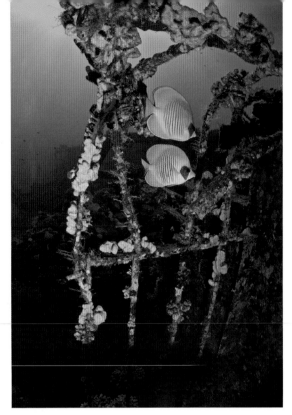

▲ Fig. 7.7b
The butterfly fish are shown in their environment, the wreck of the
Salem Express in Egypt. There is neither too much, nor too little of
the habitat in the shot.

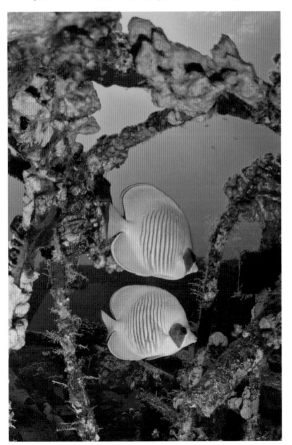

◀ Fig. 7.7c
This is now too tightly cropped in on the pair of fish. You cannot
really get a feel for the environment around them, and whilst nicely
framed, the background is all a bit messy. However, I should stress
that this is all subjective and some people will prefer this image to
the previous two.

▶ Fig. 7.8
The Rhinocrab in this shot was taken in Manado in Indonesia off one of the many walls at the depth of about 24m. The shot has been taken pointing out into the blue where it is dark and therefore easy to make the image stand out. In theory the natural angle from bottom left to top right provides the most pleasing angle to the eye.
1/80; ƒ18; ISO 250.
Nikon D200, 60mm

▶ Fig. 7.9
This image is a great demonstration of how to rotate the camera to create a diagonal. You can see by the angle of the surface of the camera that it has been rotated by about 45 degrees to the right. In terms of composition, this is also a demonstration of how curves can enhance an image.
1/125; ƒ5.6; ISO 200.
Nikon D200, Tokina 10–17mm at 10mm

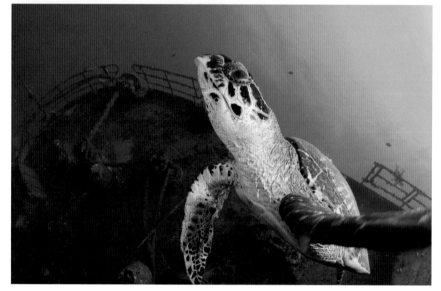

Diagonals

Another useful technique is to use, or create, a diagonal. Straight lines are really unusual under water unless you are in or around a man-made environment. Horizontal and vertical lines can split your picture into portions, causing the viewer to lose sight of their subject. Using diagonal lines can change the whole perspective of the picture and

it is often very easy to do this by simply rotating the camera through 45 degrees. If you are rotating the camera yourself, be careful of how the water's surface is portrayed – if the surface is at an unusual angle it can disorientate the viewer and this may lead to them taking an immediate dislike to your image. The idea of using diagonals is to lead the viewer's eye through the picture, giving the illusion of depth and perspective.

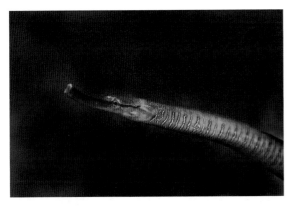

Fig. 7.10
This pipefish was taken at Trefor pier in North Wales and shows how using a small depth of field with a long thin creature can create an almost 3D effect. It was taken with a full-frame digital SLR where ƒ9, which was used for this image, still gives a small depth of field compared to a half-frame SLR, a mirrorless camera or a compact. 1/100; ƒ9; ISO 800. Nikon D700, 105mm

Fig. 7.11
Whilst this image does not have a particularly interesting subject, I have included it to show the technique of rotating the camera while shooting on a low shutter speed. The flashguns capture the subject in focus because it is close up. However the background reflects the rotation of the camera.
1/25; ƒ8; ISO 100. Nikon D200, 10–177mm at 10mm

For some reason, the diagonal from bottom left to top right tends to be the way most people like to see composition. It could be that this is because most cultures read from left to right; however, not all languages follow this format. On land, an un-level horizon is frowned upon, but under water you can be more creative. Feel free to rotate and move your camera, and remember that the angle should be determined by how you wish to compose your shot. If you can fill the frame from the bottom left to the top right, for example, focusing on a feature while using a small depth of field for the rest, then you can create an effect that looks almost three-dimensional. This technique works really well with a long thin creature such as a pipefish or a cornetfish, which tends to draw the viewer's eye along its shape.

SOME ALTERNATIVE SHOTS

Rotated Camera Shot

An interesting, though very different kind of composition is to take a rotated camera shot. This shot tends to work better, though not exclusively, with a wide-angle lens. You will need to use strobe lighting and set the shutter speed to something low – around half a second. Line yourself up on the subject, rotate the camera and press the shutter. It may take you several attempts to get it right, but even the simplest subject can become an interesting image.

Curves

Another move away from straight lines is, of course, curves. Curved lines are far more appealing to an artist's eye than straight lines. Think of how a winding road or the bend along the shoreline can lead

▶ Fig. 7.12
The curve of the diver is
complemented by the curve
of the wheel from a wreck in
the Red Sea.
1/100; *f*14; ISO 400.
Nikon D700, 16mm

▶ Fig. 7.13
A simple shot demonstrating
how this effect can create
a really clear view to show
what is above the surface.
1/125, *f*9, ISO 200.
Nikon D200, 10–17mm
at 12mm

your eye and your view towards the subject. Under water, curves can be used to a similar effect. Curves and bending lines can be found naturally or you can always introduce them yourself by using wide-angle and fisheye lenses. A great way to incorporate curves into your image is to use the curve as a frame on your subject. Most fish have a curved shape, either side on or from the front, and if there is a curved arch behind the fish, try to get the arch or curved line to mimic the shape of the fish. There are so many other great examples of curves under water. Giant clams have beautiful sinusoidal edges and several circular holes that they use to siphon their food through and these make really good general or abstract shots.

The best example of an underwater curve is probably Snell's window, which is created by refraction of the light's transition from air to water. In order to be able to see this effect, you will need to aim a wide-angle lens, preferably a fisheye, upwards towards the surface so you can see directly through the circle, or part-circle, as if it were a window. With good visibility, flat surface and sunshine the effects can be stunning.

Abstracts

There can be times, hopefully not too often, when you find yourself on a dive where there really is very little to photograph. If you have an SLR or mirrorless camera, then possibly you have taken the wrong lens. Abstract photography can come in useful at such a time, and it can also be lots of fun, even if you are not forced into it.

Underwater abstracts usually involve getting very close to a subject and filling the frame with just one small area such as eyes, teeth or scales. Nearly all abstract images are taken close-up with a macro lens and using a dioptre or close-up lens. This can allow you to get really close in and focus right into the subject. These images make excellent pictures to hang on your wall as a print in acrylic or canvas, especially if your partner is not quite as keen on the underwater world as you are.

Next time you are on a mooring or shot line carrying out a 5m (15ft) three minute safety stop, refocus your eyes and look at the tiny stuff that is drifting towards you in the water. These can be amazing images, and shooting into the light can highlight the outline of these weird and wonderful creatures. On another occasion you may be carrying out a safety stop on a wall – this is definitely a great time to look ahead, stabilize your depth, peer into the reef and look for the really small stuff. You may be amazed at what you see there.

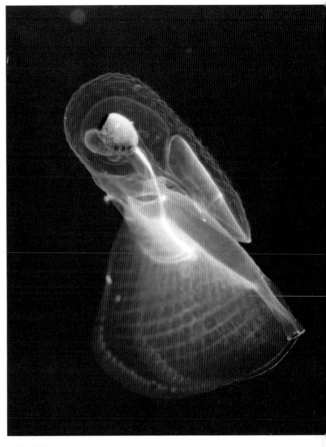

▲ Fig. 7.14
This image was taken on a safety stop in Indonesia. I had turned my strobes off and was looking at the zooplankton drifting towards me in the current. The sun was almost directly overhead but slightly in front of me, which helped pick out the outline of this tiny creature. 1/200; f10; ISO 200. Nikon D700, 105mm

MODELS

If you are photographing an underwater landscape, especially if you are using wide-angle, then a model, correctly placed and posed, will add immense value to your image.

A diver in the shot will add scale and perspective to your composition, and if you hope to get any of your photographs published in a dive magazine, then a diver in shot is virtually essential. However, just having a diver in the shot does not guarantee a better picture; position and pose are vital. It certainly

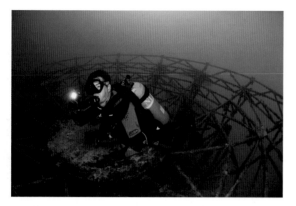

▲ Fig. 7.15
The diver in this shot is the subject, with the radar array providing the background. The wreck of the USS *Vandenberg* in Florida has three such arrays.
1/125; ƒ6.3; ISO 200. Nikon D700, 16mm

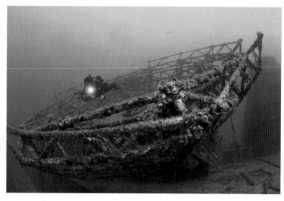

▲ Fig. 7.16
Conversely, it is the radar array that is the subject of this image, with the diver providing complementary balance.
1/125; ƒ10; ISO 640. Nikon D800, 16mm

helps if your dive buddy is willing to model for you.

It is, however, important that you talk to your model beforehand and tell them exactly what you want from them. Discuss the signals that you intend to use for movement up, down, across, rotate and so on. Using a slate can work too, but generally, pre-dive discussions and underwater signals are much easier. A really good tip when using a model is to make sure that they keep their legs together for the shot. A diver with their fins all over the place does not make a pleasing image. One factor that is often overlooked is the bubbles that are caused by breath-ing. Discuss breathing with your model before you go diving and make sure that you either have signals so your model knows when you are about to take a picture, or during the posing get your model to breathe at the same time as you do – synchronized breathing.

It is really important that the model you use looks streamlined. They do not need to have the shape of a supermodel, but streamlining is important if you want your final product to look good. Get your model to de-clutter, removing any of the equipment that they do not need and making sure that anything essential is clipped tightly to the body. If your shots are going to involve any close-up or facial shots, the mask can make or break the picture. The mask should be clear with no fogging; there should be no water around the nose, and a single lens mask for your model normally works best. If you can find a retro, oval mask, then they work really well.

If the model you are using is your buddy, remember to stay close. Your buddy needs to have as good buoyancy as you do, as moving arms around will frighten the fish away and excessive finning would just kick up the surface. Ask your buddy to hover half a metre above your own level; they can always come down if you need them to and they are less likely to disturb the seabed.

If you have a buddy who is prepared to model for you and can free dive as well, then if they are willing, make sure you shoot photographs of them during this activity. Discuss the poses that you would like your buddy to move into and make sure you have a slate with you so you can direct the next few shots. Get your buddy to play while they are free diving; follow their action and take as many shots as you can as they somersault and roll through the water. If they will free dive without a mask and snorkel and keeping their eyes open, then you really should consider paying them. If you are photographing somebody playing in the water it is very easy to find that you are shooting into the sun without real-izing it; be aware of this. If you have metered your

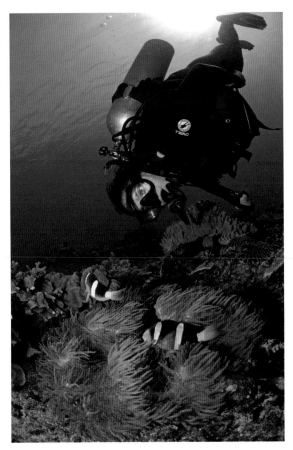

▲ Fig. 7.18
At the Canyon, in Dahab, on the Gulf of Aqaba, bubbles from divers in the cavern below seep up through the porous substrate to create a curtain which makes an excellent backdrop for an image. 1/250; ƒ10; ISO 400. Nikon D700, 16mm

▲ Fig. 7.17
This image demonstrates many of the points made in the chapter about using models. The model has a clear mask, eyes are looking at a point of interest and the arms and legs are not flailing around. You will also see there are no bubbles interfering with the shot. 1/250; ƒ13; ISO 400. Nikon D700, 16mm

exposure for the sun, then the silhouettes of a free diver playing should look really good.

Another great use of the diver is to use their lights to illuminate a subject. You can do this in two ways: you can simply use their own torch focused on something interesting, or else you can ask them to set their strobes to slave and when your own flash fires you should capture the scene that their strobes have illuminated.

If you want the diver to be the focus of the shot, then get them to hover in front of you, ideally, head-on or 30 degrees off centre with the light pointing just off-line of the camera. A side-on profile can

work too, but the rear end of a diver or creature very rarely makes a good picture. This is perhaps the nearest thing to a rule, rather than a guideline in underwater photography.

BACKGROUND

As discussed in the baseline paragraph, the background is a vital part of the composition. In some situations it can be really important that the environment your subject is in is portrayed, and this would normally be done when using wide-angle or a standard lens. If you have a macro lens and you are looking for the very small stuff, then very often you will be trying to frame so tightly there will be very little environment to see.

However, it is vital that you think about the background as you are composing your shot. Look at the background – what is behind your subject and is it distracting? Do you want to lose the background or do you want to use it? If you zoom in, get closer or use a longer lens, then this will isolate the subject and reduce the amount of background. It could be that you simply need to just get into a lower angle

and shoot up at the subject using clear water behind to create a neutral background.

In macro, the background can be portrayed in several ways. If you want to make your subject really stand out, then you can either use a bokeh technique or a black background, as discussed in Chapter 1. Bokeh, or the blurring of the background, is created using a very small depth of field (low *f*-stop). Be careful though, as it is easy to become obsessed with blurring or blacking out the background, and this does not necessarily work on every image. Sometimes, it is really important to balance the photograph, and while, in some instances, the reef can make a particularly messy image, it may also give depth and perspective to your subject. This is a balance, and it will be a decision that you will need to make at the time.

Do not be afraid to take several shots, changing your exposure or lighting to see the different effects. The best way to learn is to make mistakes, but if you can make your mistake and capture that special shot on the same dive, you will, hopefully, learn more quickly. Taking multiple images at different exposure values is called bracketing. This was a very common practice when using film cameras under water, as the opportunity to review your image was only possible once the film had been developed, some time after the dive. Many cameras have a bracketing facility, and if you select the bracketing mode the camera will take either three or five shots either side of your selected exposure value.

A dark/black background is more difficult, but can be very effective with the right subject. To create this effect, you will need some form of artificial lighting. The picture below was taken with the strobes set at a really low value; the *f*-stop is high (small aperture) and shutter speed is normally at the camera's highest sync speed (the fastest speed at which the shutter can synchronize with the flash).

It may take a few adjustments, as all camera/ strobe setups vary. The idea is that, without artificial light, the picture would be a black screen, and by

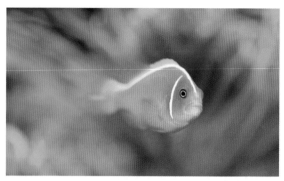

▲ **Fig. 7.19**
This image was taken in a really low depth of field, especially for a full-frame SLR. The only part that is in focus is the eye of the skunk anemone fish; everything else bokehs out fairly swiftly into a total blur of pastel background.
1/160; *f*9; ISO 400. Nikon D700, 105mm

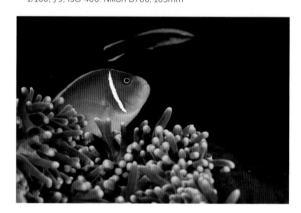

▲ **Fig. 7.20**
This image was taken in Ambon in Indonesia with the strobes set on low power to just illuminate the anemone and the two fish. The light on the wrasse and the background was a bit of an accident; there was just enough light to pick out the translucent part of the fish, but the overall effect seems to be quite pleasing.
1/125; *f*13; ISO 500. Nikon D700, 60mm

stroking the subject with a touch of light, just sufficiently to illuminate it, you will get the desired effect. If you do not have a strobe, then using a constant light source can give a similar result.

Another useful technique with a constant light source is to create a small circle of light on the subject, which can create some spooky effects. This can be done with a standard flashlight as long as it has a narrow beam, and a similar technique can be used with a strobe which has a snoot attached to it. A snoot is a shroud that fits over the end of the light source and directs the light into a small circle

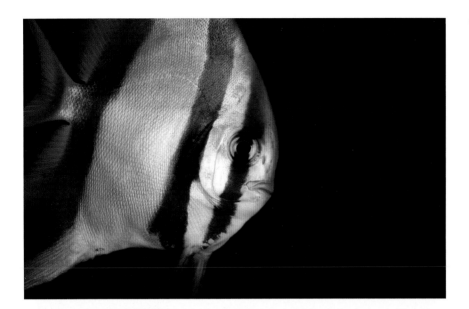

Fig. 7.21
A portrait shot of a batfish
taken using a fast shutter
speed, a high ƒ-stop and a
constant light source, which
meant the lighting was not
overpowering. Since the
fish has a silvery, reflective
surface too much light would
have reflected off the fish and
destroyed the image. The
batfish was swimming around
in front of a messy reef
background, so using this
technique not only correctly
exposed the fish but lost the
messy background.
1/200; ƒ20; ISO 400.
Nikon D700, 60mm

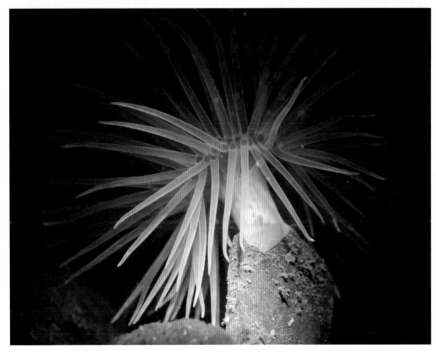

Fig. 7.22
With a narrow beamed
flashlight it is possible to
expose a very small circle of
the image.
1/100; ƒ10; ISO 320.
Nikon D700, 60mm

rather than diffusing it. This directs the flash onto
the subject, but it is difficult to make sure it hits the
subject at the right point. Using a narrow beam of
light is a lot easier, and while a constant source light
cannot provide the intensity of a strobe, it is much
easier to get right.

If the subject is stationary or slow-moving then
you may wish to consider using a tripod. You could
either fix the light/strobe to the tripod and line up
your lighting on the subject, or the whole camera
and light system can be mounted on the tripod. The
advantage of mounting the strobe on the tripod is
that there is greater flexibility on where you want
your light to come in from.

WIDE-ANGLE

Composing a shot with a wide-angle lens requires a completely different skill set than using a macro lens. Often, the subject is very large and you need to decide how much or what part of the subject you want to put in-frame. Also, the relative sizes of your subjects become distorted. Anything which is really close to the lens will appear to be much larger and closer than objects just a short distance away. The image can appear to distort the subject, and it is very easy for you to change the relative sizes of the creatures or the divers under water. If you are doing this deliberately and you get it right it works well, but if you do not see it when you are framing your subject it may not work at all.

Another feature of using a wide-angle lens is the increased depth of field that it offers. The wider the lens, the greater will be the depth of field. This effect affords you the opportunity to put the subject close-up and in focus, while everything in the background – its environment – is in focus too.

Above all, the secret of good wide-angle photography is to get close to your subject. Because a wide-angle lens makes everything appear further away, it is important that you do get close, really close. If you are shooting with strobes, you need to make sure the light is not directly interfering with your shot. It is also important to make sure that your strobes are not actually in shot. While this may seem obvious, it is not unusual that during the dive your strobes move without you noticing. It can also be quite difficult to get your lighting on the close-up subject if you are using a dome port, as this may mask your light.

Landscape Wide-Angle

When shooting underwater landscapes, it is imperative that you have a subject within the overall landscape. An underwater image of the most beautiful coral will look flat and uninspiring if there is nothing

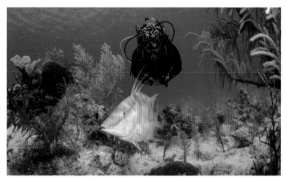

▲ Fig. 7.23
This image was taken with a wide-angle lens using a mirrorless camera in Grand Turk. With wide-angle lenses it is quite easy to get a good depth of field, and the hog fish in the middle of the image creates a colourful centrepiece.
1/100; ƒ8; ISO 200. Sony NEX-5, 16mm

to draw the eye. This can be a marine creature, a diver or even a particular piece of coral or sponge within the reef. If you have sufficient light to illuminate the subject then this can lead the viewer's eye to where you intend it, and the beautiful background can enhance the overall effect of the image.

If you are photographing in wide-angle with no form of artificial lighting, or the subject is too far away to reach with the light, then try to place the subject in a neutral environment (negative space). This way the background is not going to envelop your subject and you are drawing the viewer's eye to where you want it.

Wide-angle photography is a specific art, but you can still follow guidelines that use set formulae to compose your image. However, most of it will come with practice. If you have found something to photograph and the background is good, take as many photographs as you can from different angles – up and down, left and right. If you have over thirty photographs of the same subject from different positions, you will be able to see what works best for you when you review these on your computer screen post dive. Taking numerous photographs from different angles and positions does not have to be unique to wide-angle photography – you should do the same with macro unless, of course, you are causing stress to the animal you are photographing.

Close-Up Wide-Angle

Close-up wide-angle, as the name suggests, is getting very close to your subject, and while focusing on it there should be a secondary subject in the background. Very often this can be a diver, a boat or a shoal of fish. These images are usually quite dramatic and powerful. One of the reasons this kind of photography works is the large depth of field the photographer gets with a wide-angle lens. The best close-up wide-angle shots usually involve balancing the light. You will need to select the right exposure to illuminate the subject in the foreground while still being able to clearly see your background. Even with the high depth of field a wide-angle lens affords, you may still need to use a high f-stop to gain the depth of field for the shot.

Eye Contact

The final point to consider when composing your image, assuming your subject is an animal, is eye contact. Getting in really close to many animals underwater can be difficult as they move. Marine animals will allow a certain approach distance, but after that they are gone. Most creatures rely on movement as an indicator to whether or not they are about to be lunch.

Try approaching your subject really slowly and watch its reaction. As you get closer, the subject will normally show signs of concern and you will be able to see that they are becoming agitated. Stop! Back off a few inches and wait. Good buoyancy is essential here, do not look directly at your subject, as making immediate eye contact only tells the critter that you are going to eat it. Look at your screen or through the eyepiece and you will see the subject becomes more relaxed. After a short while you can slowly move forward a tiny bit more, slowly, slowly until the subject again shows concern. You may be able

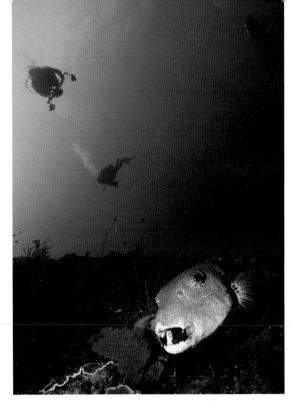

▲ Fig. 7.24
This close-up wide-angle example was taken in Bali in Indonesia. It requires a wide-angle lens that can focus really close-up to a subject so that the whole image is in focus. It was taken with a half-frame digital SLR and a Tokina 10–17mm wide-angle zoom lens. Lighting is focused entirely on the subject at the front with the rest of the image balancing the shot.
1/200, f8, ISO 200. Nikon D200, 10–17mm at 10mm

▶ Fig. 7.25
This shows the subject, a trout, with one eye in vision. It was taken at Jackdaw Quarry in Lancashire.
1/160; f10; ISO 400. Nikon D700, 16mm

▶ Fig. 7.26
In this image, one eye is looking directly at the camera and the other is only partially visible, which creates an unbalanced feel; the whole image appears to be leaning to the left. The image itself demonstrates a really good use of DOF.
1/320; ƒ3.2; ISO 200.
Nikon D700, 60mm

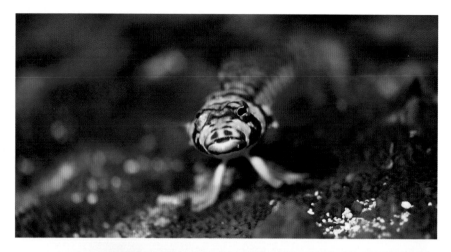

▶ Fig. 7.27
Here both eyes are visible and looking directly at the photographer. Moray eels make good subjects for practising this technique.
1/100; ƒ10; ISO 200.
Nikon D200, 60mm

to do this over several cycles and get really close-up, but it does not always work, and sometimes you will be disappointed. It depends upon the subject, and sometimes the time of day. Southern stingrays, for example, generally become much easier to approach after midday.

Once you have got as close as you possibly can, you need to capture the eye or the eyes of the animal. Try to get both eyes in your composition; however if you cannot line up the shot to get both eyes, then you should just get one. The point is this: one eye or two eyes, not one and a half. If you cannot get both eyes completely in your shot, then just get one. If you can take your shot at eye-level as well, then you have really nailed it. Again, this is not a rule, but a guideline that is well worth following.

CROPPING

With the high pixel count of most modern cameras, it is becoming increasingly simple to compose your picture post dive in the editing room, by cropping. The guidelines listed in this Chapter can easily be transposed into the editing suite. However, getting

the shot right under water the first time is not only more satisfying, but you must bear in mind that any cropping that needs to be done will reduce the resolution of your image. It is always better to seize the moment, at the moment, than to try to recapture it later. Despite this, sometimes you will find you have taken a great image of the subject but the background is doing it no favours at all. To remedy this, close crop and fill the frame with your subject so as much of the background as possible is removed.

Keep in mind, whether composing or cropping, that it is generally accepted by underwater photographers that the fish should have space to swim into, so you should endeavour to leave a small space in front of the subject, especially an animate one.

▲ Fig. 7.28
Sometimes the subject may be a little too small for the lens you are using. Get as close in as you can and focus very carefully on the subject. If you have captured it well enough, you should be able to crop in a little in Photoshop.
1/250; ƒ20; ISO 200. Nikon D200, 60mm

SAFETY

It can be daunting to compose the shot while trying to make sure that you have the ƒ-stop, shutter speed and lighting all set to what you want as you squeeze the shutter. Until it becomes second nature this process can take some serious multi-tasking. However, the more comfortable you are as a diver, the more likely you are to get everything right the first time. If you can hover without it being a distraction and without breaking or touching any coral, then you can focus on your photography. If you cannot do this, then you need to ask yourself whether you are really ready to take a camera with you, when you descend underwater. If you feel you have to concentrate really hard on your buoyancy while you are trying to take a photograph, then you probably need to practise your buoyancy more thoroughly before you get too close to any corals and sponges.

It is vital that you remember to check your air contents gauge. You will use far more air to control and adjust your buoyancy when you have a camera with you than you would without it.

▲ Fig. 7.29
Whilst this image does not really fit into any of the composition ideas we have touched on in this chapter, the complementary colours and small DOF create a pleasing result.
1/160; ƒ9; ISO 400. Nikon D700, 105mm

Remember to think about your no decompression limit (NDL); lining yourself up in order to capture a difficult shot can take some time and it is easy to become so engrossed in your photography you lose track of time. In addition, the NDL can be quite short at any depth over 18m (60ft), especially if you are on air – consider using nitrox if the dives are 18m (60ft) or over, but still keep a close eye on your no decompression limit.

Finally, make sure you and your buddy stay together; underwater photographers are notorious for losing sight of their buddies.

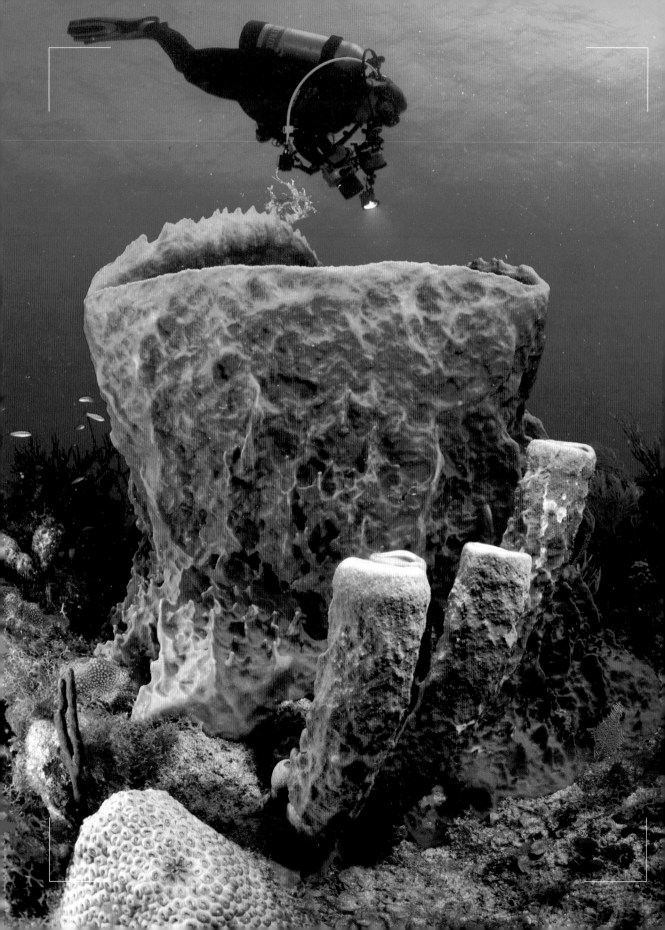

Chapter 8

Exposure Revisited

Exposure is probably the most important factor in the art and the science of photography. If the lighting is wrong there is very little you can do with your image. While many serious photographers would try very hard to avoid it, composition can be adjusted and manipulated in the post-editing suite. However, adding more light or trying to recover a burned-out, over-exposed image is more often than not a waste of time. Putting the right amount of light, in the right places to balance the image, is even harder.

HOW TO GET THE RIGHT EXPOSURE

This is a very difficult question to answer, as getting the right exposure value may be seen as the technical part of photography, but inevitably, lighting can be subjective, to a certain extent at least. With an artificial light source, getting the lighting right under water is reasonably straightforward – you need to illuminate the subject, but what about the background?

With natural light, it is far more difficult to balance your composition, especially under water. Should you choose to set your camera in the automatic exposure mode, the electronics inside the box will measure the average amount of light entering the lens and choose an exposure value accordingly. The result may be technically correct, but if you have a dark or dull subject in a light background, the subject will be underexposed. If you are selecting the f-stop, the shutter speed and the ISO yourself in manual mode, then you are controlling the exposure of the image. How you see that picture may be totally different than how your dive buddy sees it; this is the art and subjectivity of photography.

Photography has been described as 'the process of recording an image on material that responds to light'. In digital photography, this depends on three separate factors.

- The sensitivity of the sensor.
- The size of the aperture.
- How long the shutter remains open.

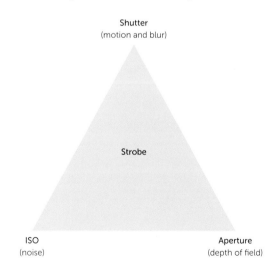

Shutter
(motion and blur)

Strobe

ISO
(noise)

Aperture
(depth of field)

▲ Fig. 8.2
This diagram shows the exposure triangle which was discussed in Chapter 1. However, this chapter will take things a step further and introduce the effect on lighting you will get when using strobes.

◄ Fig. 8.1
This picture was taken on a reef in the Caribbean using three strobes to create a balanced light image. The sponges in the foreground are evenly lit from the sides, and the aperture has been set to give a true production of the colour of the water. The diver in the background balances the composition and the light the diver is holding gives a secondary point of interest.
1/100; f13; ISO 400. Nikon D700, 16mm

Sensor Sensitivity (ISO)

If insufficient light falls on the sensor, then the resultant image will be underexposed. It will be dark, detail will be lost, and in many cases those dark areas will appear noisy, particularly if looked at under scrutiny. If too much light is allowed on the sensor, then the image will be overexposed, looking washed out or even burned out. When the exposure is right your subject should be clear with no highlights and no dark shadow. This may mean that some of the negative space, in the foreground or background, may be over- or underexposed but it is the subject that is important. Sometimes this is unavoidable, but it is essential that the subject is correctly exposed. In order to achieve this, any or all three of the controls can be manipulated independently. However, as each one is adjusted, the resultant image will be affected in a different way.

The sensitivity of the sensor is known as the ISO (named for the International Standards Organization). The ISO ratings are linear: double the ISO number and you will halve the amount of light required for that same exposure value. Before the advent of digital cameras, changing the ISO meant changing the film, so the photographer had to decide on the ISO at the beginning of each roll of film. One of the great advantages of digital cameras is that the ISO can be changed for each individual shot, if required. Increasing or decreasing the ISO is a very simple and quick way to adjust the exposure of your image.

However, the more the ISO is increased, the noisier your resultant image will appear. No matter what camera you are using, always select the lowest ISO number you can to achieve your result, as this will always guarantee you the highest resolution possible. Fortunately with large, modern, high quality sensors these days, the noise at high ISO numbers is far less distracting than it was in the past.

The Size of the Aperture

The aperture on your camera or lens is the orifice that controls the amount of light reaching the sensor. The lens aperture can be thought of as the pupil in the mammalian eye. In darkened light conditions, the pupil (aperture) opens as wide as it can in order to allow the maximum amount of light to get through to the sensor. On most lenses this would be ƒ3.5 or ƒ2.8, but on more expensive lenses it may open to as wide as ƒ1.4. The ƒ-stop number refers to the relationship between the focal length of the lens and the diameter of the aperture, so always be aware that a small ƒ-stop number will allow more light through to the sensor than a high number will; however, the depth of field, the amount of the image in focus, will decrease (see Fig. 1.8 in Chapter 1).

The exposure value of each ƒ-stop is calibrated to the same scale on all cameras. This means that whatever camera you may be using, with the same ƒ-stop, shutter speed and ISO, the exposure value – the exposure of your image – should be the same on any camera. The important thing to remember then about the aperture or ƒ-stop is that when you change it, for every single increment in the range you will double or halve the amount of light hitting the sensor. This makes changing the amount of light you are allowing through fairly easy to comprehend,

▲ Fig. 8.3
This image was taken using a large DOF in order to give an idea of the number of sharks in the water. It was taken around Aliwal Shoal, South Africa.
1/250; ƒ22; ISO 1600. Nikon D700, 16mm

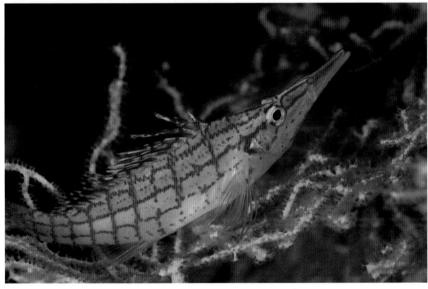

Fig. 8.4a and 8.4b
These two images were taken at a similar time. All the settings are the same apart from the shutter speed. On Fig. 8.4a the shutter speed was set to 1/125 of a second.

Fig. 8.4b was taken a few seconds later with the shutter speed increased to 1/160 of a second. As you can see by comparing the two diagrams, by increasing the shutter speed the exposure on the subject has remained pretty much the same but the background has been darkened due to the fast shutter speed. 1/160; ƒ9; ISO 400. Nikon D700, 105mm

but it controls a major factor in the result of your image. The lower the ƒ-stop is set at, the smaller the depth of field in the resultant image. As a simple guide, using a low ƒ-stop is common in macro and close-up work. A high ƒ-stop will give you a large depth of field, and this is particularly useful for reef, wreck or underwater landscape scenes.

Shutter Speed

The shutter speed controls the length of time that the light has to fall on the sensor, that is, how long the shutter remains open. It is usually measured in fractions of seconds, although it can be set to one or several seconds for certain types of exposures. The faster you set the shutter speed, then the smaller the amount of light that will fall on the sensor.

In everyday photography, and natural light underwater photography, a faster shutter speed is

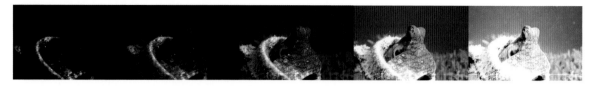

▲ Fig. 8.5
This shows how an image taken in RAW can be manipulated later in Photoshop. The image in the centre shows how it was shot, and the images either side of this have been moved up by four stops and moved down by four stops. This shows how versatile the exposure control can be when shooting in RAW.

required to capture movement without blurring. Controlling exposure with the shutter speed will allow you to depict movement the way you choose to show it. However, in underwater photography the shutter speed can be used to control the background colour of the water, especially if using artificial lighting.

As with both aperture and ISO, a one-stop change in the shutter speed will either double or halve the exposure. For example a change of shutter speed from 1/125th to 1/250th of a second will halve the length of time the shutter is open, and in exposure terms this is the same as changing the ƒ-stop from ƒ2 to ƒ2.8.

A fast shutter speed is needed to freeze the action; however, if you are using strobes, then because you are in a low-light environment the strobes will freeze the action for you, and changing the shutter speed will make very little difference to the light falling on your subject. You can try this yourself at home with a very simple experiment. In a gloomy room, use your flash or strobes in manual mode and leave them on the same setting as you vary the shutter speed on your camera. You should find that unless you use a really slow shutter speed, the difference in the exposure on the subject will be slight.

EXPOSURE VALUE

An important concept to understand, in any discipline of photography, is the exposure value (EV).

Many cameras have a light meter display which will tell the photographer whether the image is under- or overexposed. These, of course, give an ambient reading of everything that is in the viewfinder or on your screen. Compact cameras may not have a light meter, but there is usually a means to bring up the histogram. (Histograms are dealt with in more depth later in the chapter.) Other cameras suggest a higher or lower ISO with an indicator at the side of the screen, which can indicate whether you are under- or overexposed. Unless you are using a very basic, entry-level camera then one of these factors will assist you in gauging the exposure.

Before light meters were invented, photographers had to gauge the light conditions and set the aperture and shutter speed based upon their own assessment of the light value. A saying amongst photographers, called the Sunny 16 rule, is a very useful guide to helping you to decide on the camera settings you should use, namely: on a sunny day, a few hours either side of noon, at ƒ16 and the shutter speed one over the ISO you are using, you should obtain the overall perfect exposure for that light. This means that if you set your ƒ-stop to ƒ16, and if the ISO is at 100, then the shutter speed for the correct exposure should be 1/100th of a second (1/120th is close enough if you do not have 1/100th). Using that same equation, if you were to increase the ISO to 500, then the correct exposure would be ƒ16 at 1/500th of a second. Using the EV chart, you can change either the ƒ-stop or the shutter speed to achieve the same exposure value. Under water obviously it is much darker and there is less available light, but by using the exposure value chart you can get an approximation of the manual settings required to get the correct exposure under water.

EV CHART FOR ISO 100

	ƒ1.0	ƒ1.4	ƒ2.0	ƒ2.8	ƒ4.0	ƒ5.6	ƒ8.0	ƒ11	ƒ16	ƒ22
1	0	1	2	3	4	5	6	7	8	9
1/2	1	2	3	4	5	6	7	8	9	10
1/4	2	3	4	5	6	7	8	9	10	11
1/8	3	4	5	6	7	8	9	10	11	12
1/15	4	5	6	7	8	9	10	11	12	13
1/30	5	6	7	8	9	10	11	12	13	14
1/60	6	7	8	9	10	11	12	13	14	15
1/125	7	8	9	10	11	12	13	14	15	16
1/250	8	9	10	11	12	13	14	15	16	17
1/500	9	10	11	12	13	14	15	16	17	18

0	dim ambient artificial light
6	bright ambient artificial light
10	landscape shortly after sunset
16	bright daylight on sand.

As you can see from the chart, to get an exposure value of 16 under water with no artificial light is very difficult without using really slow shutter speeds. In shallow water with good visibility and the sun directly overhead, it may be possible. Using a high ISO will help.

STROBES

In underwater photography, at depths beyond about 12m (35ft), the light value becomes low and as you go deeper it gets darker. Ambient light photography starts to become very difficult, and in temperate waters it tends to be far too dark to photograph without any artificial lighting.

Should you decide to use a constant light source, such as a video light, you will be able to see just what you can illuminate and set the exposure accordingly. With strobes, which are more powerful than most video lights, you can only see the effect of the light when you squeeze the trigger and the flash fires. The pulse from a strobe, which emits high intensity light for a very short space of time, will freeze the action.

For close-up work, the settings you have on your camera will give a black image if the underwater flashes fail to work or are turned off. This means that the image captured on the sensor will be entirely due to the light that has been emitted from the strobe. Even with a slow shutter speed, nothing else will be captured as it is too dark for any exposure other than flash. Of course, if the shutter is left open long enough to capture ambient light, then some of the image will be visible.

RAW FILES

When you first pick up your camera and scroll through the menu, one of the many options is image quality. Most cameras now offer the option of RAW, JPEG or both. RAW files are very large, typically ten times the size of a JPEG file. This is because the RAW file contains ten times the information of the JPEG. When you are shooting in JPEG only, and you lift up your camera to take a photograph, the sensor

sees everything that your eye sees but it will only record the picture in the exposure value that you, or the camera if you have put it in auto, have given it.

Advantages

When you take that same photograph in RAW, the sensor captures far more of the information in front of it. A good analogy for RAW is an undeveloped film. An undeveloped film contains a lot more information than the printed image that you are eventually presented with when you collect it from the store. The negatives in the darkroom can be manipulated to show greater or lesser exposure. Shooting in RAW allows you to manipulate your images in the post-editing suite to a far greater extent than if you are shooting in JPEG. This might mean a magnificent shot can be recovered in editing, if you got it slightly wrong when you took it.

A RAW image captures all the information that falls on the sensor regardless of the settings you may have chosen. The sensor is an incredible piece of modern technology which is made up of millions of light sensitive elements; each time you take a photograph the light falls onto these elements which are sensitive to different colours. Depending on the manufacturer these sensors work in one of two different ways, but all have detectors that are sensitive to three colours: red, green and blue.

The two varieties of sensor are CCD (charged coupled device) and CMOS (complementary metal oxide semiconductor). While in principle they perform a similar process, the way that the information is received and used by the sensor varies. A CCD sensor is simpler and less expensive to make, but CMOS sensors work at a lower and constant voltage. Both types of sensor use a greater number of green detectors in their array than the other colours, as this is the predominant colour in visible light – where we may see a blue light, unless it is pure blue it will be made up of components of green or blue, and possibly even red.

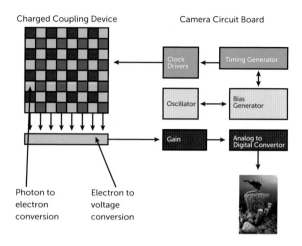

▲ Fig. 8.6
Diagram of charged coupling board device and the camera circuit board.

You will see from Fig. 8.6 that, as stated, there are twice as many green sensors as there are red or blue. In order to produce the JPEG, the camera's processor utilizes the settings the user has given it. That may be you, the photographer, or the camera if a non-manual setting has been chosen. A lot of other information is also carried into the file, which is known as metadata. This data can be found on all digital photographs. When you process your own images in a photo-editing suite you can bring up all the data on how, when and with modern cameras even where, the image was taken.

In order to be able to transfer the RAW data to a usable format, conversion software is required. Most photo-editing software can manipulate the RAW files, but very often, specific conversion software needs to be installed first. This usually only happens when you are using a camera that is more up to date than the software you have. If your current software will not work on your RAW files most of the conversion software is available as a free download from the camera manufacturer's own website. This may seem slightly complicated, but the ability of the software to manipulate and fine-tune your images can be dramatic, and it is certainly worth the extra effort.

▲ Fig. 8.7
This image shows the metadata that is contained within the photograph of the skunk anemone fish against a black background. This information can be accessed from any image in JPEG, RAW or any other format once it has been imported into Photoshop.

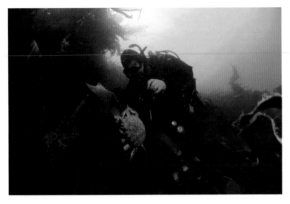

▲ Fig. 8.8a
This image shows the photograph as shot in RAW before being worked in Photoshop. The diver is approaching a spider crab in West Wales, getting ready to take a shot.
1/250; ƒ7.1; ISO 400. Nikon D700, 16mm

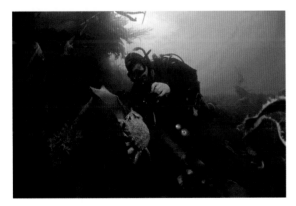

▲ Fig. 8.8b
This image shows the same shot, but this is after the RAW image has been worked in Photoshop.

Disadvantages

There is a downside in using RAW files. The files are huge, especially with full frame digital SLRs: currently file sizes are running at 10–40MB. This of course means a larger and faster memory card is required, or you will find that it will slow down, considerably, the speed at which you can take the next image even with a buffer, which nearly all digital cameras have. The transfer of information from sensor to memory card, inside the camera, will take some time and the more information there is to be transferred, then the longer that time will be.

Another potential drawback when shooting in RAW is that, not only will it slow down the camera's shooting operation, you may also find that you are getting reduced functionality from the camera. However, this is becoming less common as camera technology improves.

Despite these drawbacks, the advantages of using RAW will nearly always give you the ability to produce a better image than shooting in JPEG alone. It is important for you to realize that, even shooting in RAW, a poor picture cannot be turned into a great picture by manipulating a RAW image in photo editing. However, a good picture can become a great picture and a great picture can be a winner.

HISTOGRAMS

Histograms are great visual tools for the underwater photographer. Using menu settings many photographers have modified the information displayed on the screen so that the histogram always shows alongside the image review. However, many novices avoid histograms as they find them confusing and difficult to interpret. They are, in fact, an easy-to-use function and can be very helpful, especially for underwater photography where, in low light, the image alone can be misleading when viewed on the screen.

A histogram is, quite simply, a graphical way to show a visual representation of data distribution. In the case of a digital image, the data is the intensity of the individual colours – red, green and blue. When all three colours are combined in equal amounts, it produces white, and therefore, the white curve on the histogram is a visual representation of all the colours combined.

The histogram is merely a graphical representation – a simple two-dimensional line graph with the x-axis running horizontally and the y-axis rising vertically. The x-axis is measuring the colour scale from left to right.

In the case of the monochrome graph, absolute black is at the left and absolute white is at the right. The vertical, y-axis is measuring the intensity, or quantity of that shade of the colour – in this case, white, grey or black. Imagine that you had a one pixel monochrome camera. If you took a picture in a pure black room then that would appear as a single point at the far left of the x-axis at the bottom of the y-axis. If you imagine that the subject was pure white, then that point would be at the far right of the x-axis. A 50:50 mix of pure black and pure white would give grey and it would sit in the middle.

Now imagine that you have the latest technology 20 pixel camera. These points would appear as a function of their intensity – how many of each colour that will appear vertically on the y-axis depends upon the amount of that particular tone of colour. It is when the curve is at the far right or the far left that it becomes really useful to the underwater photographer. If the white line is at the far right of the x-axis this would suggest that the picture may, in some parts, be overexposed. If the histogram is touching the y-axis at the left it is telling you that some points may be underexposed. This could of course mean that there are, in fact, black and white objects in the image and therefore, the exposure would be correct.

When looking at a colour histogram – red, green and blue – the principle is the same, except that the

▲ Fig. 8.9a and 8.9b
This image is shown with the histogram alongside so you can see how the light and the colours are represented in graphical form.

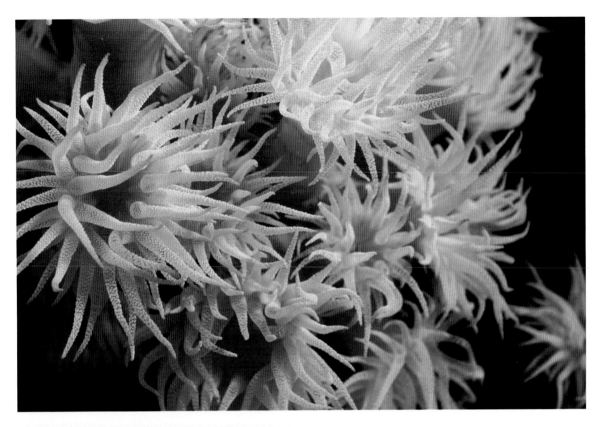

▲ Fig. 8.10a and 8.10b
This histogram of the image illustrates that the curve is generally biased to the right, which shows the brightness of the polyps. However, the spike on the left indicates an area of blackness.

graph will now show the distribution of the three colours; they can also be represented on three separate histograms. Bear in mind that the blue object in the image may have components of red and green to achieve the specific tone of blue that you can see.

Shooting to the Right

Using the histogram as a guide to show the distribution of light from the dark shadows on the left to the highlights on the right, you would imagine that the best exposure is one with all the information completely within the confines of the two vertical axes. If the graph is predominantly across to the left of the x-axis, then you are losing detail in the shadows, because this area is too dark for the sensor to be able to detect any definition. If the curve is across to the right and moving up the y-axis then there will be at least some areas of overexposure in your image. The sensor inside all digital cameras will find it easier to capture bright light than low light. This means that

SHOOTING TO THE RIGHT

You can try this yourself by repeating a similar experiment from the ISO module (see Chapter 1). Shoot on a low exposure at something dark in relatively low light. Then increase the exposure, without changing the ISO, as this too will introduce noise. Increase the exposure until the histogram shows the curves towards the right.

Now zoom into the darkest areas in both your shots. The underexposed image will look noisy, with tiny red spots, while the more highly exposed image will have better colour definition – the black should look black. When you reduce the exposure in the editing suite, this image will contain more definition and detail than the corresponding image shot to the left.

When you look at the highly exposed images on your screen it will initially seem wrong. They will look washed out and may even seem unpleasant, but as long as they are not overexposed, when you reduce the highlights in Photoshop they will look better than the lower exposure shot.

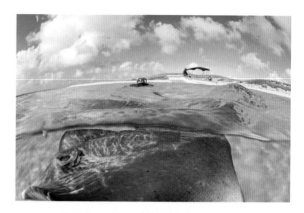

▲ Fig. 8.11a and 8.11b
The histogram for this photograph shows that the curve is predominantly to the right of the x-axis. This is because the exposure is high, and therefore the intensity of the colours is greater.

if you can get your exposure set to the point that the histogram is across to the right without overexposing, then you are making better use of the sensor.

In order to see this for yourself, you need to shoot an image and then review what you have taken on your histogram: you can do this indoors. What you are trying to achieve is for the curves to be at the right hand side of the histogram, but not sliding upwards along the y-axis as this will be overexposed. If your histogram is showing to the left or the middle then you may need to increase your exposure. If the histogram is showing the curves across to the right and sliding up the y-axis then you need to reduce the exposure.

You will find when you review the picture on your screen that the correct exposure will look slightly washed out. However, what you have done is allowed the sensor to read any definition in the shadows, and when you correct the image in the photo-suite later, when the exposure is turned down you will still have definition in the dark areas, and the part that looked washed out before will now be vibrant. Had you shot your image on a lower exposure, the shadows may well have been noisy and would lack definition.

Shooting to the right will really only give you an advantage when you shoot in RAW, as there is far

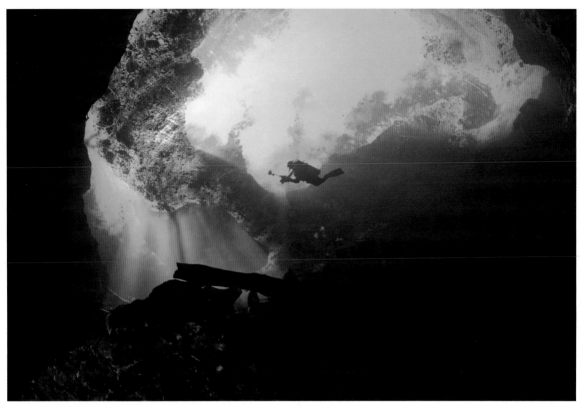

▲ Fig. 8.12
This is a particularly challenging shot where exposure is concerned.
Low down and the foreground of the image is dark whereas the
surface is light, especially where the diver's bubbles have created
a circle for the bright sunlight to penetrate. The shutter speed has
been metered for the green at the surface, and the ƒ-stop is set to
try and give some DOF but also wide enough to get some light in
the foreground.
1/60; ƒ8; ISO 200. Nikon D200, 10–17mm at 10mm

more recorded data for you to use than there is in a
JPEG file. Very small adjustments can be made if you
have recorded your images in JPEG, but because of
the lack of information outside the parameters that
have been recorded in this mode, there is very little
latitude to change anything. This is another reason
to always shoot in RAW.

This chapter has looked at the elements of
exposure and reviewed what each of these compo-
nents can do to alter your image. The topics have
been examined in more depth than they were in
Chapter 1 to give you a greater understanding of the
overall interaction between the three components.

This chapter has also looked at exposure value and
how useful it is to be able to understand the concept
of having a value for your exposures. The section on
RAW and histograms has shown the advantages of
using this setting and how reading the histograms
to assess the exposure of your image can help you
get it right when reviewing the image on your
viewer. Finally the concept of shooting to the right
has been investigated and if you can grasp this and
use it when capturing your images, your final results
should improve. If your camera has the ability to be
set to bracketing then you will have all the options to
look at for yourself.

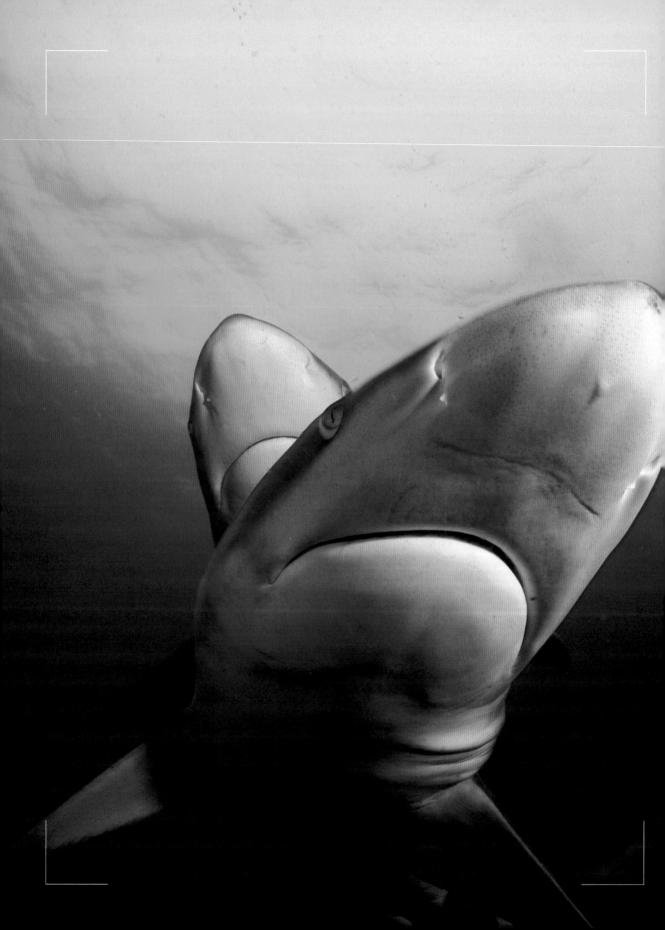

Chapter 9

Animal Behaviour

When taking photographs one of your greatest assets is understanding your subject. News photographers do not get the shot because they just happen to be in the area at the time – good news photographers understand what is going on and where they need to be in order to catch the action. It is the same for the sports photographer – it is no coincidence that an array of Nikon and Canon digital SLRs are lined up behind the goal area in many sports.

You do not have to be a marine biologist to understand the behaviour of many of the animals that you see and photograph under water. However, it is an amazing fact that many of the world's best photographers are biologists. Knowing your subject and understanding its normal behaviour can make it far easier for you to capture the image that you wanted to get.

PEAK ACTION SHOTS

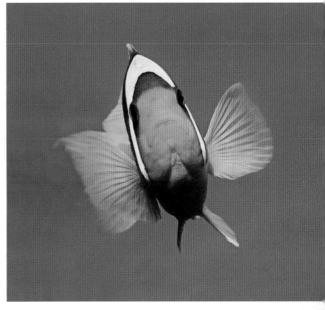

▲ Fig. 9.2
This image was taken of the dominant female protecting an anemone on a reef just off Dahab in Egypt. It was taken with a 60mm macro lens using continuous tracking focus mode. When anemone fish are approaching a camera, there will normally hover for about a second in front of the lens and this is the time to grab the shot.
1/160; ƒ8; ISO 100. Nikon D200, 60mm

Most of the best underwater animal shots are taken at the peak of the action. Many animals will hide as the photographer approaches but if you are patient and make the right moves, or no moves, your subject may just appear. Wildlife photography is all about patience and knowing what you are waiting for, so if you have the time to carry out a little bit of

◀ Fig. 9.1
These two oceanic black-tip sharks were captured on camera in Aliwal Shoal, South Africa. I have called the image 'The Krays' as an homage to David Bailey's image of the twins taken in 1963. I used a high ISO number to allow a low power setting on the flash, to reduce any flare from the white underbelly, and a high ƒ-stop for a large depth of field.
1/250; ƒ18; ISO 1600. Nikon D700, 16mm

research on the creatures that you are intending to photograph, then it should pay dividends.

When you are on a dive trip, talk to the dive guides, not only because they are familiar with the area, but because they know the dive sites and they know the animals. If you tell them the picture you want to take, then they will be able to help you to take it. However, you must never ask them to move the animal or its environment for you just so you can get the shot that you want to show off to your friends. It is a good idea to ensure the dive guide understands your environmental awareness beforehand.

▶ Fig. 9.3
This image of a humpback whale was taken in South Africa whilst looking for sardines on the sardine run. I was able to get the image by following the movement of the humpback whale as it migrated northwards. For some reason it turned round, and the captain dropped me in the water about 50m (150ft) directly in line with its movements. I just had to wait and hope I was in the right place, and sure enough out of the blue came this 15m leviathan directly towards me. 1/160; ƒ11; ISO 400.
Nikon D700, 16mm

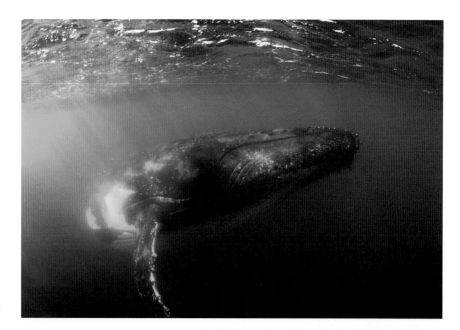

▶ Fig. 9.4
This basking shark was taken in Cornwall off the south-west coast of England on a lovely sunny day. The dappled sunshine created beautiful highlights across his upper body and it had his mouth wide open, filter-feeding on the plankton in the water. 1/125; ƒ11; ISO 500.
Nikon D700, 16mm

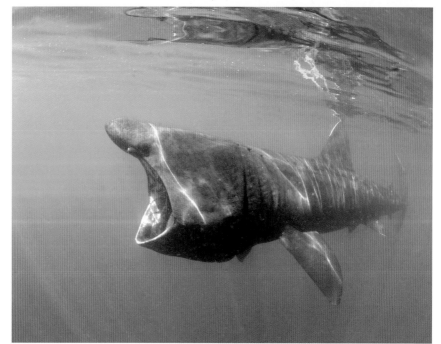

Like any wildlife photography, if you can capture the personality of the animal, then you can create a stunning image. If you watch the subject for a few minutes, then most of the time you will then be able to work out a repeating pattern of behaviour. For example, anemone fish will approach the lens in an attempt to scare you away. This can be a great opportunity for you to get a really close-up, in your face, image of the anemone fish. Do bear in mind, however, that staying too long and repeatedly firing strobes at it, may be causing excessive stress to the animal.

Bigger animals too, follow behavioural patterns. A basking shark will move along the line of plankton, then turn and move the other way and so on. By studying and watching an animal's behaviour, especially where it is repetitive, you should be able to predict where the subject is going to move to. With a little bit of luck, getting your observations right and with nature on your side you could be in just the right place at the right time. This is known as peak action photography.

For most macro work, studying the behaviour from a short distance away will help you to compose your shot. Think about it, and ask yourself what would be the best angle and what do you want as your background? Can you make a demo shot close by to check your exposure settings? Is it possible to kneel without damaging anything or stirring up the substrate, or is hovering the only option for the shot you want to get? Think about the position of the sun; can you get the shot with the sun behind you or do you need to shoot into the sun or into the reef? Really think about the background; if the shot has to be taken into a messy reef can you bokeh it or can you darken it? Very often, there are a lot of factors to consider before you squeeze the trigger.

This chapter is broken into several sections to try to help you understand and use the animal's behaviour in the different circumstances presented. There are many aspects to animal behaviour, and understanding it will help you to photograph it.

MUCK DIVING

Muck diving involves diving on sandy slopes or amongst rubble and sporadic coral reefs looking for unusual creatures. There are many dive-sites for muck diving around the world, but three of the best sites for this kind of diving are in Indonesia – the Lembeh Straits in Sulawesi, Laha in Ambon and Secret Bay in North-West Bali. All these sites

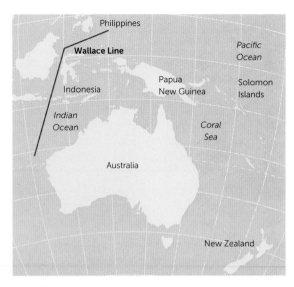

▲ Fig. 9.5
This map shows the hypothetical line drawn up by Alfred Russel Wallace in the nineteenth century and shows the line demarcating the fauna of Asia and Australasia.

are close to busy ports and the Wallace line – a hypothetical line in Indonesia demarcating the distribution of Asian and Australasian fauna: to the west of the line are found organisms related to Asiatic species; to the east, a mixture of species of Asian and Australian origin. All these sites have litter discarded across the sea floor.

Several places around the world are putting junk in metal frames or concrete blocks to encourage coral growth and create an artificial reef. An abandoned tyre, a can or a bottle can make a great home for an eel or a blenny. Lembeh and Laha are both tuna fishing ports, and any discarded fish waste could feed a multitude of creatures and supply a sizeable nutrient boost for all the small creatures around. The most prolific of the dive sites where you can find these weird and wonderful creatures are shallow, and this will allow a longer dive time for the photographer and encourages fewer predators on the creatures that live there. Diving in this environment is not for everybody – you may see the odd unpleasant thing drifting along – but if you can see past the detritus, you will be able to photograph all sorts of unusual creatures.

▶ Fig. 9.6
If you look very carefully amongst the coral, sponges and anemones you can find hundreds of minute creatures. This tiny shrimp seems to be full of eggs. A +4 dioptre which fits over the port was used to get closer and hence magnify the image.
1/200; ƒ18; ISO 500.
Nikon D700, 60mm

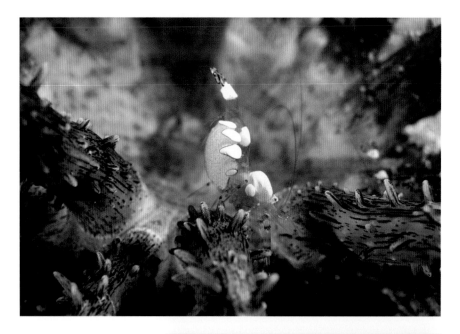

Look for the really minute stuff – this is an ideal place for you to go super-macro. However, with the tiny and the camouflaged creatures that inhabit these zones, you need either a good guide or a sharp pair of eyes. A good guide is best as they have the knowledge of what to look for and where to look for it on specific dive sites. Rare species are often slow-moving and territorial so it is not a bad idea to take a magnifying glass with you. If you can get your buddy to hold the magnifying glass over a tiny creature the whole picture could create a really inter-esting image with the unique composition.

Unusual octopus and crustaceans, frogfish and pipefish are all abundant in these places. Your guide may point out stuff to you that you simply cannot see, either because it is too small or it is so well camouflaged you just cannot see it. This is a serious macro, close-up and super macro environment. If you have done your research beforehand, spoken to the guide and know the kinds of things to expect, you will stand a better chance of seeing it; having a search image in your head really makes it easier to see the subject. You are almost guaranteed to find a wealth of unusual and bizarre species that have evolved and adapted to this strange environment.

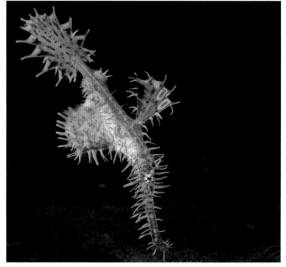

▲ Fig.9.7
Ornate ghost pipefish are magical creatures which will drift pass your camera lens with seemingly no method of propulsion. The camouflage pattern, particularly around its eyes, makes it very difficult indeed for an auto-focus system to work; the huge DOF used here helps.
1/200; ƒ32; ISO 800. Nikon D700, 60mm

Why do these animals live here amongst all this rubbish? Like all creatures, marine or otherwise, they need to get nutrition, find a mate, avoid predators and establish somewhere for the young to develop. In many ways this environment is ideal.

CAMOUFLAGE

When you are diving with your camera and looking for something different to photograph, you really need to know just what you are looking for and where you need to go to find it. Some species blend into their surroundings so well that unless you know it is there you will never see it. Even armed with this knowledge, some creatures can still be really difficult to spot. It makes the photographer's task harder when some animals actually change their colour and texture to blend into their surroundings.

While they may be difficult to see, there are many positives to photographing these secretive creatures. These species can often be in full view, if not somewhat camouflaged into their surroundings, as they believe that you cannot see them and their strategy relies upon them not moving. This suggests that you should be able to make an approach to these animals with ease, providing you move slowly and do not disturb the reef. Avoid making direct eye contact as this informs the subject you have seen them. If you make any sudden movements, you will probably be left with a puff of sand or sediment where your subject was hiding.

The hardest part of this kind of photography is trying to make your subject stand out. A pygmy seahorse, for example, mimics the coral they live in so they have a textured skin matching the closed coral polyps of the sea fan they inhabit. Couple this with the fact they are miniscule, even when the guide is directing it to you with his pointer it is still practically invisible. Another similar example is a sand-coloured flounder lying on the sand which looks like... well, sand. Try to pick out a small part of the animal and try to create a neutral background.

Trying to create contrast can be another challenge. Many of these critters are monotone, and you need to create some shadow in order to give depth to the image. An all-black subject can be particularly challenging; very often your image may show the

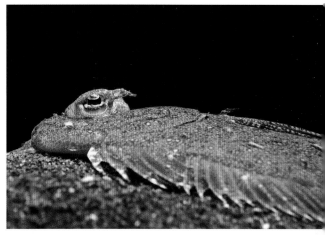

▲ Fig. 9.8
This peacock flounder is so well camouflaged into its surroundings that they are almost impossible to see, and even when you do see them, shooting them on the sand does not create an interesting image. The best way to photograph animals like this is to get down on the same level and try to create a neutral background. This was taken using a fast shutter speed and high ƒ-stop to blacken the background so that the outline of the eye stood out.
1/250; ƒ14; ISO 400. Nikon D700, 60mm

▲ Fig. 9.9
A frogfish hiding in a sponge; they have the ability to change colour to match their surroundings and can sometimes be very difficult to see.
1/160; ƒ13; ISO 500. Nikon D700, 60mm

outline but any features are lost in the lack of contrast in its colouration. Angle any lighting you are using, as this may help to introduce some contrast by creating shadow off any of the animal's features.

One of the hardest groups of aquatic animals to photograph is the cephalapod. This group includes

octopus, cuttlefish and squid. They have incred-
ible skin that can change both colour and texture
as they move around the seabed, adapting almost
instantly to blend into whatever environment they
find themselves in. They are often referred to as the
chameleons of the sea, and they are also particularly
intelligent animals – in fact, the most intelligent of
any invertebrates. They are fascinating subjects to
photograph, but again the best way to shoot these
creatures is to try to shoot up, against blue water
if possible, so that you are getting a neutral back-
ground. Cuttlefish and octopus can very often be
seen making their way across the seabed, but if you
try to photograph them by shooting down, then you
will be very lucky to get a decent shot.

Make sure your photographs are interesting and
the background is neutral, and endeavour to get an
unusual angle. If you approach your subjects slowly
then they will usually stay in position; remember
they think you cannot see them. Try using natural
or constant light rather than a strobe. This gives
you a great opportunity to adjust and play with your
depth of field, and you have a thumbnail view of
what your image will look like on the screen. Use
different settings to get the whole frame in focus,
or close in tightly to get just the eyes of a peacock
flounder. As many of these creatures move slowly,
try to manoeuvre yourself into the best position for
the shot without damaging any of the reef. As you
are manoeuvring yourself into position however, be
aware of your fins and avoid damaging any corals
and sponges. Above all, be patient: with frogfish,
for example, wait long enough and you may just be
rewarded with that wide-mouthed yawn shot.

BRIGHTLY COLOURED

One alternative to camouflage is to choose entirely
the opposite strategy. Some aquatic species have
evolved to become very brightly coloured or have

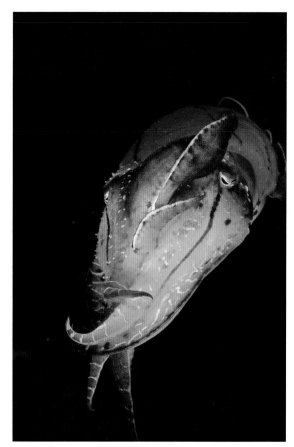

▲ Fig. 9.10
Displaying on a reef, this cuttlefish was where it blended into the
background. In order to make the cuttlefish stand out I used a high
ƒ-stop, ƒ18 and fast shutter speed with the twin strobes turned
down to a minimum. This technique blacks the background out and
makes the cuttlefish pop out.
1/250; ƒ18; ISO 400. Nikon D700, 60mm

obvious patterns, and this colouration is normally
associated with being highly poisonous or, alterna-
tively, tasting disgusting (a strategy of providing a
warning to potential predators, called aposematism).
From a photography point of view, brightly coloured
creatures tend to believe they will not be attacked
and therefore are generally easy to approach.

A good example of bright colouration is the nudi-
branch. Nudibranchs tend to come in a huge range
of bright colours and patterns, and they can be an
addictive subject for many divers and photographers
alike. There are over 3,000 different species and
there are more being discovered all the time. Their

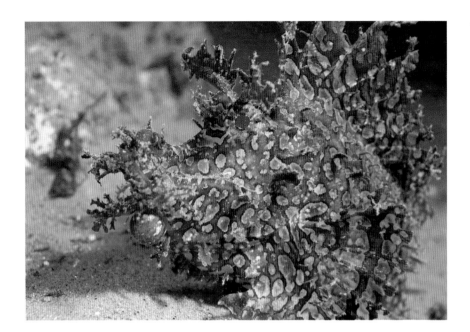

Fig.9.11
Brightly coloured often means beware, and this rhinopias comes well-armed. The purple colour is a warning to any predator, and photographer, that they should not get too close, as the spines are venomous. 1/160; ƒ13; ISO 500. Nikon D700, 60mm

bright colours signal to their potential predators that they do not taste very nice. They pick up this foul or toxic taste from the poisonous sponges and stinging hydroids that they graze upon. They are found all over the globe in both temperate and tropical waters, though the temperate species tend to be slightly less colourful.

Another group of animals, the lionfish, found only in warmer waters, have wonderful warning patterns on their body to signal to any bigger fish to stay away. They have a poisonous tip to each of the needle-like dorsal fins and the red and white stripes are a clear warning for all to see. It is a hugely successful predator and is a species that is spreading its range, which now includes the Caribbean where it has no natural predators. The population of lionfish is growing at an alarming rate. Lionfish like to hover in mid-water and offer some great photographic opportunities from all angles. Do be careful of their spines though, as getting too close can lead to a very painful trip to casualty.

SCHOOLING FISH

With the right lens you can capture amazing photographs if you come across a school or a shoal of fish. There is a difference between a school and a shoal of fish, which is useful to understand as a photographer. A shoal is a loosely formed group that are in the same area but going about their daily business as individuals, while schools of fish move together in the same direction and are much more tightly packed and coordinated. They do this for a reason: when tightly packed together and moving as one, they become far more difficult to prey upon. Not only are there far more eyes to spot the danger, but being in a large school can also increase an individual's chance of survival simply by diluting the individual fish's chance of being eaten.

Many other fish you may see when you are diving around the world have stripes, and when they are swimming alone this would appear to make them stand out. However, just like zebras on the plains of Africa, when they aggregate into groups, this disruptive colouration actually confuses the predators. Rather than seeing just one prey, they

▶ Fig. 9.12
It is not always the large fish which form into schools. This image of small catfish schooling and working together was taken on a muck diving site in the Lembeh Straits in Indonesia.
1/200; ƒ6.3; ISO 200.
Nikon D700, 105mm

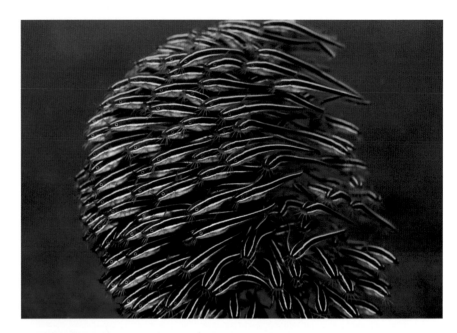

▶ Fig. 9.13
Protean behaviour is a method of defence favoured particularly by silver fish. As they move, and dart as one, the reflections off their scales and their lateral lines cause havoc with the predator's vision. A slow shutter speed was used to try to show the motion blur as the bait ball moved through the water.
1/160; ƒ9; ISO 400.
Nikon D700, 16mm

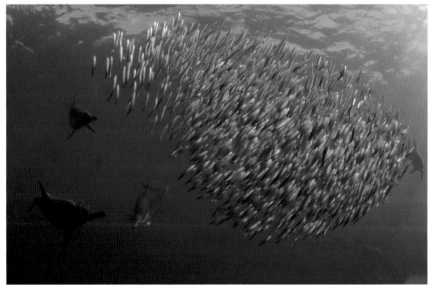

see a mass of moving lines and it is very difficult to single out an individual to strike upon. Should an individual become isolated, however, their lifespan suddenly becomes vastly reduced.

A school of fish can also adopt the 'protean defence' mechanism, whereby unpredictable escape movements can confuse predators. This strategy is normally adopted by silvery fish darting one way and another while the sun catches and glints on their scales. This confuses hunting animals which use sight to find their prey, and for predators that hunt using the lateral line or electro-sensory systems, the school of fish twisting and turning in the water as one coherent unit makes it harder for them to pick out a single victim to target. There are more benefits to living in a coordinated group of fish than trying to go it alone on the reef.

Schooling fish are usually continually on the

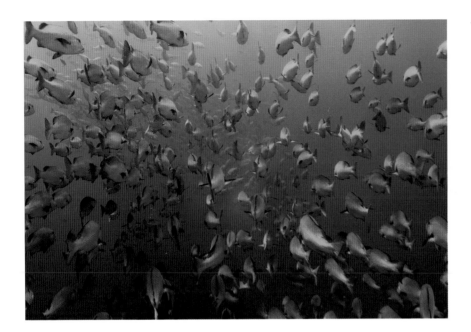

Fig. 9.14
Whilst normally fish bottoms would not make the best of images, sometimes the rules are meant to be broken. This was taken by the photographer drifting into the huge school of snapper in Egypt and waiting until the fish had become accustomed to his presence. The fish close around you and you can get the feeling that you are part of the school.
1/125; ƒ8; ISO 200.
Nikon D200, Tokina 10–17mm at 15mm

move trying to avoid predation, and are not necessarily going to stop to allow you an easy Kodak moment. You need to be ready, you need to plan your shot, you will need your camera set up beforehand and possibly even get an expert to drop you in the exact position with the school coming towards you. There is no such thing as a lucky shot; you have to be ready and you have to be there.

Be careful not to end up in the middle of a shoal when there are predators about. For example on the sardine run in South Africa, you must be particularly careful to follow this rule. A shark or any other predator may not see you in time to stop its strike.

Exposure Control

Many of these schooling fish are silvery in colour and are therefore highly reflective. This means that the sun or your strobes will tend to overexpose the scales, so you need to be particularly careful with your exposure control – set your exposure for this reflection, not the background. In these circumstances where there are a lot of fast-moving animals, many photographers choose to select aperture priority. This may help but the camera's own light meter will tend to underexpose due to the

light reflecting off the fish so you may need to use the exposure compensation button and set your +/- to a positive number.

If all the action is going on near the surface it may be a better idea to use natural lighting, but make sure that you position yourself with the sun behind you. If you are in wide-angle and trying to photograph a large school of fish then it can be helpful to show some perspective, so try to compose your shot with a diver or a different animal in the background. If all else fails you could use the silhouette of the boat at the surface.

For many shots with schooling fish, you should be looking for that peak of the action moment. If there are no predators around this is unlikely to happen, but if you are privileged enough to be in the water with a large shoal of fish then there is usually some form of predation about to happen.

Schooling behaviour can be seen in many places all around the world. For many species, as you, the photographer approach them, then they will see you as the predator and may perform a display for you. In the Caribbean, on many of the larger wrecks there can be huge schools of Jacks swirling in a huge circle around the mooring line; in the Red Sea at

▶ Fig. 9.15
The anemone fish in this image is making sure that no-one else approaches his home. The shot is taken to show the environment as much as the fish. On a half-frame SLR like the D200, ƒ13 gives a large enough DOF to capture the habitat in focus. 1/250, ƒ13; ISO 200. Nikon D200, 60mm

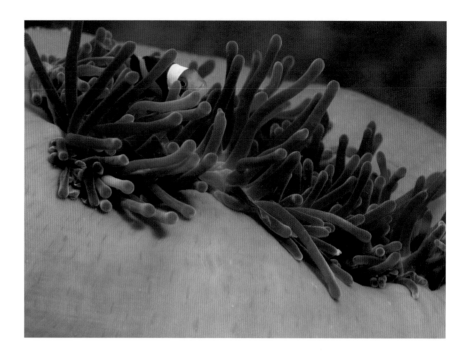

Ras Mohammed in the summer there are always, it appears, huge schools of snapper and bat fish swimming in giant 'herds' just off the reef wall; and in Malaysia you can very often see enormous schools of barracuda in formations that form a massive cone of circling predators rising to the surface.

DEFENDING TERRITORY

The territoriality of sea creatures usually offers some of the very best shots. Many species are territorial, and photographers can use this behaviour to their advantage. If you know that an anemone fish is going to dart up to your lens where it is possible they are seeing their own reflection in the glass, then you can prepare yourself for this and adjust the exposure settings in advance. However, it is not always the animal's home that it is protecting; it could be a specific area that it uses for food or it could be about breeding – or it might simply be the best place to hide from predators or photographers.

Probably the most photographed fish in the sea is the anemone fish. These colourful characters generally live in the same anemone for the duration of their lives, the stinging tentacles offering protection, a food source and a place to breed. The anemone fish have become immune to the stinging cells of the anemone, but few of their predators have. This is not a one-sided relationship; it is believed that these charismatic little fish clean the anemones and remove any parasites. In addition, their constant swimming motion keeps the anemone aerated and healthy.

If you want to get the best photographs of the defiant anemone fish, then watch it for a brief while from a short distance. As you approach, it may start to move towards you, and if it is protecting young then it is likely to get very close indeed. If you have a camera with a really fast focus, then use tracking mode and you should get a superb shot as the anemone fish approaches you. If your system has any kind of shutter lag this is much harder, but if you use focus lock and preset the distance then you are more likely to grab an in-focus Nemo when it comes into your pre-focused zone.

It is of course, not just anemone fish that defend

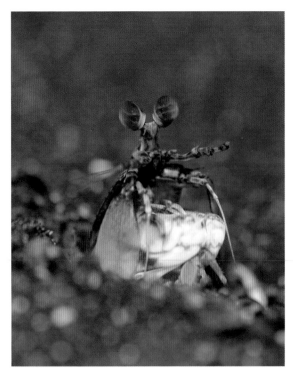

▲ Fig. 9.16
Mantis shrimps are particularly aggressive when defending their territory. If you move in too close to photograph, they may even run right at you. The eyes should be the focus; they move independently and are made up of thousands of individual cells.
1/160; ƒ4.5; ISO 200. Nikon D700, 105mm

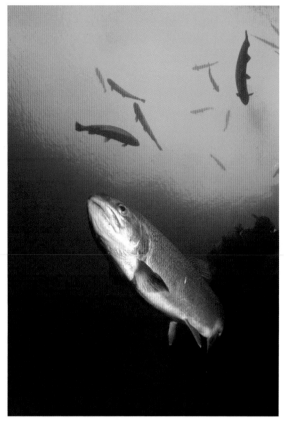

▲ Fig. 9.17
This trout was constantly circling, defending the feeding zone, and by tracking its movements I was able to predict where it would be to allow for the pronounced shutter lag of this much older-generation compact camera.
1/200; ƒ8; ISO 200. Canon A570.

their territory. Mantis shrimps make particularly inviting subjects, although they can move rather quickly. The eyes of the mantis shrimp are the most complex in the natural world, far more so than the human eye. A close-up macro shot of the mantis shrimp's eye will make a superb abstract shot, but be careful – the peacock mantis shrimp packs a very powerful punch and there are tales of photographers having the glass on their port broken by these feisty but endearing creatures.

Studying animal behaviour when they are guarding their territory is a great way to get a good shot. However, most animals, when protecting their territory, tend to move very quickly, and fast shutter speeds or strobe lighting along with careful focusing are really important to capture the action and get it in focus. If you are using a compact camera, this can

be frustrating, but if you watch your subject carefully and try to predict its movements, using focus lock and patience may reward you.

BREEDING TIME

When it comes to breeding in the animal world it can be a complex and sensitive time. The subject is a large one as it involves finding a mate, a place to guard the eggs, and protecting and bringing up any young individuals. The male of the species may have to battle with competitors in an effort to ensure

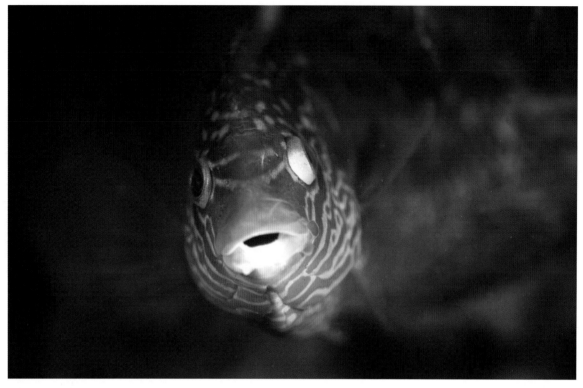

▲ Fig. 9.18
At breeding time, some species of fish become far more brightly coloured. This corkwing wrasse was in full mating livery and was defending his nest with vigour. The shot was taken with a very small DOF, with a large focal length for a macro lens.
1/100; ƒ6.3; ISO 400. Nikon D700, 105mm

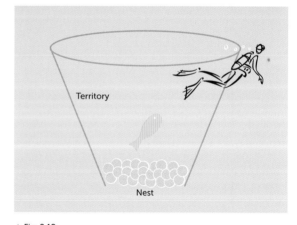

▲ Fig. 9.19
This diagram is meant to represent the conical area above the nesting site of triggerfish, which the fish sees as its own territory. If you enter that territory during nesting, the triggerfish, with big teeth, will pursue you. If you try to escape its jaws by heading upwards it will still pursue you, so the best way to remove yourself from the triggerfish territory is to move horizontally.

that it is his genes that are passed on, and the female cannot afford to make any mistakes with her choice of mate either. At breeding time the males will display, which can be a spectacular sight. For this short period many males exhibit bright colouring or elaborate tail fins that under normal circumstances would increase their chance of becoming prey. Of the several aspects of animal behaviour that you can use to get yourself a better shot, breeding and nesting time when the animals take to displaying, can provide the most stunning.

Most of the creatures under water tend to have a breeding period. During this time their behaviour will generally be more overt, dramatic and sometimes aggressive. Their colours and patterns tend to be brighter and more vibrant, sometimes looking quite different from how they normally would. If the animal you are trying to photograph is of a reasonable size, then you may need to be more cautious.

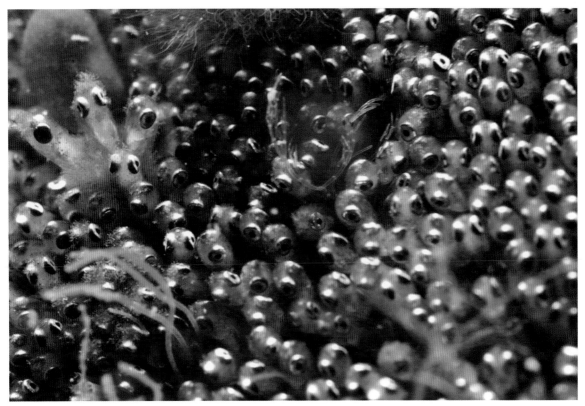

▲ Fig. 9.20
If you look carefully at the anemone fish eggs, you may see millions
of eyes looking back at you.
1/200; ƒ14; ISO 400. Nikon D700, 60mm

A triggerfish tending its nest can be a formidable creature and it has very large teeth. If you do find yourself being pursued, swim off horizontally, as most fish see a cone above its territory as its own, and unless you move out of that cone you are still its target.

In general, trying to get an image of mating marine life is not at all easy. This is a private affair and it leaves the animals vulnerable to attack, so generally they will not be happy at a cameraman watching what they are doing. You can of course observe the ritual behaviour beforehand and also the parenting behaviour afterwards as this can provide for some special images. When the fish are protecting their eggs, they will not move far away from their young. They will however be fast-moving and you will need a fast shutter speed or a strobe to freeze the action.

A pregnant male seahorse is an easy subject to capture, as they tend not to move too quickly and rely upon their camouflage to keep them hidden. Seahorses however are particularly sensitive to light, so if you are using artificial light then restrict the length of time or number of flashes that you use. If you are in a group of photographers all using artificial light, then the consequences for the seahorse could be catastrophic. Be considerate to the wildlife.

SYMBIOSIS

Symbiosis is defined as a close relationship between two different species, and although this relationship is not necessarily evenly balanced, there is always some benefit to one of the species, while the other may not be affected at all.

Mutualism is where both species benefit from the relationship, and there are many situations in the underwater environment where this takes place. This interactive relationship can lead to situations that provide some wonderful photography. One common example of this can be seen at a cleaning station. This is where one species offers its services to clean another species. The creatures performing the cleaning can be fish or shrimps and as they offer this service at the same place every day then you should have plenty of opportunity to organize your photography.

Another type of marine symbiosis is called commensalism, which normally occurs in species that are vulnerable to predation or have difficulty moving. Barnacles for example are really slow-moving animals, but by attaching themselves to fast-moving animals they can travel huge distances and benefit from the scraps of food their host has lost. An emperor shrimp riding on the back of the sea cucumber is another example of this kind of symbiotic behaviour.

Parasitic behaviour is another example of symbiosis. Parasites always benefit from their hosts, while usually the host gains nothing in return. The most successful parasites are those that do not kill their hosts or slow them down. It is the removal of these parasites at cleaning stations that provide some of the best photographic opportunities.

If you are looking to photograph symbiotic or parasitic behaviour, be aware that many of the symbionts and parasites are very small. Ideally, you will need a close-up, macro lens, and for the really small stuff, a magnifying glass can really be effective.

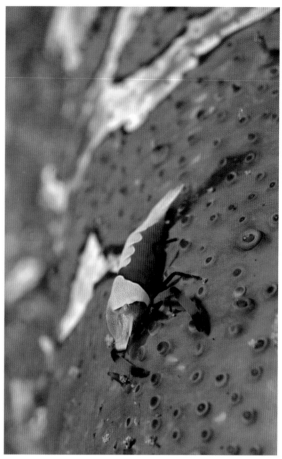

▲ Fig. 9.21
Emperor shrimps like to hitch a ride on passing sea cucumbers. The sea cucumber is not harmed, and may even benefit from the shrimp cleaning any parasites from its skin.
1/250; f13; ISO 400. Nikon D200, 60mm

Finally, there is the issue of human interaction with sea life. There are many places around the world where sharks, for example, are being fed by humans in order to be able to take photographs. Many non-divers view sharks as nasty animals to be avoided or destroyed at all costs, but as a diver you may have a different opinion. Chumming with sharks has certainly helped to raise global awareness of the plight of the shark, and it also provides fantastic opportunities for some great photography.

Fig. 9.22
Commonly seen on the back of whip gobies, parasites harm their hosts by taking nutrients. These spiral parasites can be clearly seen on a whip goby from Manado, Indonesia.
1/125; ƒ8; ISO 100.
Nikon D200, 60mm

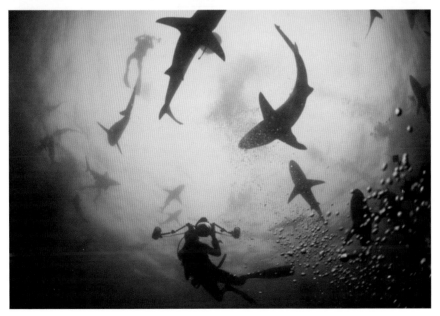

Fig. 9.23
This behaviour, seen off Aliwal Shoal in South Africa, is very unusual for blacktip sharks. This group has formed a permanent 'pack', possible due to tourism in the area. They are attracted to boats either fishing or throwing in food deliberately, so that underwater photographers can get these images.
1/200; ƒ10; ISO 400.
Nikon D200, 10–17mm at 10mm

There are, of course, many animals that are inquisitive and therefore will voluntarily interact with photographers in the water. The most common of these are manatees, seals and dolphins. While other marine life may tolerate you being there, or simply ignore you, some of these species will sense you are there, seek you out and positively encourage you to interact. Many will pose or demand attention and even stop in front of the camera while you capture your image. Some cleaner shrimp and wrasse will even see you as the next potential customer, and if you have a buddy or a dive guide willing to remove their regulator while the cleaners go about their business, then the photographic opportunity should be before you.

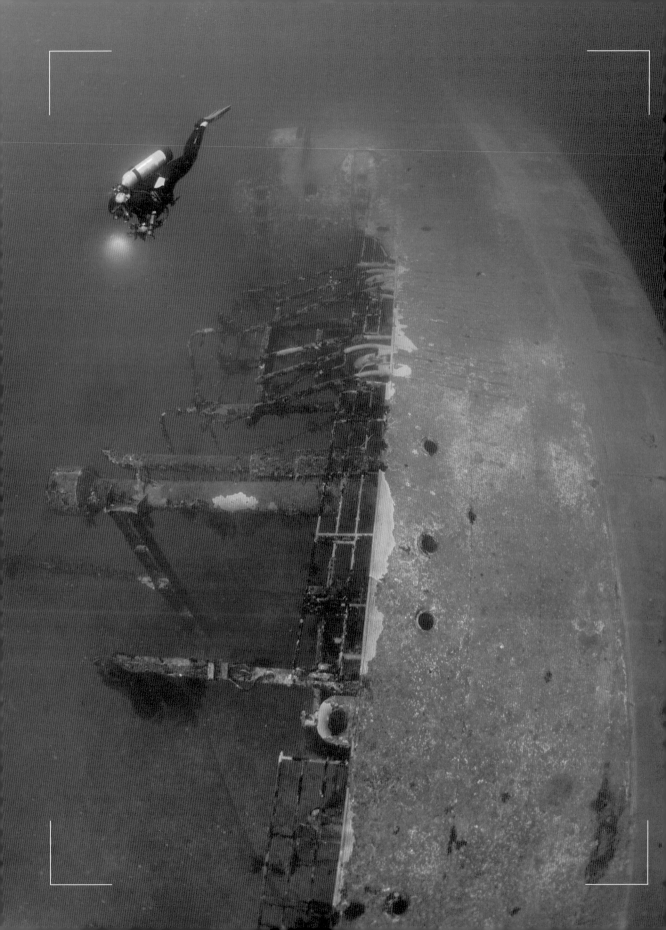

Chapter 10

Wreck Photography

Wreck photography is such a large subject that a whole book could be written on the techniques of how to capture the best undersea wreck shots.

Many non-divers, when they imagine a ship-wreck, find it evokes the whole idea of the underwater environment. You can show your wreck compositions to your family and friends to impress upon them how imposing or provocative a wreck can be and just how privileged you are to be able to have captured these images yourself. Every wreck will have a story, and creating a profile of your wrecks with their own individual history is another way to express your passion. Many wrecks have been sunk where souls have died, and while many of these are sacred and diving is forbidden, some are not. One such example is the *Salem Express*, a few hundred metres off the coast of Hurghada in the Egyptian Red Sea. Littered all around the wreck is the evidence of a sudden sinking, with lifeboats still hanging from their derricks.

Nearly all the techniques that are used for wreck photography involve the use of a wide-angle or fish-eye lens. A standard lens can be used for picking out individual artefacts and small features of the wreck, but if you want to take some serious wreck shots, then you need to invest in a wide-angle, preferably a fisheye, lens.

▲ Fig. 10.2
One of the lifeboats still hanging from the derrick of the *Salem Express*, which sank in the Red Sea. The image captures the tragedy where the ship sank so quickly that the lifeboats did not get used. 1/50; ƒ8; ISO 200. Nikon D200, Tokina 10–17mm at 10mm

If you are going to do some close-up wide-angle shots, then you will need some form of lighting so that you will be able to illuminate the foreground. However for a lot of the wide-angle photography you can turn the strobes off, white balance the camera and use natural lighting. You may wish to consider taking a tripod with you, and using long exposures to be able to capture your image. This will allow you to use a high ƒ-stop, giving you a greater depth of field and also eliminating backscatter.

◀ Fig. 10.1
This image was taken of the *Charlie Brown*, a 100m long cable layer that was deliberately sunk to create an artificial reef in 2003 in St Eustatius. The image is taken in excellent visibility and the diver has been asked to get into that position to give perspective and scale to the overall image.
1/100; ƒ10; ISO 400. Nikon D700, 16mm

▶ Fig. 10.3
Another image of the *Salem Express*, this time showing people's belongings strewn by the side of the wreck, to help to create the feeling of the huge loss of life.
1/80; ƒ9; ISO 640.
Nikon D700, 16mm

COMPOSITION

When the visibility is good and you can see the whole or most of the wreck, it hardly matters what angle you compose your shot from. Wrecks make great subjects whether you shoot from side-on, head-on looking up or looking down – the secret is where to place your model. If the visibility is poor, include big fish, shoals of fish or look for the arte-facts and features, like coral growth or anemones. Shoot against these into the light to create silhou-ettes – or use artificial lighting to create a balanced light composition.

Many wreck shots taken in poor visibility actu-ally look better if they are converted to black and white in the editing suite. It is better not to set your camera to shoot in black and white – you can always convert to black and white later but if you shoot in monochrome you cannot go back. Another technique for poor visibility wreck photography is to turn the ISO up high. The excessive noise gener-ated by being at a high ISO setting will make your image look grainy and only add to the old-fashioned appearance of your image, giving it character. It will also allow you to raise the ƒ-stop number, which will give you a greater depth of field for the wreck.

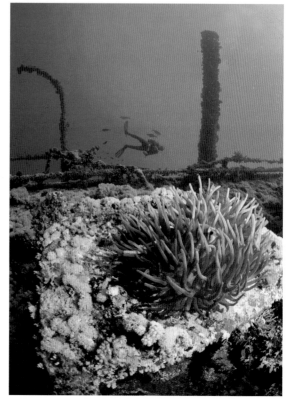

▲ Fig. 10.4
An anemone and its guardian fish have been lit in the foreground as the focal point of the wreck shot. This can work very well if the wreck is in poor visibility.
1/100; ƒ11 ISO 400. Nikon D700, 16mm

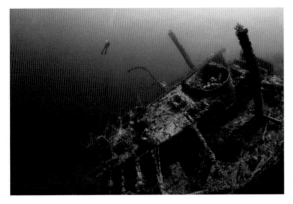

▲ Fig. 10.5
The wreck of the *Numidia*, off Big Brother Island in the Red Sea, which is great to photograph with natural lighting as the top is at 10m. This image has been de-saturated to give a silvery-blue effect, and the diver in the background helps to give scale and perspective. 1/80; ƒ9; ISO 200. Nikon D200, 10–17mm at 10mm

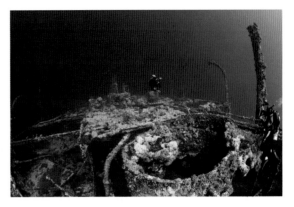

▲ Fig. 10.6
Another shot of the *Numidia*, from a different angle. This image has also been de-saturated.
1/80; ƒ9; ISO 200. Nikon D200, 10–17mm at 10mm

There are so many ways to photograph a wreck and often it can be purely subjective. One, some-what protracted, way to decide how you want to photograph the wreck, is to do a recce dive first. If the wreck is large and deep this may be impractical or may take several dives. However, if you have the time and you really want to get the best possible shot of the wreck, take your camera and make sure you get plenty of shots from different angles. Look at the images you have captured on a large screen and decide which ones you think would create the best angle.

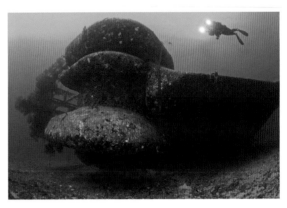

▲ Fig. 10.7a
Charlie Brown wreck, St Eustatius, with a diver hovering off the bow.
1/100; ƒ10; ISO 400. Nikon D700, 16mm

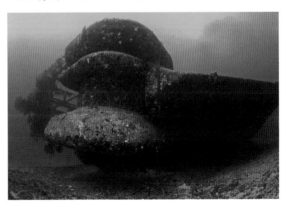

▲ Fig. 10.7b
The same image as shown in Fig. 10.7a, but the diver has been removed in Photoshop, which gives you the opportunity to directly compare the two images: most people would say that the addition of the diver add impact and scale.

TECHNIQUES

Size and Perspective

When photographing a wreck, one way to illustrate the size and scale of the subject is to shoot from the bow of the ship. If the visibility is good, then shooting slightly down with the sun behind you will capture the size and perspective of the whole wreck. By shooting down with the sun behind you, contrast and definition will be far better than shooting into the light. If you have a model willing to shine a light at you, then this will add scale and depth and also

enhance your image. Your buddy may not be willing to do this, but there are usually other divers on the wreck at the same time as you, and if you can be the first one in the water then capture the divers descending onto the wreck as you hover above the wreck. Make sure you capture plenty of images of them – as they descend, as they are level with you and as they go beneath you. The streams of bubbles caused by the diver's exhaust all adds to the effect.

By contrast, shooting upwards towards the wreck is probably the best way to show off the size and wonder that a large wreck can create.

While it may be hard to establish any rules for photographing shipwrecks, it is very difficult to find a really good wreck shot which does not feature a diver, or divers.

Small Wreck

If the wreck is small, and the visibility is good, it is the perfect opportunity to get a whole wreck shot. Where you can get the whole of the wreck in your image it can be very difficult to decide which angle is best. Even shooting from the stern, or back of the boat, can work really well, especially if the wreck still has its propellers and they are visible. Normally, the rear view of any subject is not the best image but because the propellers are such an important part of the subject they can make a really good shot even if you are using a standard lens.

If you can safely get into the wheelhouse, try shooting out through the windows overlooking the bow, but be careful not to damage any coral that may have formed; ensure you have the diving quali-fication to do this and be particularly careful with your fins. There is nearly always sediment inside a wheelhouse, and not only will this ruin your shot, it may make it difficult to see your exit. If going into the wheelhouse is an option for you and you are with a dive group, try to be the first one there before half a dozen sets of fins destroy the visibility.

As you move around the small wreck be aware of where the sun is. Whether you are shooting up at

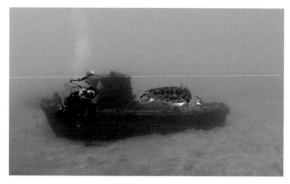

▲ Fig. 10.8
This image of the tug boat taken side on illustrates that if you can get the whole wreck in the frame, where it is taken from is not as important as it is with many other subjects. In this instance, the presence of the diver photographing the turtle renders the tug as the background rather than the subject.
1/100; ƒ8; ISO 100. Nikon D200, 10–17mm at 10mm

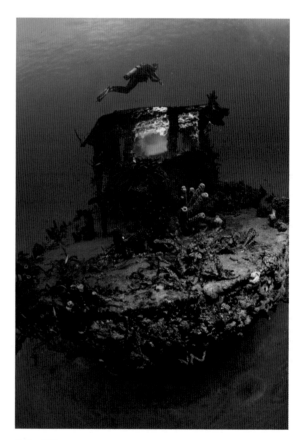

▲ Fig. 10.9
Head-on, the tug boat has an entirely different feel to it. This image was taken with remote lighting to enhance the colours inside the wheelhouse. The obligatory diver is hovering above the wreck.
1/60; ƒ14; ISO 200. Nikon D700, 16mm

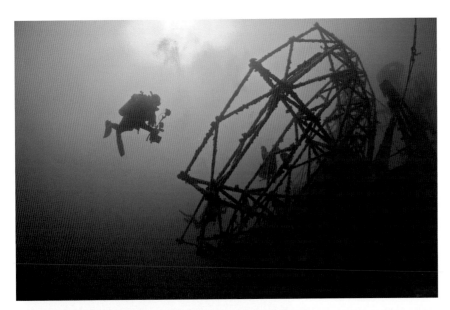

◀ Fig. 10.10
Shooting into the light can be a bit of a gamble. Too often the camera will struggle to cope with the dynamic range of the sun, but if you are deep enough, or your camera is good enough, it can create a wonderful image.
1/250; ƒ10; ISO 320.
Nikon D200, 10–17mm at 10mm

▲ Fig. 10.11
Getting your buddy to look through a gap or window inside the wreck creates a natural framing. This image was taken on the *Adolphus Busch* off Big Pine Key, Florida.
1/160; ƒ9; ISO 200. Nikon D700, 16mm

the wreck or down at the wreck you need the sun to be behind you. If you are shooting across the wreck the sun's position is not quite so important, but it will still play a major part in your composition if the sky is cloudless. If the sun is in the wrong position, is it possible to dive the site at a different time of day when the sun is in a different position?

Large Wreck/Features

If you are diving a large wreck and you have taken all the shots you want of the whole ship, then if the wreck is reasonably intact, photographing features and artefacts is also important, especially if you are intending to document the wreck. These features can often tell the story of the wreck, and give clues as to what kind of ship she was. A military vessel may still have a gun on the deck; not only are these important features to capture, they can actually make some of the most interesting images from the wreck. Shoot them as silhouettes against the light or use your own lighting to illuminate the underside while, again, shooting towards the surface.

Some of the interesting features may well be inside the wreck, and if you have the qualification to penetrate the wreck, then engine rooms and cargo, especially military cargo, help to tell the story of the sunken ship. Lighting is particularly important for shots inside the wreck, and if you can get to the subject before other divers, then you are less likely to be faced by a cloud of sediment.

Remember that wreck diving is potentially hazardous and you must ensure you have the skill, the qualification and the knowledge to do this. Many wrecks lie in water that is deeper than most reefs, and when you are trying to focus on getting your photography right it is very possible to lose track of the depth you are at and hence, your no decompression limit. Bear in mind that you will also be using more air trying to control your buoyancy to compose your image and also because you are deeper. Your well-being, and indeed that of your buddy, is far more important than your photography.

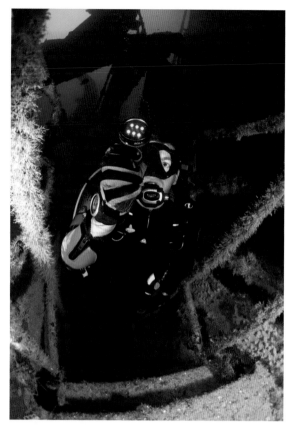

▲ Fig. 10.12
A diver ascends the steps, having penetrated one of the rooms below.
1/125; ƒ6.3; ISO 200. Nikon D700, 16mm

Marine Life

One of the other advantages of shipwrecks, particularly the larger ones, is that they attract marine life. Many photographers are not particularly interested in the metal structure but are drawn to the wreck solely to photograph the marine life that it attracts. Not only is it an artificial reef which many fish use as a creche for the young, it also provides nooks and crannies for animals like octopus and turtles. Often large swarms of schooling jacks can be seen swirling around the mooring line and, if you are really lucky, the wheelhouse of the wreck itself.

If you are diving the wreck with a standard lens, then the corals and sponges that have grown on the wreck provide shelter for many smaller animals and there are usually many opportunities for macro

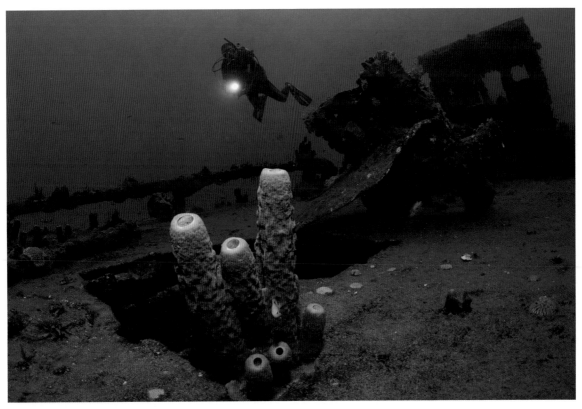

▲ Fig. 10.13
A classic wreck shot with a colourful sponge in the foreground as
the subject and a diver hovering with a light just off the port side of
the wreck.
1/60; ƒ11; ISO 200. Nikon D700, 16mm

and close-up photography. The brightly coloured
anemones make fabulous images in their own right.

Many wrecks make the perfect subject for off-
camera creative lighting. This idea, which was dealt
with in more detail in Chapter 6, can provide some
really different and stunning shots. It involves firing
strobes remotely so that the light will illuminate an
area away from the camera. This can be done with
video lights too, but they will need to be powerful in
order for the light and colour to carry to the camera.
A quick and easy way to do this is to ask your buddy
to remove the covers from the light sensor on his or
her strobes and to use your own strobes to trigger
those of your buddy.

This chapter has only scraped the surface of what
you can do and how you can photograph wrecks.
They are fascinating subjects, and most wrecks that
have been down for some time will be teeming
with wildlife, anemones, corals and sponges. There
are many underwater photographers who like to
specialize in wreck photography, and if you find
that this is what appeals to you then once you have
tried some of the techniques listed here, you should
be ready to move on and discover your own art and
techniques.

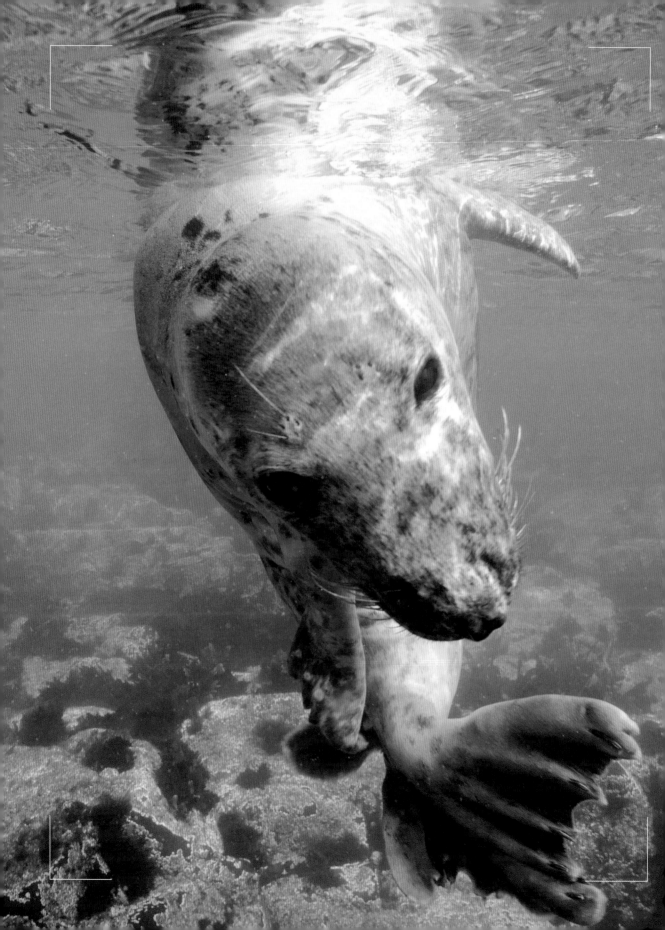

Chapter 11

Low Visibility

Taking images in low visibility is something that all underwater photographers will encounter at some time. Visibility can be perceived as an estimation of water clarity, usually specified as the distance one can see horizontally. In poor visibility objects become colourless, with poorly defined shadows, and judging distance becomes nearly impossible. Very often, you can look down into the water from the surface and the visibility will appear to be very good, yet once you are in the water visibility in the horizontal plane can actually be very poor.

BACKSCATTER

The biggest single challenge that underwater photographers face in poor visibility is not the light loss, as this can be overcome by using artificial lighting. It is also not colour loss, as using white balance correctly or artificial lighting will restore colour into the image. The most problematic issue is backscatter.

Backscatter is caused when the light from the strobe or continuous light source strikes tiny particles in the water and this is reflected back into the camera lens. To make matters worse, any of the particles in front of the image that are not in focus will refract the light, and this will make them appear larger, an effect which can totally destroy an otherwise superb image. Compounding this

phenomenon is the fact that when using a strobe the effects of these particulates cannot be seen by the photographer until the image is reviewed. It can be very difficult to see on the screen, even zooming in, and besides, at this point it could be too late – the subject may have swum away or disappeared into a tiny crevice in the reef.

One of the principal components to bear in mind when photographing in poor visibility is the ambient light. Available light can make a huge difference to the way we use artificial light to illuminate the image. If the sun is out then the availability of natural light is greater than when it is a cloudy and overcast day. This can improve the visibility, but sometimes it can make it worse. It depends where the sun is in the sky, or where you are in relation to the sun. In nearly all circumstances, it is better to shoot with the light behind you, unless you are specifically intending to shoot into the sun. This is also true if you are shooting downwards.

It is not just the amount of daylight above the water that affects the quality of the photography under water; the weather conditions will also affect the amount of light breaking the surface. If the sea is choppy then not only will the bottom be disturbed by the water movement kicking up the substrate, but less light will enter the water (as explained in Chapter 4). The angle of the sun makes a huge difference to the amount of light that can penetrate the water. A choppy sea will reflect more of the sun's rays upwards, and the lower the sun is in the sky, the greater the angle that the rays will hit the water. This will cause the light to skim off the surface and reduce the amount of light available to you under water. These effects are known as radial light factors.

◀ Fig. 11.1
This image was taken in low visibility, and staying close to the surface meant there was more natural light and the strobes could be turned down or off.
1/160; ƒ7.1; ISO 400. Sony NEX-5, 16mm

SOME CAUSES
OF POOR VISIBILITY

Rain

Water running off from rivers and from the land brings mud and small fine particulates that are easily stirred up by surge or divers' fins. Pollutants such as phosphates and nitrates are brought into the oceans by such run-off, and this feeds microscopic organisms.

Strong winds and waves

The wind and the waves can cause surge in the water and stir up the sand and sediment on the seabed, lifting it into the water column where you are trying to photograph.

Strong currents

Strong currents can sometimes help by moving the particulates more quickly, but very often they can bring poor visibility if the direction of the current brings particulates from another area of low visibility.

Fins

Of all the factors that affect visibility under water the most common cause of localized poor visibility is careless finning. If you are under water with a camera, nothing is worse than seeing a beautiful reef suddenly clouded over by another diver not thinking about the effect that his or her fins are having. It is quite possible, and not that difficult, to move only inches over fine sediment if you use your fins properly.

Some fins are less prone to kicking up the silt than others, and those fins that may be ideal in strong currents and extreme environments are probably not the best fins for an underwater photographer. Using split fins properly by gently finning from your ankle is probably the least destructive in terms of sediment disruption. A good dive school could help you with these techniques.

▲ Fig. 11.2
This image was taken deliberately to show backscatter.

PLANKTON

When you do encounter poor visibility under water, suspended inanimate particles and microscopic animals and plants are usually the principal cause of discolouration and poor definition. Whilst many of these particulates are too small to be seen with the naked eye, when present in high levels of density they can, and do, cause serious loss of visibility.

Phytoplankton

Phytoplankton tends to be the principal organic culprit of poor visibility (the name comes from the Greek *phyton* and *planktos*, meaning plant and wander respectively). It can give water a green colour, which is due to the chlorophyll in the cells, like those you can see in the leaves of plants and trees on land. However, the colour can vary depending upon the species, and some may have additional or accessory pigments.

Phytoplankton tends to live in the euphotic zone, or daylight zone, which is where the light is, and therefore near to the surface. It requires light to photosynthesize (the process of converting light into energy), so as a result, the more dense that the plankton becomes, then the thinner the layer, as those at the bottom of this platform try to get closer to the light. Unfortunately for the photographer, under these conditions the light beneath this plankton 'mat' can disappear almost entirely.

As phytoplankton is dependent upon minerals such as phosphates or nitrates, run-off and discharge from the land, industry and golf courses has been shown to raise phytoplankton levels locally.

Zooplankton

Zooplankton are less likely to cause problematic low visibility (*zoo*, from the Greek meaning animal, and *planktos*, meaning wander). However, they do contribute to the reduction in visibility and are worth looking at in an underwater photography study if only because they can make wonderful imagery.

Zooplankton comes in two main forms. Zooplankton in embryonic form such as a larva or eggs cause a temporary low-visibility problem. They are referred to as temporary plankton and tend to be close to the coast and seasonal; however, because the different parent species also tend to be seasonal, where zooplankton occurs it is usually present all year round. Permanent plankton is made up of thousands of species; the numbers of protozoans, foraminiferans and radiolarians are so abundant that

▲ Fig. 11.3
Diagram of plankton mat, low density.

▲ Fig. 11.4
Diagram of plankton mat that has formed a very dense floating carpet that blocks out much of the light below.

much of the seabed is made up from their calcified skeletons. Protozoans are ciliated, which allows them a small degree of movement; they are tiny, but can appear in such vast numbers that they may have a seriously negative effect on the horizontal visibility.

DENSITY GRADIENTS

Thermocline

A thermocline is a temperature gradient and can be seen as a layer of water, sometimes over half a metre thick, where this stratum of cold water meets a layer of warm water. They are particularly prominent in

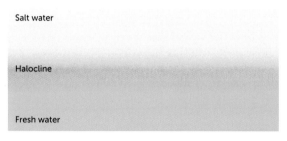

Salt water

Halocline

Fresh water

▲ Fig. 11.5
Diagram of a halocline.

tropical waters but not necessarily uncommon in temperate or cooler water. It is caused by the cold water and the warmer water having different refractive indices, which creates a similar effect to seeing warm air rising off hot tarmac or looking through spectacles that are far too strong for the user.

A thermocline tends to be seen as a transient effect on visibility, as once you are through the temperature gradient on your descent the visibility will revert to normal. However, if the subjects you are looking to photograph are sitting in the thermocline you will find it almost impossible, unless you want a psychedelic, marbled effect.

Halocline

A halocline is a salinity gradient, which occurs where there are two layers of water, one more saline than the other. The halocline is usually formed when water evaporates from the surface, concentrating the salt and leaving a layer of higher salinity. Where the two meet there is a hazy blurred interface, which is usually only seen when diving in conditions that are very calm and still. Because the upper layer becomes denser, and therefore heavier, this layer of blurry water is caused by the mixing of the high salinity water trying to descend and the lighter salinity water trying to rise.

A halocline can also be formed from freshwater run-off lying on the top of seawater. Where this occurs, the effect can be much longer-lasting as the freshwater is lighter than the seawater and hence the mixing effect will take much longer. An example of this version of a halocline is the freshwater run-off from the mountains of Scotland onto the waters of the sea lochs.

LENS SELECTION

When taking photographs in poor visibility it is generally very difficult indeed to get any worthwhile images if you are using a wide-angle lens. When the visibility is really poor, realistically it is only viable to take macro and close-up shots. One exception to this is to mount the camera on a tripod and use a long exposure. Because the particles are moving across the frame, they will not be visible on the image.

For the macro shots, it is vital that you choose a lens that will allow you to get as close to the subject as you possibly can. This way you will minimize the water column (the amount of water between your subject and the lens) and hence, the number of particulates in that column. If you are looking to buy a lens for your close-up and macro work and you use an SLR or mirrorless camera, check the minimum focusing distance of the lens. If you are likely to be photographing in areas of low visibility, then you need a lens that has a minimum focusing distance of no more than 200mm; less is even better.

There are some lenses that are great macro lenses in normal conditions but really will not work when the particle count is high. This tends to happen more with the higher focal length lenses, such as a 105mm intended for an SLR. One of the main issues is auto focus. The lens will constantly try to refocus on the many particles passing between you and your subject, and you will become increasingly

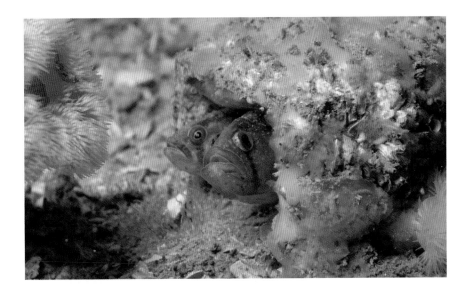

Fig. 11.6
Taken under a pier in Wales, this image was shot in very poor visibility. The high ƒ-stop assisted in reducing the effects of the particulates in the water.
1/160; ƒ22; ISO 500.
Nikon D700, 60mm

frustrated as you try to get a bead on your subject. Under these circumstances, use manual focus if you have the facility, or focus lock on a known distance and hold the focus with the shutter half-depressed or with the focus lock button.

Whichever lens you choose, and however you decide to focus on your subject, get as close as you possibly can to the subject. Then, if you can still focus, get even closer. There are not many rules in underwater photography, but a very useful mantra is to get close, get closer and then get even closer.

SETTINGS

When there are numerous particulates in the water, one way to avoid getting any backscatter is to shoot with no artificial light. However, as poor visibility tends to suggest low light levels, this could prove to be difficult. If you have played with the basic facilities of your camera, then you should know the highest ISO you can use before the image starts to become too noisy. Of course, if the visibility is poor then a little bit of noise in your image is going to be fairly well disguised by all the particles in front of your lens.

USING THE FOCUS LOCK

You can practise using the focus lock in the comfort of your own home.

Exercise 1

If you have a focus lock button try focusing on an object, lock your focus and move your camera to your subject, and you will see by moving the camera backwards and forwards you can effectively manually focus on the subject. Some cameras have this facility by holding the focus lock with the shutter half-depressed.

Exercise 2

Find yourself an object to photograph that has either good contrast or definition – fake aquarium coral works well – and cover it in a piece of window netting. Shine a light onto the subject through the netting, and then try to focus and take images of the object beneath the netting. Using the camera's autofocus system you will find it is particularly difficult. However, if you try using the camera's focus lock, then this should provide you with much better results, and you will learn a lot about your camera and your own patience by practising this.

▶ Fig. 11.7
Diagram to show side
lighting to reduce the effects
of backscatter.

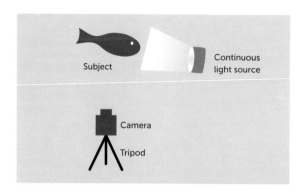

▶ Fig. 11.8
Tube worms hang off a
demolished pier in Loch
Long, Scotland. Using a
relatively slow shutter speed
allows the strobes to be set
to a lower power setting.
1/60; ƒ8; ISO 400.
Nikon D700, 24mm

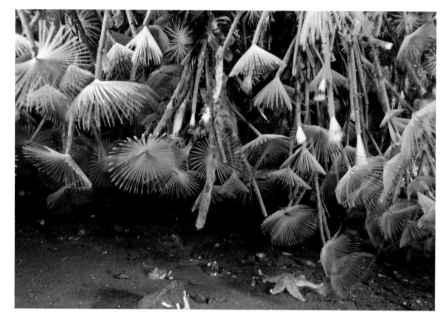

Using a high ƒ-stop number will give you a
greater depth of field, and as you may remember
from Chapter 6 the size of the particulates is
increased if they are out of focus, due to refraction.
If there is sufficient light to use a high ƒ-stop, then
do so, as this should put everything in your image in
focus, including the suspended particles, and if they
are in focus they will not appear quite so large. You
may need to really push your ISO number in order
to be able to use a high ƒ-stop, and you will need
a relatively high shutter speed too, especially if the
particulates are moving across your line of vision in
the current. If they are out of focus then the refraction
will make them appear larger than they are.

If you are using a strobe then you will need to
put the flash settings in a position that allows for
the minimum – or certainly a very low – power
output. The idea is to try to put just enough light
on the subject to restore the colour. Alternatively,
you can try using one of the techniques discussed
in Chapter 6, whereby you remotely mount your
strobe, or video light, on a tripod and position it
near your subject. The beam would then be at right
angles to the camera.

As with shooting without any artificial light, push
your ISO number as high as your camera will allow
without making the picture too noisy. This will allow
you to bring down the power setting on your lighting.
Using a high ƒ-stop number to increase your
depth of field will also help to minimize the effects

◀ Fig. 11.9
Trying to capture a tiny
shrimp moving rapidly in the
water is difficult and in very
low visibility it is even harder.
Strobes were used to freeze
the action, whilst ƒ10 and
a relatively low DOF on a
full-frame camera blurred the
unwanted background.
1/100, ƒ10; ISO 320.
Nikon D700, 60mm

of any backscatter. There is a trade-off here between using the minimum amount of light and how wide you set the aperture. If you are using a strobe then you can bring down the shutter speed as the flash will freeze the action. This will allow you to raise the ƒ-stop number while keeping the exposure value constant. This method is not necessarily absolute.

Using a low ƒ-stop number with a small depth of field and a small stroke of light from the strobe can sometimes work too. If you find yourself in a situation where the visibility is seriously poor, then try both methods and see which one works best for you and your camera.

Remember the exposure triangle when you are

under water and when you are taking photographs, it should be imprinted in your brain. Changing one component of the triangle will have a systemic effect and as a consequence, you may need to alter one of the other components.

VERTICAL VISIBILITY

Visibility up or down is nearly always better than the horizontal visibility. Shooting down with the sun behind you will usually allow you to see more. Even if the sun is in front of you, the bright light will give you superior vision looking down than if you are shooting horizontally. Shooting towards the sun in poor visibility does not generally work, but sometimes it just may be worth trying, if only to see if you can get some unusual effects.

Should you decide you want to measure the visibility then a Secchi disk can give a very good approximation. It is a circular disk divided into four quadrants, the opposing quadrants of black and white, which was designed to measure the vertical water transparency. The disk is placed on the end of a pole and lowered into the water. As the disc is lowered, the contrast between the black and the white reduces, and when the eye can no longer differentiate between the two then that is the distance considered to be the extinction coefficient – the amount of visibility. If you want to know a good approximation of the visibility under water than try this process horizontally, by getting your buddy to move away from you while holding the Secchi disk in your direction.

Taking photographs in low visibility is a challenge, and it is very unusual that an image taken in really poor visibility can compete with the quality of an image shot in clear crystal water. However, there are many environments around the world where the visibility is never particularly good, and if you happen to live in this area and dive in this area then

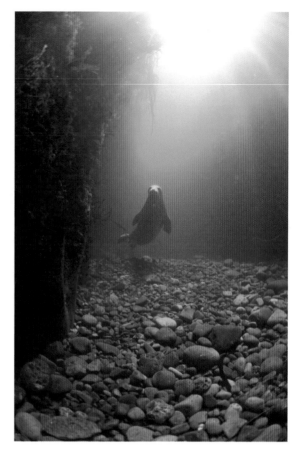

▲ Fig. 11.10
Shooting into the sun in a low visibility environment is something to avoid. However, sometimes these rules are meant to be broken. This image was taken without the use of strobes, and high ISO which allowed the use of a fast shutter speed to capture the moving seals without blurring.
1/500; ƒ7.1; ISO 1000. Nikon D700, 16mm

it is a challenge you may need to confront. If you do have to dive regularly in poor visibility then techniques using a tripod and slow shutter speeds are probably the best way to overcome the low visibility. Practise using the focus-lock method at home, preferably with the camera in its housing so you become familiar with where the buttons are. Finally, it is probably worth mentioning that when you have mastered the art of photography in poor visibility, when confronted with crystal clear water you will find it very easy indeed, by comparison.

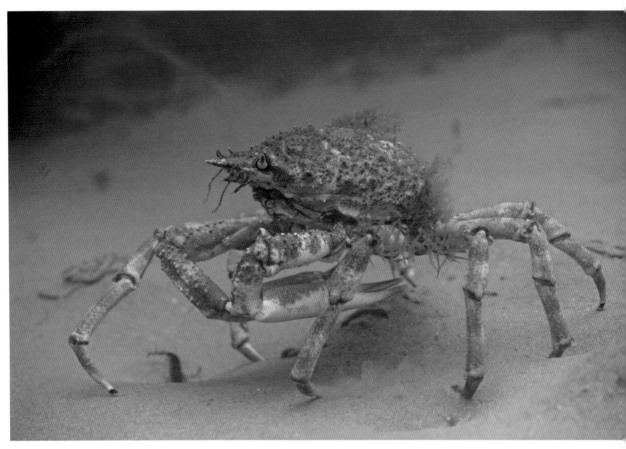

▲ Fig. 11.11
This spidercrab scuttling across the sand was taken close-up with a
low ƒ-stop to blur the background.
1/100; ƒ6.3; ISO 400. Nikon D700, 105mm

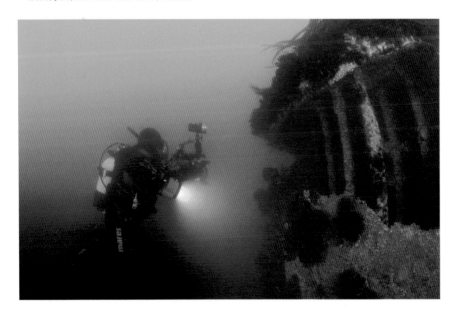

◄ Fig.11.12
The conditions really were
terrible for this shot. It was
cold, there was about 2m
(6ft) of visibility and the
current was running. Whilst
the diver with the gloomy
light gives atmosphere, there
were so many particles in the
water that the photographer
turned his powerful video
light off to minimize the
backscatter.
1/125; ƒ5.6; ISO 160.
Nikon D200, 10–17mm
at 10mm

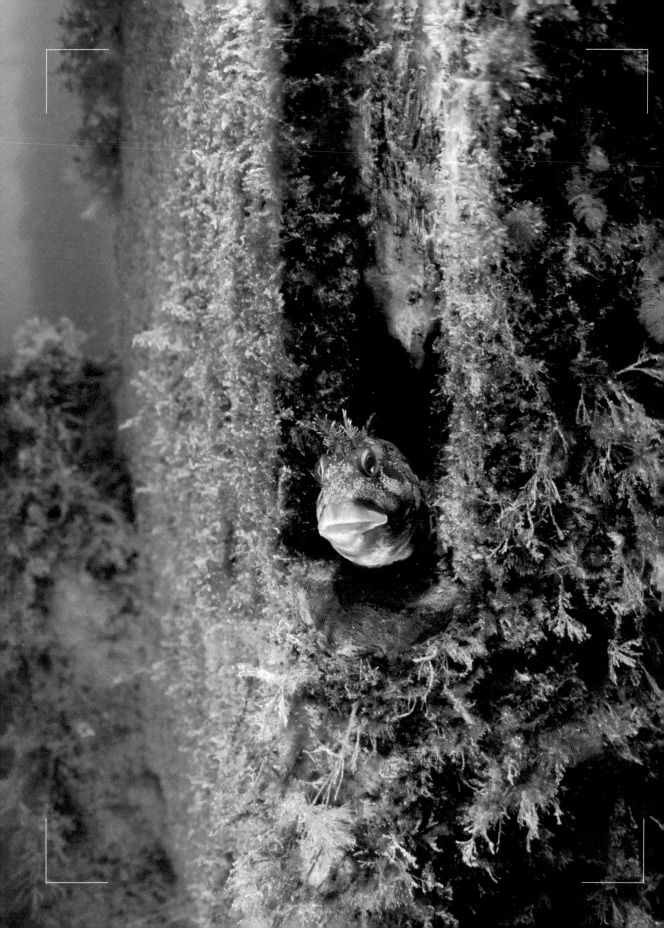

Chapter 12
Habitats

When you are looking for specific crea-tures to photograph, it is really helpful if you know where you can find them. Different animals have become adapted to living in different environments; they have found their own little corner of this planet to live in. Chapter 9 touched on the subject of adaptation, discussing colouration and shape. This chapter is a short guide to assist you in understanding which creatures you might find in any specific environment. Keep in mind that nature is never a certainty, however. You may find yourself in a sandy, muck diving site expecting to find the weird and wonderful, when suddenly a lone Spotted Eagle Ray swims majesti-cally straight towards you as you are focusing on a beautifully coloured nudibranch.

▲ **Fig. 12.2**
An underwater photographer approaches an impressive array of barrel sponges. The image has been taken with a strobe set to high power on the right and low power on the left, to create shadow and depth.
1/125; ƒ13; ISO 200. Nikon D700, 16mm

TROPICAL LOCATIONS

Coral Reefs

Coral reefs can be visualized as the rainforests of the underwater world. Most of the coral reefs of tropical waters are full of colour, teeming with wildlife and abundant with corals, anemones and sponges. They also offer a particularly varied kind of photography, as you can go hunting for miniscule gobies and seahorses or shoot the whole scene in wide-angle. There are so many different kinds of mini habitats within the reef that as a photographer you can be spoiled for choice, and choosing the right lens can be a challenge. The coral reefs are generally alive with colour and are ideally suited to artificial lighting techniques.

Mangroves

Under the water near the mangrove's root systems is a place that is rarely captured by the underwater photographer. The protection offered by the man-groves is ideal for small fish and juveniles, although in some parts of the world you may find the odd alligator or crocodile. The mangroves offer the perfect opportunity for split shots, and because they tend to be shallow they are really suitable for natural light photography, but this does not exclude using artificial light.

◀ **Fig. 12.1**
This tompot blenny has made its home in the strut of a pier at Swanage in the south of England.
1/250; ƒ5; ISO 400,. Nikon D200, 10–17mm at 17mm

▲ Fig. 12.3
Seagrass can be a crèche for all sorts of juvenile creatures.
1/250; ƒ6.3; ISO 400. Nikon D700, 60mm

Seagrass

There are many divers who would not bother diving in the sandy beds of seagrass, as they can be considered too sparse. However, with a sharp eye or a good guide you can often see many critters in the seagrass. It is typically the habitat for seahorses, various pipefish and other smaller stuff. Very often you can find turtles, various kinds of ray and if you are in the right areas of the world you may be lucky enough to see a manatee or a dugong.

Sand

Diving in sand is probably not everybody's idea of a perfect dive, and if you have your camera with you then there probably will not be much to photograph. However, there are places around the world where you can find creatures that like to hang around on the sand. In the Caribbean for example southern stingrays like to rest on the sandy bottom, and if you catch them at the right time of day you may be able to get very close.

Sandy areas may also hold secrets from the past, especially if it is in a sheltered bay. There are many places around the world where ships have gone down and all the wreckage has disappeared. However, periodically big seas and storms can kick up the bottom revealing artefacts from the past. For example off the tiny Caribbean island of St Eustatius just north of St Kitts, divers regularly search the bay for slave trading blue beads.

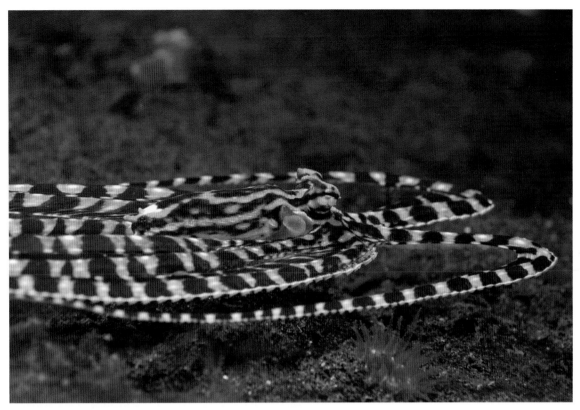

▲ Fig. 12.4
Muck diving, or exploring sandy ocean bottoms, can reveal the
weird and wonderful. This mimic octopus was spotted zooming
along the sand to avoid the paparazzi.
1/250; ƒ10; ISO 400. Nikon D700, 60mm

MANMADE STRUCTURES

Wrecks

Wrecks can be the most amazing habitats for wild-
life. There are many underwater photographers who
see the wrecks as sunken vessels with a history to
be photographed in their surroundings. However, to
others, a wreck can be seen as an entire ecosystem
for all the animals that inhabit it. When wrecks are
sunk, they take time to mature and it can be years
before they eventually become a fully evolved reef
system in their own right.

When wrecks first go under water, be it deliberate
or accidental, it usually takes several months before

life starts to take over. Initially it is usually larger
schooling animals that inhabit the wreck, but slowly,
as the soft corals and algae start to grow on the
structure the smaller fish and creatures start to ap-
pear and make it their home. Depending on where
in the world the wreck is, it can often be regularly
inhabited by larger pelagics like tuna, barracuda and
possibly sharks.

Even long after the structure of the ship has
disappeared, the remains of the vessel, which may
include ballast bricks like the wooden ships that
sailed the Caribbean, can become a fully-fledged
coral reef that may be completely surrounded by
sand. It is really useful to have a local dive guide for
these reefs as the inhabitants rarely move away if

▶ Fig. 12.5
Sometimes the artefacts from
wrecks can make interesting
subjects. This 300-year-old
anchor is encrusted with
corals and serves as home to
many creatures.
1/125; ƒ10; ISO 200.
Nikon D700, 16mm

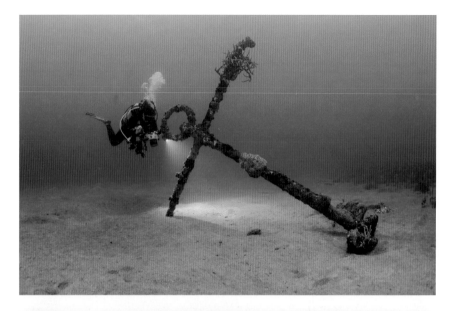

▶ Fig. 12.6
These shannies can often
be seen hiding in the nooks
and crannies of man-
made structures. They
have wonderful faces full
of character. This one was
wedged in a crack in a
concrete pier wall.
1/100; ƒ25; ISO 400.
Nikon D700, 60mm

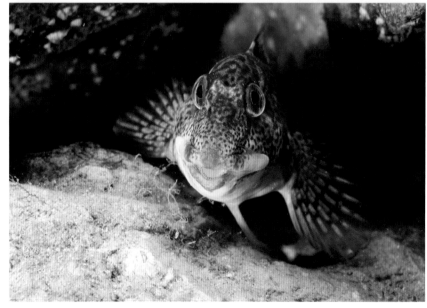

this artificial reef is isolated. The guide can tell you
everything you are likely to see and he will probably
know where the stuff is hiding.

Piers and Jetties

Wherever humans go in the world, we impact upon
the local environment and it is not always in a bad
way. There are very few piers and jetties around the
world which do not become home to thousands of

animals. To an underwater photographer, a pier or
jetty is always an attraction. However, where there
are piers and jetties there are usually boats and
propellers, and if there is active boat traffic then you
need to be really cautious especially if you are focus-
ing on taking images. Make sure it is safe to dive
before you get in the water and like anywhere with
boat traffic, it is a good idea to have someone you
can trust at the surface. You will always find small

creatures for you to get the macro and close-up shots, and on larger piers you can often find larger schooling fish too.

NON-TROPICAL DIVING

Seaweed and Kelp

Seaweed and kelp can provide a great environment for natural light photography. On a sunny day with sunbeams breaking in and around seaweed you will probably find it difficult not to get some nice shots, especially if there are any fish sitting in between the rising kelp. In temperate zones the seaweed is the natural habitat of nudibranchs, for those who want to focus on macro. If there are seals or sea lions about then you will need to take your wide-angle lens.

Rocky Seabeds

If your local dive sites are not pristine coral reefs or mangroves then you may be fortunate enough to have rocky seabeds with lots of nooks and crannies and crevices. While this habitat may not have the colour and the beauty of coral and sponges, it can very often be the perfect place for finding lobsters, crabs and possibly eels. If you are photographing on this particular kind of dive site, then it can be quite difficult to decide which lens you will need to take with you. This is probably the ideal scenario for a zoom lens which will give you both macro and wide-angle. It is a good idea to take your own hand light with you too, so that you can peer into the crevices to look for the lobsters and eels which may have made their home there.

Lakes and Quarries

When diving in lakes and quarries you will normally be in fresh water, but not always. While the wildlife in these habitats tends to be less abundant than marine environments, there are some advantages

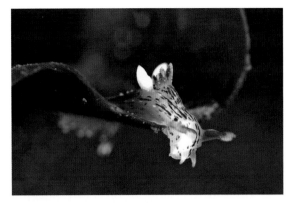

▲ **Fig. 12.7**
This minute nudibranch, found in Loch Long in Scotland, was photographed foraging on the kelp.
1/100; *f*7.1; ISO 640. Nikon D200, 60mm

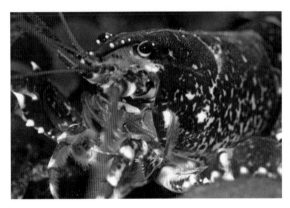

▲ **Fig. 12.8**
These critters and their cousins can be found all over the world. Very often you need to be alert, as they can move very quickly.
1/125; *f*10; ISO 400. Nikon D700, 105mm

to diving in fresh water. The first thing you will notice is that you need to wear less weight to be able to descend, and if the water quality is good, a very quick rinse off at the end of the dive is sufficient to clean your equipment. Many inland dive sites are used for dive training, so it could be that the visibility has been affected by the novices who are learning to dive. If this is the case, try diving on a weekday rather than the weekends, which tend to be busier.

It is very difficult to list here everything you might find in a lake or quarry, but if it is a man-made training-site then usually it will contain deliberately sunken artefacts. Many have sunken ships and aircraft and even scrapped vehicles which can

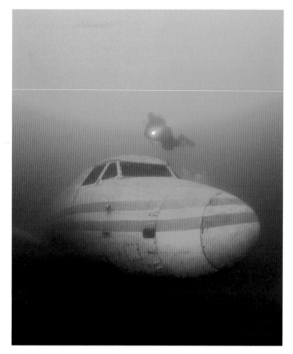

▲ Fig. 12.9
Many inland dive sites have deliberately sunk artefacts such as planes, trains and automobiles. This twin engine transport plane provides a great subject.
1/125; ƒ6.3; ISO 400. Nikon D700, 16mm

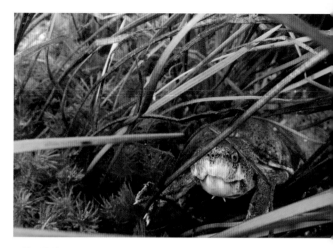

▲ Fig. 12.10
This terrapin was spotted hiding in the undergrowth at about 2m (6ft) depth in the slow moving Rainbow River, in Florida. The small DOF emphasizes the terrapin's face.
1/80; ƒ6.3; ISO 320. Nikon D200, 10–17mm at 17mm

provide some really interesting images. Many lakes have been stocked with fish for anglers so it is not unusual to see pike, salmon and possibly sturgeon swimming in and around the artefacts that may have been deliberately placed there. These are particularly good sites to visit to try out any new camera equipment and techniques.

Rivers and Streams

If you live a long way from a shoreline or a lake, then maybe there is a river nearby which could offer some good underwater photography. Be aware that rivers can be dangerous places to go diving, especially once they become large enough to carry boat traffic. Currents can be unpredictable, and rivers by their nature are flowing water, often fast flowing. If you are going to try to photograph in rivers, then make sure you have done your research and ensured that it is a safe place to dive.

Most of the best river diving is where you can stand up or even where you have to lie down partly exposed to the surface to be able to capture the fish or the creatures in the water. There are many great images in magazines that show salmon, for example, embellished in their magnificent red colouration as they head upstream to spawn. If you are taking photos in streams and at the source of the river, the visibility is often excellent.

Caves and Caverns

Photographing in caves and caverns can produce and wonderful images, and this environment offers you a great opportunity to use all your artificial lighting. If you are not qualified to go to caves, then you are restricted to open caverns but you will always have some natural light to use in these. Nearly all the best shots will be taken into the light, where you can use sunbeams if there are any, or you could use a diver to create silhouettes against the cavern opening.

If you have a cave diving qualification, then remote lighting can get you some really dramatic effects. If you can take two or three spare strobes that you can activate remotely with light, then carefully

▲ Fig. 12.11
The slow shutter speed used in the photograph helps to create the silhouette. It is because of this that the sky looks bright despite it being a gloomy day.
1/25; ƒ13, ISO 320. Nikon D200, 10–17mm

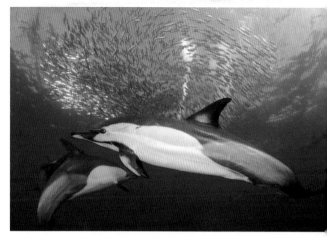

▲ Fig. 12.12
This is another shot taken on the sardine run in South Africa. On this occasion I was able to get plenty of light on them, as they came very close to the camera.
1/160; ƒ9; ISO 400. Nikon D700; 16mm

place them so it is not obvious where the light is coming from. Backlighting on things like stalactites, for example, look stunning.

OPEN OCEANS

Diving in the open ocean you may spend a lot of time in mid-water with very few references other than the surface. It can be a particularly barren environment unless you have found something that is swimming with you. Without any immediate references it can be quite hard to maintain neutral buoyancy, and you need to be aware of this and monitor your depth gauge.

The open ocean is the home to vast numbers of large pelagic species and if you find yourself in the midst of a large shoal of fish or a super pod of dolphins then you are certainly going to need a wide-angle lens. There are many places around the world where you can see large numbers of schooling fish or dolphins. You may be waiting for migrating leviathans, such as humpback whales, and for all these occasions you will need to be diving from a

vessel driven by a captain who not only knows what he is doing, but also knows where to find what you are looking for.

Commonly referred to as the greatest shoal on earth, there can be no superior experience an underwater photographer can witness than the annual sardine run in South Africa. Like a lot of open ocean photography there can be very little diving involved. When you are following a super pod of dolphins or migrating whales, you need to be patient and only get in the water when the moment is right. However, if and when you do, it is truly breath-taking.

Chapter 13

Image Manipulation

At the end of your day's diving, or when you have returned home from your holiday or expedition, you will need to examine your images on the computer screen. Digital cameras are designed and made to be used in air, so when you take photographs under water you will need to use either white balance or underwater lighting. Because of this artificial light and the colours that you find under water, there are very few images you will take that cannot be improved by minor adjustments in a photo editing software suite.

Imaging software products all do the basics in much the same manner, and most underwater photographers will only want to do the minimum amount of image manipulation. There are many discussions about the ethics of image manipulation but the general consensus is that it is a tool and it is here to stay, so why not use it. This chapter will be dealing with the basics of image manipulation and the techniques that create effects that could all be carried out in the darkroom before the digital age.

IMAGING SOFTWARE

Ideally, your computer system should comprise a high quality screen that allows colour calibration, a modern computer with as much hard disc space and RAM as possible and an external hard drive as backup for your best images once you have edited them. It is also a good idea to get the fastest USB connection, which will allow you to download your images quickly.

There are various imaging software programs available for you to be able to work on your images. Adobe Photoshop or Adobe Lightroom are the brand leaders, and this chapter will talk you through the basics of image manipulation using Photoshop Elements, the entry level package for Photoshop. For manipulating underwater images, this inexpensive package will carry out all the functions you should need.

Whichever product you decide to go for is a personal choice, but as some can be rather expensive it is a good idea to seek advice and research the subject before you purchase any particular one. It is not just the expense of the product that you need to consider – if you purchase the wrong one, you have become familiar with that product and it can be difficult and frustrating to train yourself to use another format.

Once you have installed your imaging software you can download the images and import them. If you have just purchased the latest technology in cameras and the imaging software you have installed is more than a few months old, you may need to go to the software manufacturer's website and download the latest software update. This is normally a free download and should only take a few minutes.

◀ **Fig. 13.1**
This frogfish was taken on a muck diving site in Ambon in Indonesia. I had taken a macro lens, expecting to be shooting small stuff, and so was only just able to frame this rather large fellow as he tried to land on my camera. There were several male frogfish and one female in the area and their behaviour was somewhat erratic, which is why he is approaching my camera.
1/200; ƒ13; ISO 200. Nikon D700, 60mm

Viewing Your Images

If you have recorded your images in both JPEG and RAW, the best way to view your images, and select the ones you wish to fine-tune, is to look at the JPEG images as this will take considerably less time than scrolling to the RAW images. Some people take a note of the numbers of the best ones and then go back and edit them using these numbers, while others will work through their images editing them as they go. It will generally take less time to select your images first and then go back and edit them. If you have software that has a workflow capability, then this is by far the most efficient method of annotating and editing. You can batch process a whole group of files with metadata tags of the location taken, copyright information and a whole host of other elements that can be included.

You need to remember that image manipulation software allows you to alter your images, but it cannot make a really poor shot an excellent one, so focus on taking great shots in the water and use Photoshop as a tool for minor adjustments. Bear in mind there are still some photography competitions that do not allow any image manipulation at all.

▲ Fig. 13.2
This screenshot shows the screen in the RAW file editing mode.

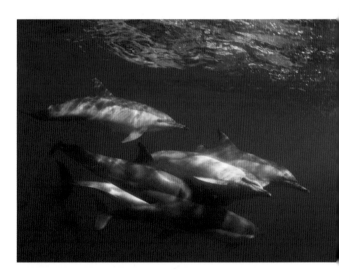

RAW FILE
MANIPULATIONS

When you have decided upon the images you are going to edit, import them into your editing software, in the RAW format if possible. For some of the aspects of editing there is no set order, however certain adjustments do seem to follow naturally.

Once you have imported your RAW file in Photoshop you will get a screen showing you a host of settings that you can adjust. As you use the sliders to change for example the exposure, you will see the effect immediately on the screen.

The first thing to do is to look at the colour balance and ask yourself whether it needs adjusting.

▲ Fig. 13.3a and 13.3b
The original image of this pod of dolphins is quite blue. As you can see from the screenshot (Fig. 13.3b) you can adjust the colours by changing the temperature or white balance until the image shows a truer representation of what they actually are.

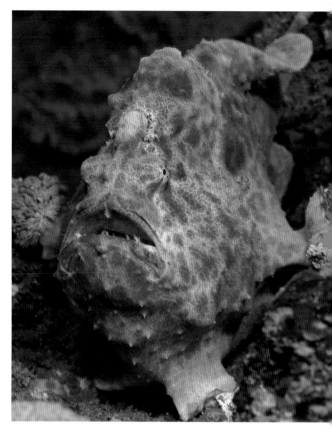

There are two ways to carry out the white balance in Photoshop. One way is to select the dropper from the toolbar on the top left, then move it over something in the image that looks white or grey and click. The other way is to move the temperature slide left or right to give the colour you see closest to actual. The temperature should be in the region of 5,000 to 7,200 Kelvin. It is may also be worth moving the Tint slide left or right by a small amount in deciding whether this offers any improvement.

If you have taken your images in RAW you will be able to adjust the exposure, often by as much as four steps either way. Use the histogram to examine the light levels. If you have followed the advice from Chapter 8 about shooting to the right, then you should reduce the exposure on the slide until the lighting looks right to you and the main curve of the histogram should be in the centre. If you have a lot of contrast in the image then the curve may not follow the normal.

The next slide down on the right is Contrast. Most underwater images can use a small increase in contrast, but try not to increase this more than 10. Contrast adjustment is usually required as water is a very dense medium, and the more water you have between the lens and your image the greater the reduction in the contrast of your final result.

The next four slides are Highlights and Shadows and Whites and Blacks. Moving these will adjust what they say. For example, if you move the highlights to the right, you will brighten the well-lit areas and if you move it to the left you will darken the well-lit areas. Generally you do not need to adjust these, but if you do feel it is necessary be careful not to overdo it. An overworked picture often looks worse than the original.

▲ Fig. 13.4a and 13.4b
You can adjust the exposure of your image. However, be warned, it is much better to get it right in the camera than to try to make large adjustments here.

JPEG MANIPULATIONS

Once you are satisfied with the processing in the RAW suite, you can import it into the main software platform as a high resolution JPEG by clicking on the open button on the bottom right of the screen. The image will now appear within the main software screen.

Cropping and Rotating

While you should always endeavour to compose the image correctly when you initially capture it, there are times when that is not possible, and you will need to crop the image in Photoshop. You should be cautious when cropping as you are reducing the resolution and the number of pixels in the image.

You may need to remove distractions that are in the background or foreground of the image with the result that the subject may be lost in too much negative space.

Sometimes you may look at your image and decide that it would look better in portrait than it does in landscape.

Another option is simply to rotate the image by a few degrees. As underwater photographers, we do not suffer the same problems that land photographers have in ensuring the horizon is exactly horizontal, but an image may still be more pleasing to the eye if the surface or substrate is also horizontal.

Consider flipping the image. If the subject is moving towards you from the right, flip it horizontally through 180 degrees so it is moving towards the viewer from the left. Very often this can transform the image, sometimes for the better. This is particularly subjective and it is your decision, but it is always worth a look as you can revert back to the original with ease if you do not think it betters the image.

Remember when you are cropping or rotating the subject that this is your last chance to get the composition right. Think about the rule of thirds, negative space and framing discussed in Chapter 7.

 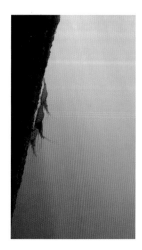

▲ Fig. 13.5a, 13.5b and 13.5c
This set of images shows the original shot of the prawns on a wooden pier leg, the screenshot from Photoshop of the crop and rotate function, and where the pier has been put on a diagonal.

Lighting and Colour

Even if you have already done RAW adjustments, or if you have a camera that does not shoot RAW files, then the next set of tools to use is situated under the Enhance/Adjust Lighting menu choice. In this part of the software you can adjust your contrast and brightness; you can also carefully change shadows and highlights, and then the most important adjustment you can access here is the Levels. This is where you can adjust the colour of your image.

There are several ways of doing this but the simplest is to go to the RGB histogram and select an individual colour. If you experiment by moving the slide to the left or the right, or the sliders at the left and right towards the centre, you will find you can increase or decrease the density of the individual colours. This is particularly useful in underwater photography, as you may be able to boost the red in your images if you have not been able to get enough light on a subject while diving.

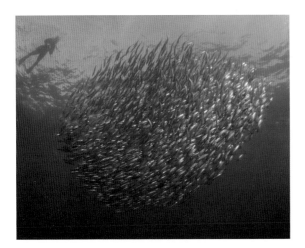
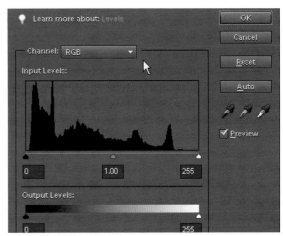
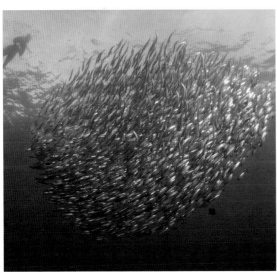

▲ Fig. 13.6a, 13.6b, 13.6c, 13.6d
This set shows the same image as it has gone through level manipulation in Photoshop.

Spot Removal

As we have discussed in previous chapters, the particulates in the water can show up in your images as backscatter, when light reflects off these particles. Even one or two spots on an image can ruin it, but a few can be removed quickly by using the Spot Healing Brush Tool in your software. Select the size of the removal and then click over a spot that you want to remove. The software will take data from the area surrounding this spot and fill it in. If your whole image is full of backscatter, then this process cannot fix the issue. Next time you go diving make sure you adjust your strobes while still in the water so the beam is angled away from the lens.

This tool can also be used to remove unwanted objects in your image, such as a distracting small fish in a sea of blue. Watch carefully what you get as a result – you can always use the Undo button to revert to the original and try again. You can also try the Cloning tool, which copies a selected portion of your image and replaces the area you then select. This can help when trying to remove larger areas of an image, like coral reef or a diver's limbs.

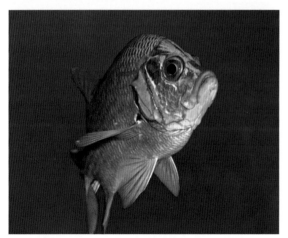

▲ Fig. 13.7a, 13.7b and 13.7c
Fig. 13.7a shows the spot removing tool, which can be used to remove small blemishes. Figs 13.7b and 13.7c show the before and after of using the clone stamp tool, where larger areas of unwanted coral have been removed by cloning the surrounding blue water.

OTHER OPTIONS

Adding Text

If you are going to post your images onto the internet or send them on to others to view, then you will want to add some text declaring that you own the copyright of the image. There is no shortage of unscrupulous people who are more than willing to help themselves to your images, so you really need to protect them. There are plenty of other reasons to add text to an image as well.

To do this, simply select the Type tool, which is usually depicted by the letter T, and then put your text box in the position you want and add text. Simply use this tool as you would a word processor, selecting font, text size and positioning.

▲ Fig. 13.8
It is important to add your copyright information to any image that you are going to share online.

Converting to Black and White

There are a number of ways that you can convert an image to black and white. You can simply reduce the saturation levels to 0, or you can use specific tools within your software to do this. The latter gives you greater control over the final product, but reducing the saturation level to a really low number can leave a really nice silvery blue effect.

Wreck shots convert to monochrome particularly well, so remember to try this on your images and be guided by the colour of the water. Images taken in green temperate water often convert really well to sepia rather than black and white. Some underwater animal portraits also work well in black and white.

With monochrome images it is also worth going back and reimporting the RAW file and trying to increase the contrast again. If you have worked your image in colour and think it would look good in black and white, save the colour print but reimport the original image and carry out your manipulations with a view to converting to black and white. You will find it is a different technique.

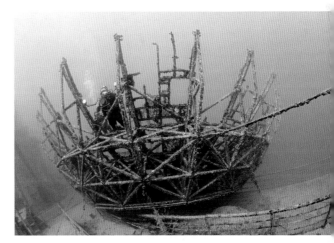

▲ Fig. 13.9
Black and white conversion can improve an image and works particularly well on wreck photography.

Sharpening an Image

The final piece of image adjustment you should consider is to sharpen the image. This should always be performed as the last procedure you do before saving the image. The Sharpen tool in Photoshop Elements increases the contrast among adjacent pixels to give the illusion that things are sharper. You should usually see a separate window with an enlarged portion of your image displayed. This will change as you edit the amount of sharpness that you select. This is another tool that you do not want to overdo – so select sharpness increases in tiny increments.

There are a huge number of additional manipulations that you can do to your image should you wish to. However, this is a time-consuming task, and spending huge amounts of time in front of a computer editing does not necessarily give you a great image. You can create layers, select effects, and even add one image to another, but these types of photo editing go beyond what is necessary to produce a great underwater image. You would be better off getting back in the water and improving how you took an image in the first place.

SAVING MANIPULATED IMAGES

It is important to be clear in your own mind how you want to label images that have been altered. Always keep your original files – do not overwrite them with the images that you change – so that you can always go back if you need to.

A simple way to keep track is to store your images in a folder named after the location of the dive, then add an 'e' to the front of the image file name to tell you it has been edited. You can then build on this idea. For example, a file named ec_DCS0123, would

▲ Fig. 13.10
This original image, with screenshot of the sharpening tool overlaid, shows how you can sharpen the image at the end of your processing.

show that it had been edited 'e' and copyright text added 'c', or a file named eclr_DCS0123 would show that this version had been saved as a low resolution file for publication on social media. The key is to work with the naming routine you want to use and then stick with it.

RESIZING IMAGES

You might want to resize an image for a number of reasons. If you take a great underwater shot then you might want to enter it into a competition or put it on your website or social media site. In these cases you will need to resize the image.

Read competition rules carefully to see what specification they want. Open your file in your editing software. Select Image/Resize and then alter the resolution and dimensions as instructed.

For images that are to be posted on the web, you will want to reduce the resolution down to about 72dpi – this ensures that if someone downloads it, they will not be able to sell the image on as their own, and it also means that the image will be of an easy size for uploading.

For printing or publishing images, you will want to keep them as high resolution (300dpi) files. On saving the image keep the quality settings as high as the software will allow.

▲ Fig. 13.11
A screenshot of a blenny, to show how you can use the cropping tool to assist with your composition, even after you have come to the surface.

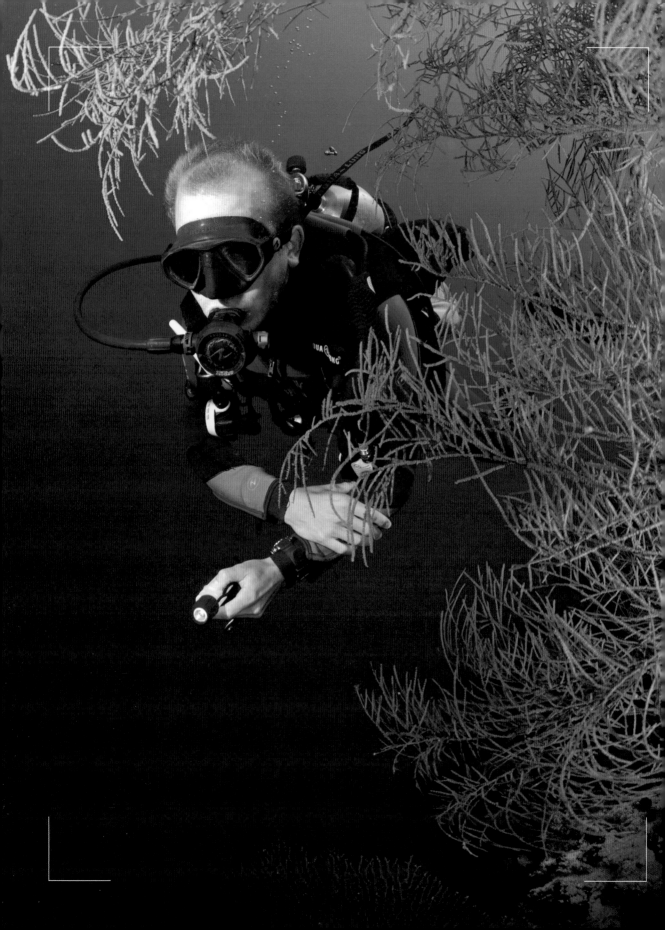

Chapter 14

The Responsible Photographer

If you are already an underwater photographer you will be aware that many divers who choose not to take a camera down below view you, in part, negatively. If you dive in a group then you will often be seen to be 'slowing down' the rest of the divers as you stop to consider your shot, compose the angle and then review and perhaps shoot again. There are divers with cameras who will occupy the interesting finds for lengthy periods of a dive, preventing the non-photographers from looking at the very reason they came to that site in the first place.

It is not always the diver with the camera who crowds out the rest of the group, but too often it is. This is unacceptable behaviour and it is avoidable. You will never stop the ignorant people who barge everyone else out of the way, kick the sponges and corals to get a closer look and hang on to delicate formations rather than use good buoyancy and awareness of their surroundings. You can, however, make sure that this person is not you!

PREPARATION

If you want to spend your time under water getting better images and improving your own photography, then tell the dive company that you want the time to do this. You will usually find that for a small extra cost – although not always – you could be given your own dive-guide. Remember that dive-guides normally have excellent buoyancy and diving skills, and know exactly where to look for the special creatures and those secret finds that you are looking to capture on your sensor. They also make great models as subjects or to add balance to your composition. If you decide to do this, talk to them about what you want from the dive and ask if they would be willing to model for you. Most guides really enjoy being the centrepiece in their diver's photography.

Another way to ensure that you are given time and support on your dive is to book onto specific dive-photo trips. These can be daily or weekly, live aboard or day boat. There is an increasing number of good underwater photographers who are offering their services for tuition, and there are very few who are so good that they cannot pick up ideas and improve their photography by listening to a pro or semi-pro underwater photographer.

While there are many articles and manuals encouraging divers to make sure they follow good, environmentally-friendly diving practices, there is very little guidance as to how to achieve this. The following few paragraphs are not meant to lecture you, but are meant as a guide to help you to set out a framework of best practices that you can follow.

◄ Fig. 14.1
This picture was taken in Menjangan in north-west Bali. It shows the dive guide, who took his duties seriously; all his equipment is clipped closely to his BCD, and his are arms tucked in front of him too. 1/160; ƒ10; ISO 320. Nikon D700, 16mm

DIVING BEHAVIOUR

Getting Access

You may be on a dive looking for subjects to photograph and when you find one, or your guide points them out, they may not actually be accessible to photograph. If you are using a compact or mirrorless system, then you will have a slight advantage over the photographers that are using a somewhat larger digital SLR and housing, but you still have a responsibility to show good environmental diving practice.

If you cannot get the angle and composition that you want without causing damage, then do not even try to take it. If it means disturbing silt or sand, then you need to query if the resultant image will actually be worth it when you consider the loss of visibility and backscatter the sand or silt will cause.

Do not let perceptual narrowing – the attitude of getting the photo at all costs, creep into your photography. Always be prepared to move on and accept that it may not have been meant to be. You could always shoot the subject from further away or at a less flattering photographic angle, looking down if all you want is to get an image of something you have not seen before.

If you see others damaging the reef you have a responsibility to challenge this behaviour. No need to be aggressive but a shake of your head can work wonders. Be aware that some dive guides are so keen to please that they will move the subject to allow you to photograph it from a better angle. Before you go diving make sure that they understand that you do not want them to interfere with the subject. Should they still attempt to do so while under water you can shake your head gesturing you do not want them to, and then move off without taking the shot.

Fingers and Pointers

This topic leads us on from the previous one, as sometimes your subject may be in a perfectly

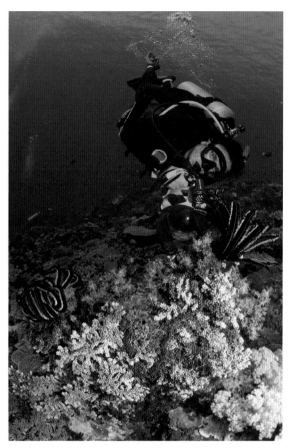

▲ Fig. 14.2
If you want to take photographs of coral or sponges and you need to get low down, then to avoid doing any damage go in head first and leave your fins above you.
1/250; ƒ11; ISO 400. Nikon D700, 16mm

acceptable position but a small amount of surge or current can make it really difficult for you to frame or focus with your camera. As you are lining up the shot and squeezing the focus button, the backwards and forwards motion or the current trying to push you to one side makes it too difficult to get it right. If there is a small area, close enough to your subject, of non-living rock or sand, can you use one finger or a pointer on this area in order to be able to stabilize yourself? Most responsible resorts and guides will encourage careful use of this practice, but there are a few who refuse to allow any contact at all and their wishes should always be respected.

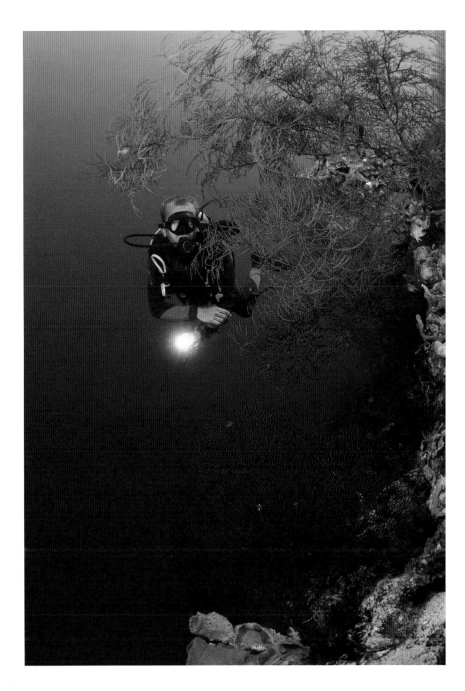

◀ Fig. 14.3
This image shows responsible diving around delicate coral.
1/160; ƒ10; ISO 320.
Nikon D700, 16mm

Kicking the Sea Fan

Most photographers will exercise care and responsible diving behaviour when lining up their shot, but some seem to think that snapping is all you need to think about to complete the shot. When reviewing the image, it is very easy to lose concentration as you examine the screen to see what you have taken.

It is not difficult to lose your buoyancy, and your fins may drop onto the reef or into a soft coral. This can be avoided by carefully backing out using breath control and reverse finning. Come up and out of your position and if you do get a fin entangled in a soft coral, then do not kick to get yourself out of the position you have found yourself in. Use your

breathing to lift yourself out and away. A few metres away while you safely review the shots you have taken, you can adjust any settings and this will allow time for others to approach the subject to look for themselves or get their own photographs.

CODE OF PRACTICE

This code of conduct has been introduced by the U.K. Marine Conservation Society with funding from PADI Project AWARE. It is endorsed by the British Society of Underwater Photographers, the Northern Underwater Photography Group, and the Bristol Underwater Photography Group, as well as being supported by the Sub-Aqua Association, the British Sub-Aqua Club and the Scottish Sub-Aqua Club.

The advice in this chapter has not been written to lecture diving photographers on how to behave under water. It is intended to offer ideas and guidance for when you are under water taking photographs. When you are diving and striving to maintain your buoyancy and trying to compose your photograph while struggling to get your settings right and your lighting set, and the subject you have your sights on has settled below a sea fan, it is difficult. However, if you think about it carefully and take your time, following the advice given here, you should never damage the reef.

THE NEXT STEP

Once you have got all your equipment and you have taken it diving you can start to gather a portfolio of all the images you have taken. As you start to get to know and understand your equipment the standard and quality of your own images will improve. Many divers just want to use their photography as a memory of where they have been and to show

their friends and families just what their hobby is all about. You may belong to a photography club and want to enter your images into a competition to offer something a little bit different or you may want to enter specific underwater photography competitions. Once you feel confident enough to show your images in public, there are several ways you can do this.

Presentations

There are many clubs and societies that rely on the members to get up in front of the group and present a slideshow or a lecture based on the images from a trip or holiday. You may be a teacher or a college lecturer and you want to use your images to encourage and inspire your pupils. While your enthusiasm will carry the presentation a long way it is important that you put your images together in a way that will tell a story.

Use your best images for presentations, and make sure the images are clean, as many people find it irritating watching a slideshow where a speck on the sensor is in the same position on the screen in every shot.

Competitions and Exhibitions

When you get to the point where you feel your images are good enough to compete with other photographers then why not enter them into a photography competition. This could be a general competition, wildlife or a specific underwater photography competition. There are competitions running all year round in magazines, newspapers and societies. For many of these competitions you do not need to be a member. Some are free to enter; others may cost a small amount, and some are quite expensive. Make sure you study the rules so you enter your images in the right format, the right size, and the correct resolution; otherwise you will be eliminated before your picture is even looked at by the judges.

UNDERWATER PHOTOGRAPHY CODE OF PRACTICE

- No-one should attempt to take pictures under water until they are a competent diver. Novices thrashing about with their hands and fins while conscious only of the image in their viewfinder can do untold damage.

- Every diver, including photographers, should ensure that gauges, octopus, regulators, torches and other equipment are secured so they do not trail over reefs or cause other damage.

- Underwater photographers should possess superior, precision buoyancy control skills to avoid damaging the fragile marine environment and its creatures. Even experienced divers and those modelling for photographers should ensure that careless or excessively vigorous fin strokes and arm movements do not damage coral or smother it in clouds of sand. A finger placed carefully on a bare patch of rock can do much to replace other, more damaging movement.

- Photographers should carefully explore the area in which they are diving and find subjects that are accessible without damage to them or other organisms.

- Care should be taken to avoid causing stress to a subject. Some fish are clearly unhappy when a camera invades their 'personal space' or when pictures are taken using flash or lights. Others are unconcerned. They make the best subjects.

- Divers and photographers should never kill marine life to attract other types to them or to create a photographic opportunity, such as feeding sea urchins to wrasse. Creatures should never be handled or irritated to create a reaction and sedentary ones should never be placed on an alien background, which may result in them being killed.

- Queuing to photograph a rare subject, such as a seahorse, should be avoided because of the harm repeated bursts of bright light may do to their eyesight. For the same reason, the number of shots of an individual subject should be kept to the minimum.

- Clown fish and other territorial animals are popular subjects but some become highly stressed when a photographer moves in to take a picture. If a subject exhibits abnormal behaviour move on to find another.

- Night diving requires exceptional care because it is much more difficult to be aware of your surroundings. Strong torch beams or lights can dazzle fish and cause them to harm themselves by blundering into surrounding coral or rocks. Others are confused and disturbed if lights are pointed directly at them. Be prepared to keep bright lights off subjects that exhibit stressed behaviour, using only the edge of the beam to minimize disturbance.

- Care should be taken when photographing in caves, caverns or even inside wrecks because exhaust bubbles can become trapped under overhangs killing marine life. Even small pockets of trapped air which allow divers to talk to each other inside them can be lethal for marine life.

- The image in the viewfinder can be very compelling. Photographers should remain conscious of their position and of the marine life around them at all times. In sensitive areas, they should avoid moving around on the bottom with their mask pressed up against the camera viewfinder.

- Areas of extensive damage or pollution should be reported to the appropriate authorities. Today, when so many more divers are taking up underwater photography, both still and video, it is essential that the preservation of the fragile marine environment and its creatures is paramount and that this Code of Good Practice is carefully observed.

Image Sharing and Social Websites

There are many websites on the internet that allow you to show your images. This could be a good way of getting feedback on your image, especially on image sharing sites such as Flickr. However, be aware that you must put a copyright watermark into the image – this can be done in Photoshop. Any of your images on the internet that do not bear your name are considered orphan images, and in many cases anyone wanting to use your image can do so legally.

Join a Photography Club or Society

There are numerous underwater photography clubs and societies all over the world. By joining one that is local, you will find like-minded people who will offer you advice, and in time you will be giving advice too. It does not have to be an underwater photography society either; many photography clubs would welcome the addition of an underwater photographer who can offer them something different in their own inter-club competitions

Prints and Books

As time progresses your portfolio of images will expand. If you have them neatly filed on your computer, it will make it easy to access any images you may require for any of the above reasons. However, it is really nice to see them in print so have your best images printed in A4. You will be amazed at how different they can look than they do on your computer screen.

Many people like to select their best images and put together a photo-book – this can work well especially if you use it to tell a story. If you have any images that are really good and that you are particularly proud of, have them printed on canvas or acrylic and display them on your wall.

Qualifications

One way to drive the quality of your photography forward is to work towards a qualification in photography. Most countries have an internationally recognized society or organization which offers different levels of qualification. You can do this simply to focus on improving your photography, or you may be seeking credibility in order to work and make money from your hobby. You may decide at some point that you are good enough for your hobby to become your career.

And Finally...

All the ideas and suggestions offered are just that, ideas. Whatever your reasons for taking photographs under water, you should enjoy it. There will be times when you will come up from a dive and be thoroughly disappointed with your images; conversely there will be days when you will be ecstatic. The most important point is that you take as much of the advice and guidance in this book as you feel you need, and then get under water, take great photographs and above all, have fun.

▲ Fig. 14.4
A shot of the author, about to go diving in the Menai Straits, North Wales.

A SHORT FOOTNOTE FROM THE AUTHOR

As an underwater photographer, freelance journalist and biologist I know just what a privileged career that I have. I get to dive all over the world, not only in some of the more famous resorts, but also in some places that most people have never heard of. For example, who has ever heard of Pramuka Island off Jakarta, which translated means Boy Scout Island? I spent four days there once with my wife Caroline, and in all that time we were the only Western faces there. The diving was really very good too, with several interesting wrecks.

Probably the most common question I get asked by the public when I am doing talks or presentations is, 'what is the best place that you have ever dived?' On many occasions I have stopped and thought for a while, and depending upon my mood, I have come up with one or another of various diving locations around the world. One day, whilst editing some photographs, I decided to think more deeply about this question to try and come up with a definitive answer, and I found that actually, it wasn't a particular dive site, but that it was a type of diving. Shipwrecks can be inspiring and thought-provoking and macro diving can be great fun searching through the muck and rubbish for an interesting creature. However, the kind of diving really inspires me is getting into the water with the world's most misunderstood creature – the shark. Sharks come in all shapes and sizes, and they can be found all over the world in the diversity of environments, but when you slip into the water with your camera and you are surrounded by one or seventy free swimming sharks, you are in their environment, you are privileged and most of all, you are in awe of these magnificent predators.

Sharks are persecuted all over the world by man, and yet very few humans, worldwide, are hurt by these magnificent beasts. However, still we continue to persecute them, killing millions every year through fear, ignorance or greed. I have seen pictures of basking sharks in the press with headlines of 'killer', 'predator' and worse – and let's not forget basking sharks do not have any teeth.

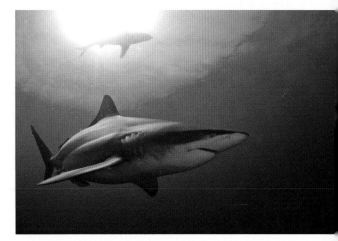

▲ Fig. 14.5
A black tip oceanic shark cruises past the lens on Aliwal Shoal. I have shot this into the sun but you can see the silhouette of a second shark in Snell's window.
1/160; ƒ10; ISO 200. Nikon D700

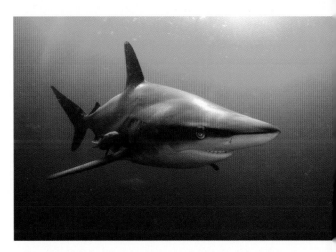

▲ Fig. 14.6
Another black tip on Aliwal Shoal. This female appears to be smiling for the camera and you can see the Ramora attached to her side.
1/160; ƒ8; ISO 200. Nikon D700

The best way to photograph free swimming sharks in mid-water is to use a wide-angle or fisheye lens. This involves getting up really close and personal with the animals, but as you can see from my photographs, both here and in previous chapters of the book, whilst they are curious animals and may be interested in us, they really do not see us as food. There are, of course, as with everything, some exceptions. The great whites and bulls need to be afforded greater respect and if you are diving to photograph any of the more unpredictable species, then you need to make sure that you're in the company of people who understand them.

One thing to bear in mind if you are in the water with sharks is the noise your strobe makes when recharging. I'm not sure if sharks love or hate this noise, but on several occasions I have had a shark try to take a strobe when it was recharging. One piece of advice would be to make sure that your strobe is firmly clamped to your camera housing and your housing is firmly attached to yourself. They do tend to let go when the sound of the charging stops. Another way to avoid this is to use natural light photography. Many of the dives that involve free swimming sharks are fairly close to the surface and as most of this kind of diving involves the use of chum, there will be lots of particles in the water, much of it will be reflective scales and this may cause horrendous backscatter.

Finally, these animals are apex predators, and if you are photographing them in their environment, respect them and they will respect you.

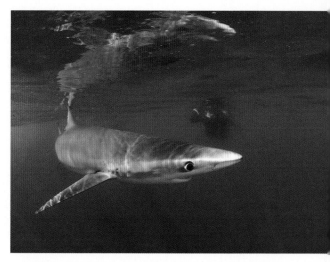

▲ Fig. 14.7
This is a blue shark. Since finning has finally been banned in UK waters, their numbers have risen. This really curious female played with us for over thirty minutes, off the Penzance coast, SW England. 1/160; ƒ9; ISO 250. Nikon D200

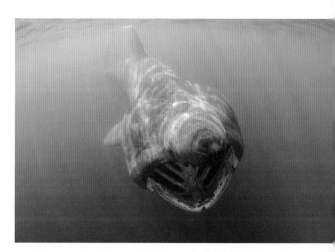

▲ Fig. 14.8
Basking sharks are one of the gentle giants of the sea. This one is over 8m (25ft) long. I used a high ISO so that I could increase the shutter speed to reduce any motion blur, but also you need a high shutter speed to capture any sunbeams. Taken in Cornwall, UK. 1/160; ƒ9; ISO 800. Nikon D800

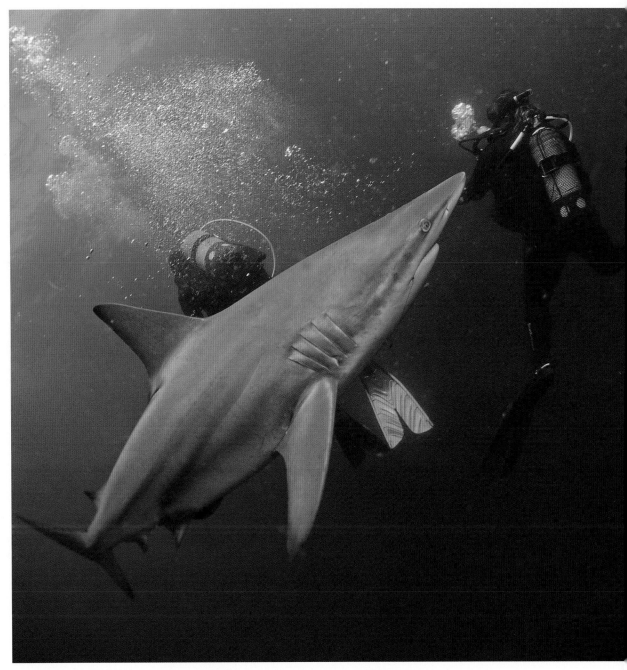

⬕ Fig 14.9
Another black tip from Aliwal Shoal; this image shows just how
inquisitive these 2m (7ft) sharks can be. This one has a fishing line
trailing from its mouth and has probably been stealing the catches
from sport fishermen.
1/160; ƒ5.6; ISO 200. Nikon D700

▶ Fig. 14.10
This close up of a blue shark
was taken off Cornwall. It is
the same curious female as
in Fig. 14.7. You can see the
RIB and the captain watching
the action through Snell's
window.
1/160; ƒ7.1; ISO 250.
Nikon D200

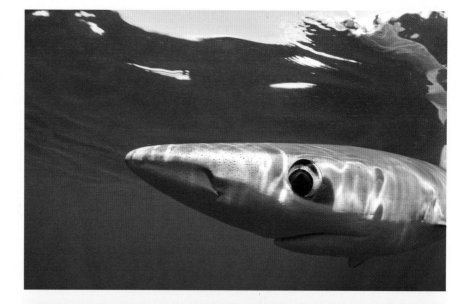

▶ Fig. 14.11
This black tip has just
taken the remains of a
sardine, which you can
see inside its mouth.
1/160; ƒ6.3; ISO 200.
EV −0.7. Nikon D200

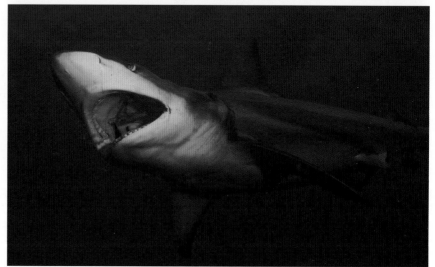

▶ Fig. 14.12
This picture gives an idea
of the mayhem that ensues
when sixty eight-foot sharks
are all trying to get at the
sardines that are used to
attract them to the boat. The
washing machine drum is full
of sardines.
1/125; ƒ4.5; ISO 100. ISO 200.
EV −0.7. Nikon D200

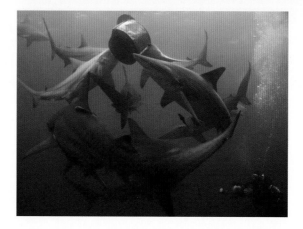

Glossary

AE lock (AE-L) Auto exposure lock, which allows you to select a part of your image to meter light from and then hold that setting whilst you capture the image.

AF lock (AF-L) Auto focus lock, which allows you to select a part of your image to focus on and then hold that setting whilst you capture the image.

ambient light The light around you under water, with no influence from artificial lighting.

aperture The orifice in the lens which can open and close to allow more light through to the sensor; opening the aperture will decrease the depth of field.

aperture priority (A) or (Av) An exposure mode on the camera which allows the user to set the aperture, and therefore the depth of field, whilst relying on the camera's own metering system to select the shutter speed and ISO for the correct exposure.

autofocus (AF) Facility which relies on the camera to focus on the part of the image the user has selected.

automatic (AUTO) An exposure mode found on all digital cameras whereby the metering system inside the camera will select all the components of exposure including ISO, white balance, aperture and shutter speed.

backscatter A condition of poor visibility, caused by the light from the strobe or continuous light source striking tiny particles in the water which is reflected back into the camera lens; sometimes referred to as dirty water.

beam angle The angle at which the light is emitted from a strobe, normally expressed in degrees.

bokeh All the parts of an image that are out of focus; bokeh is deliberately created by many photographers to focus the viewer's eye on the particular part of the image that is in focus, normally the subject.

bracketing Taking several pictures either side of the optimum exposure value by changing either the camera's exposure settings or the flash settings; many cameras have a setting which will bracket the camera's exposure settings automatically for you.

bulb (B) A setting on the camera allowing the shutter to stay open for as long as the release button remains depressed.

buffer A RAM unit inside the camera's processor which will store images before they are passed to the memory card, allowing you to shoot a number of photographs without having to wait for each to be recorded to the memory card; the size of the buffer varies greatly from one camera to another.

CCD (charged coupling device) The light sensor, comprises millions of tiny light sensors, which records the image; its size is measured in megapixels.

centre-weighted metering An automatic exposure system that uses the centre part of your frame to meter the exposure value.

colour temperature All light has a colour, based on a hypothetical black body radiating light as it is heated, whereby the warmer the light is, the bluer the colour; this temperature is measured in Kelvins.

compact flash Memory card typically used with the higher end digital SLRs.

composition The art of balancing the subject with its environment to create a pleasing image.

contrast (composition) The positioning of the subject and the supporting elements create the emphasis required to direct the viewer's attention towards the subject.

contrast (exposure) Relates to the difference in exposure between the darker and brighter parts of an image.

cropping Taking out unwanted parts of the image using photo manipulating software.

depth of field (D of F) The amount of the image that is in focus around the subject, controlled by the size of the aperture, the focal length of the lens or the distance between camera and subject.

diffused lighting Lighting where the intensity from a single light source has been softened by spreading the light across the image.

diffuser A translucent material placed over a strobe light to widen and soften the beam.

digital image An image created when the light from the subject is converted to a digital signal and then converted back to an image.

digital zoom The zoom facility inside the camera which focuses in on an image by expanding the area being zoomed into; this area will look larger but contains the same number of pixels and should not be used for capturing images.

dioptre lens A lens which can be placed in front of the camera lens or port in order to allow you to focus close to the subject and hence make it appear larger.

dome port A hemispherical piece of glass or plastic placed over the lens to eliminate refractive distortion.

dynamic range A measure of the range of brightness that a digital sensor can record.

EV (exposure value) A measure of the amount of light that is allowed through to the sensor.

exposure The brightness of the image; if it is overexposed it is too bright, and if underexposed it is too dark.

exposure compensation Allows you to adjust the camera's metering system to a greater or lesser extent; normally denoted by a button with a +/- button.

fill-in flash Using the flashgun to add some colour to an image that is predominantly natural light, or using a secondary strobe to soften the shadows created by the primary; also termed flash fill.

first shutter curtain Setting the flash to fire as soon as the shutter opens; particularly useful in low light as it reduces the effect of camera shake.

fisheye lens Lens with a very wide field of view, normally, at least 180 degrees; predominantly used in underwater landscapes and wreck photography.

flare A fault, often seen as a bright line across the image, which most commonly occurs when light from the flashgun encroaches on the dome port causing the image to lose contrast and sharpness.

flash synchronization Coinciding the firing of a flashgun with the shutter mechanism to allow light from the flash to the sensor whilst the shutter is open.

focal length Describes the magnification of the lens; the greater the focal length, the greater the magnification.

focusing The process of ensuring that the point at which the rays of light converge is on the sensor and will create a sharp image.

focus priority (single servo) An autofocus mode which will only allow the shutter to be released once the subject is in focus.

frame A single image; or it can refer to how you compose your image.

ƒ-stop number A measure of the relationship between the size of the aperture opening and the focal length of the lens: at a setting of ƒ8, the diameter of the aperture is 1/8 of the focal length of the lens; the larger the ƒ-stop number, the greater the depth of field.

highlights The brightest areas in an image.

histogram A graphic representation of the light density in an image; the curve shows the dark areas to the left and the light areas to the right.

hot shoe The mounting on the top of the camera that has contacts so the flash can be connected.

image stabilization An electronic system now available on most cameras which reduces camera shake, especially if using slow shutter speeds; especially useful for natural light photography where conditions are gloomy, as it allows for slower shutter speeds.

infinity Effectively the distance about 1000 times the focal length of the lens, where the light rays arriving at the sensor are virtually parallel.

interchangeable lens A lens that can be removed from a camera to be replaced by another, which would normally have a different focal length.

inverse square law The law that causes light from a flash unit to fall away exponentially; for example, the light from a flash on a subject 4m away is 1/16 of the light on the subject 1m away.

ISO (International Standards Organization) A standard notation to denote the sensitivity of the sensor; originally designating film of the same standard, it has been adopted in digital photography.

JPEG A file format used as a method for compressing information, enabling a massive reduction in file sizes; it takes its name from the Joint Photographic Experts group.

Kelvin The unit of measurement of colour temperature.

landscape The notation for an image taken with the camera horizontally orientated.

LED (Light Emitting Diode) Lights displayed on the camera to show data.

lens filter A large piece of coloured glass, plastic or gelatine placed over the lens to adjust or balance the colour.

lens speed Refers to the widest aperture to which a lens can be opened; the lower the f-stop number, the faster the lens is said to be.

macro lens A lens that is specifically designed for close-up photography, allowing the photographer to get very close to the subject.

matrix metering The system that uses a grid across the image to evaluate each section in order to determine the exposure.

megapixel One million pixels, or a light detection unit on the sensor.

modelling light A small light attached to the flashgun to allow the photographer to see where the strobe is pointing.

monochrome Literally meaning single colour, although usually refers to black and white.

motion blur The process of creating blur by moving the camera so the sensor has nothing to focus on.

M Indicates that the photographer has full manual control of the exposure settings on the camera.

negative space Everything in the image that is not the subject.

neutral density filter A filter that reduces the amount of light entering the camera without affecting the colour.

noise Faults in the image, usually seen in the shadowy regions where the dark areas should be black but very often have a speckled appearance; occurs where pixels with random values are encountered in the image.

optical zoom Used in a compact camera enabling the lens to be adjusted to magnify the scene by zooming in or out; not to be confused with digital zoom.

overexposure A pale image where too much light has been allowed through to the sensor.

panning The process of using the camera to follow a moving subject so the subject is in focus whilst the background will be out of focus due to motion blur.

parallax error Occurs where the viewfinder and the sensor have a different viewpoint so that the image the camera will capture will be slightly offset from the one the viewer can see.

pixel The smallest part in a digital image; also the shortened word for picture element.

port The glass or Perspex window on the front of a camera housing which allows the lens access to the view in front of it.

P (program mode) One of the modes normally offered by a camera, where the camera selects both aperture and shutter speed automatically.

rear curtain synchronization A setting whereby the camera fires the flash at the end of the exposure just before the shutter closes, so the action is frozen at the end of the shutter operation.

recycle time The time taken for a strobe unit to recharge between the flashes.

refraction The change of the direction of light as it passes from a medium of one density into another medium of different density; if it moves from lower density to higher density it will move towards the normal. This is why things look larger and closer when viewed through a mask under water.

resolution The quality of the image that has been produced by the processor, in part due to the number of pixels but also depending upon the quality of the image processor and the lenses; do not assume that one camera's resolution will be better than another just because it has a higher pixel count.

RGB The colour system used in most digital cameras, where red, green and blue light is captured separately and then used to create the whole image.

short focal length lens A lens that provides a wide angle of view, often referred to as a wide-angle lens.

shutter The mechanism on the camera that blocks the light from getting to the sensor unless the shutter release has been depressed, opening the shutter and allowing the light to the sensor; modern digital cameras do not necessarily have a physical shutter: the shutter is constantly charged and only when the fire button is pressed will the sensor pass that image through to the processor.

shutter lag The time taken between pressing the shutter release button and the camera actually taking the shot; in most modern cameras, the shutter lag is very short.

S (shutter priority mode) A semi-automatic exposure mode in which the photographer sets the required shutter speed and the camera selects the aperture to give what the camera sees as the correct exposure.

shutter speed The amount of time the shutter remains open, allowing light through to the sensor.

single lens reflex (SLR) A camera which has a mirror in front of the shutter reflecting the actual view through the lens to the viewfinder, so the photographer sees exactly what is in his or her lens; when the shutter release is pressed, the mirror lifts out of the way of the sensor and shutter.

slave flash unit A strobe that is activated by the light from another strobe.

Snell's window The circular window which becomes visible on the under surface of the water when using a wide-angle lens, caused by the effects of refraction.

spot metering A metering system which uses a single point in the viewfinder to calculate the best exposure.

stepless shutter speeds In any mode other than manual or shutter priority, the camera will select a shutter speed to give the correct exposure, and in these cases not necessarily a speed that is in the standard range.

stop An aperture setting that indicates the size of the lens opening.

stop down To decrease the size of the lens aperture by one stop.

tele converter An open-ended lens that can be used to increase the effective focal length of the lens; it is mounted between the lens and the camera.

TTL (Through The Lens) Metering which measures the light coming into the camera through the lens and closes the shutter, having registered the correct exposure.

thumbnail A low resolution of an image, which can be used to preview the results.

underexposed Describes an image where insufficient light has been allowed through to the sensor to get the correct exposure, usually resulting in a dark image.

vignetting Reduction of an image's brightness or saturation at the periphery, caused by using a poor quality lens or the wrong lens, or where the edges of a port infringe the view.

zoom lens A lens that offers several different focal lengths which can be altered whilst the camera is in use; a lens the focal length of 10–17mm, for example, can be varied from 10mm through to 17mm.

Index